VOID | In Art

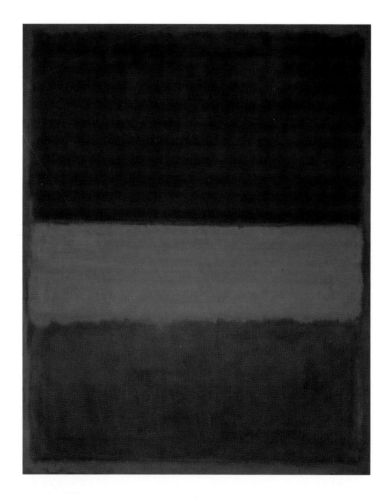

Frontispiece | Mark Rothko: *No. 61 (Rust and Blue) Brown Blue, Brown on Blue*

# VOID | In Art

Mark Levy, PhD

Bramble Books

For information please contact:
Bramble Books
E-mail address: info@bramblebooks.com

**Library of Congress Cataloging-in-Publication Data**

Levy, Mark, 1947-
  Void — in art / Mark Levy.
    p. cm.
  Includes bibliographical references and index.
  ISBN-13: 978-1-883647-11-7 (alk. paper)
  1.  Spirituality in art. 2.  God—Art. 3.  Art and religion. 4.  East and West in art.  I. Title.

  N8248.S77L48 2005
  704.9'48—dc22

                                            2005021893

First Printing 2005
1  3  5  7  9  10  8  6  4  2
06  08 00  09  07  05

Printed in Korea

The paper used in this publication meets the minimum requirements of American National Standard for Information Sciences—Permanence of Paper for Printed Library Materials, ANSI Z39.48-1984

**Cover Art:**
Please be aware that the original intent of the artist, as the title indicates, was to paint a tilted white square on a white background. Overtime, the tones have shifted and we are faithfully reproducing the way the painting looks now.

# CONTENTS

# LIST OF ILLUSTRATIONS

**COVER**
Kazimir Malevich
*Suprematist Composition: White on White,* 1918
Oil on canvas, 31¾ × 31¾ in.
Museum of Modern Art, New York, Whitney Bequest
Museum of Modern Art/Licensed by Scala/Art Resource, NY

**FRONTISPIECE**
Mark Rothko
*No. 61(Rust and Blue) Brown Blue, Brown on Blue,* 1953
Oil on canvas, 115¾ × 91¼ in.
Museum of Contemporary Art, Los Angeles,
Panza Collection
Courtesy of the Museum of Contemporary Art, Los Angeles
©2003 Kate Rothko Prizel and Christopher Rothko,
Artists Rights Society, New York

**FIGURE 1**
Shiva Mahesvara
India, 9th century
Stone, 130 × 120 in.
Photo: Mark Levy

**FIGURE 2**
Nataraja: Shiva as King of the Dance
Chola dynasty, India, 11th century
Bronze, 45½ × 40 in.
©Cleveland Museum of Art

**FIGURE 3**
Supreme Goddess as Void
Andhra Pradesh, India, 19th century
Brass, 9 × 4 in.
Collection of Ajit Mookerjee
From *The Tantric Way* by Ajit Mookerjee and Madhu
Khanna, Thames and Hudson, New York, 2003
Courtesy of Thames and Hudson

**FIGURE 4**
Chinnamasta
Bengal, India, 20th century
Chromolithograph, 48 × 36 in.
Collection of Mark Levy

**FIGURE 5**
Samanthabhadra
Tibet, Nyingma and Kagyu lineages, 1600–99
Ground mineral pigment on cotton, 33½ × 28 in.
Courtesy of the Collection of Shelley and Donald Rubin
http//www.himalayart.org

**FIGURE 6**
Vajra
Nepal, 18th century
Bronze, 6¾ × 1¾ in.
Collection of Mark Levy

**FIGURE 7**
Shri Yantra
Rajasthan, 18th century
Gouache on paper, 26 × 27 in.
Collection of Ajit Mookerjee
Courtesy of Thames and Hudson

**FIGURE 20**
Ni Tsan
*Rongxi Studio*
China, 13th century
Hanging scroll, ink on paper, 29⅜ × 14 in.
   National Palace Museum, Taipei, Taiwan,
Republic of China

**FIGURE 21**
Giotto
*Expulsion of Joachim from the Temple*
Scrovegni Chapel, Padua, ca. 1305
Fresco, 78¾ × 72¾ in.
   Alinari/Art Resource, NY

**FIGURE 22**
Leonardo da Vinci
*St. John the Baptist,* 1514–15
Oil on panel, 27 × 22½ in.
Musée du Louvre, Paris
   Alinari/Art Resource, NY

**FIGURE 23**
Domenico Beccafumi
*Stigmatization of St. Catherine of Siena,* 1515
Oil on panel, 80¾ × 61½ in.
Pinacoteca Nazionale, Siena
   Alinari/Art Resource, NY

**FIGURE 24**
Caravaggio
*The Calling of St. Matthew,* 1599–1600
Oil on canvas, 127½ × 134 in.
Contarelli Chapel, S. Luigi dei Francesi, Rome, 1609
   Alinari/Art Resource, NY

**FIGURE 25**
Caravaggio
*The Conversion of St. Paul,* 1600–01
Oil on canvas, 90½ × 70 in.
S. Maria del Popolo, Rome
   Alinari/Art Resource, NY

**FIGURE 26**
Francisco de Zurbarán
*St. Francis in Meditation,* 1635–40
Oil on canvas, 59¾ × 40 in.
   National Gallery, London

**FIGURE 27**
Caspar David Friedrich
*Monk by the Sea,* 1809
Oil on linen, 43¼ × 67½ in.
Staatliche Museen zu Berlin
   Bildarchiv  Preussischer Kulturbesitz
Photo: J. P. Anders

**FIGURE 28**
Caspar David Friedrich
*Wanderer Overlooking the Fog,* 1817
Oil on linen,  37⅛ × 29½ in.
Kunsthalle, Hamburg
   Bildarchiv Preussischer Kulturbesitz
Photo: Elke Waterford

**FIGURE 29**
Shen Chou
*Poet on a Mountain Top*
China, late 15th–early 16th century
Hand scroll, ink on paper, 15¼ × 23¾ in.
Landscape Album: Five Leaves by Shen Chou
Collection of the Nelson-Atkins Museum of Art,
Kansas City, Missouri
(Purchase Nelson Trust) 45-16
   1991 The Nelson Gallery Foundation

**FIGURE 30**
J. M. W. Turner
*The Slave Ship,* 1840
Oil on canvas, 36 × 48 in.
Museum of Fine Arts, Boston
Henry Lillie Pierce Fund
©Museum of Fine Arts, Boston

**FIGURE 31**
J. M. W. Turner
*Boats at Sea,* undated
Watercolor, 8¾ × 11 in.
Tate Gallery, London
   Tate Gallery, 2002

**FIGURE 32**
Alberto Giacometti
*City Square (La Place),* 1948
Bronze, 8½ × 25⅜ × 17¼ in.
Museum of Modern Art, New York
Museum of Modern Art/Licensed by Scala/Art Resource, NY
  2003 Artists Rights Society, New York/ADGP, Paris

**FIGURE 33**
Yves Klein
*Room of Emptiness,* 1961
Museum Haus Lange, Krefeld, Germany
Courtesy of Museum Haus Lange
  2003 Artists Rights Society, New York/ADGP, Paris

**FIGURE 34**
Ad Reinhardt
*Abstract Painting No. 3,* 1962
Oil on canvas, 60 × 60 in.
Berkeley Art Museum, Collection of the University
of California
Courtesy of Berkeley Art Museum, University of California
  2003  Estate of Ad Reinhardt, Artists Rights Society,
New York

**FIGURE 35**
Diamond World Mandala
Japan, ca. 1500
Ink and colors on paper, mounted on brass fittings and furls,
41 × 32½ in.
Marion Stratton Gould Fund
  Memorial Art Gallery of the University of Rochester

**FIGURE 36**
Agnes Martin
*The Rose,* 1964
Oil, red, and black pencil, sizing on canvas,
71¾ × 71/¾ in.
Art Gallery of Ontario, Toronto
Purchase with Assistance from Wintario, 1979 78/751
  Art Gallery of Ontario

**FIGURE 37**
Sam Francis
*Moby Dick,* 1958
Oil on canvas, 92 × 144 in.
Collection of Mr. and Mrs. Armand Bartos, New York City
  The Estate of Sam Francis, Los Angeles, California

**FIGURE 38**
Sam Francis
*Blue Balls I* from the Blue Balls series, 1960 (destroyed)
Oil on canvas, 117½ × 161¼ in.
  The Estate of Sam Francis, Los Angeles, California

**FIGURE 39**
Sam Francis
*Untitled* from the Sail series, 1968
Acrylic on canvas, 120 × 96 in.
Collection of the artist
  The Estate of Sam Francis, Los Angeles, California

**FIGURE 40**
San Francis
*Facing Within* from the Mandala series, 1975
Acrylic on canvas, 84 × 66 in.
Collection of Byron Meyer, San Francisco
  The Estate of Sam Francis, Los Angeles, California

**FIGURE 41**
Mark Tobey
*Edge of August,* 1953
Casein on composition board, 48 × 28 in.
Museum of Modern Art, New York
Museum of Modern Art/Licensed by Scala/Art Resource, NY

**FIGURE 42**
Robert Irwin
*Untitled,* 1968
Acrylic lacquer on Plexiglas, 53¼ × 53¼ × 24½ in.
San Francisco Museum of Modern Art
T. B. Walker Foundation Fund Purchase
  Robert Irwin
Photo: Don Meyer

**FIGURE 43**
Anish Kapoor
*Adam,* 1988–89
Sandstone and pigment, 46¾ × 40 × 93 in.
Tate Gallery, London
   Anish Kapoor
   Tate Gallery/Art Resource, NY

**FIGURE 44**
Anish Kapoor
*Void Field,* 1989
Sandstone and pigment, 20 parts, variable dimensions
Installation at British Pavilion, XLIV Venice Biennale, 1989
Photo: Graziano Arci, Venice, 1990
   Anish Kapoor
Courtesy of Lisson Gallery, London

**FIGURE 45**
Montien Boonma
*Drawing of the Mind Training and Bowls of the Mind,* 1992
Crayon on paper, terra-cotta, and wood bases,
variable dimensions
Collection of Chongrux Chanthaworrasut, Bangkok
   Boonma Estate, courtesy of Apinan Poshyananda
Photograph courtesy of Asia Society and Museum, New York

**FIGURE 46**
Montien Boonma
*Lotus Sound,* 1992
Terra-cotta and gilded wood, 118 × 137¾ × 118 in.
The Kenneth and Yasuko Myer Collection of
Contemporary Asian Art
Purchased with funds from the Myer Foundation and
Simcha Baevski through the Queensland Art Gallery
Collection: Queensland Art Gallery
   Boonma Estate, courtesy of Apinan Poshyananda

# PREFACE

After more than thirty years of meditation practice, I can attest that—to use the words of Samuel Beckett in his novel *Malone Dies*—"*Nothing is more real than nothing*" (1965a, 192). As the presence of the Void has deepened for me in both formal sitting meditation practice and the concerns of my everyday life, I have struggled to come to grips with my experiences in conceptual terms. These experiences, compounded by my curiosity as an art historian to examine how various artists in the East and West have presented the Void in their works, are the foundation for this book.

Over the last eight years, my ideas on the Void have constantly changed. For now, my understanding has more or less stabilized, yet I expect it will evolve as my meditation practice continues and I am able to find words to describe my experience. Any verbal concept of the Void is a shadow of the actual experience of the Void. Visual representations or presentations of the Void come closer; they show what cannot be said.

Ludwig Wittgenstein wrote in *Tractatus Logico-Philosophicus*, "There are, indeed, things that cannot be put into words. They make themselves manifest. They are what is mystical" (1961, 151). He believed that art, whether images or poetry, was uniquely situated to show aspects of the mystical that could not be conveyed in ordinary discourse. Nevertheless, the most advanced meditators, such as the nineteenth-century Tantric master Ramakrishna and the thirteenth-century Japanese Zen

Buddhist Dogen, have attempted to describe their experience of the Void. There is a natural desire to communicate what is most meaningful in one's spiritual life to others in words, in part to clarify the experience for oneself and perhaps to inspire others to begin a spiritual practice.

I began my search for the Void after reading accounts of spiritual practice by meditation masters. After some false starts, I met my root guru, Swami Rudrananda—Rudi, as he was affectionately known by his students. He taught a form of kundalini yoga in which breathing practices are used to open the subtle body system of the major and minor chakras and the *nadis*, the connections between them. The major chakras are centers of consciousness that are located in most kundalini systems at the top of the head, the third eye (center of the forehead), the throat, the heart, two inches below the navel, the root of the sexual organ, and the base of the spine. They are not accessible to the normal senses; the senses have to be expanded initially by visualization and breathing in order to feel the chakras and the energy, or *shakti,* running through them. At a further stage in the meditative practice, the *shakti* of the adept merges with the primordial energy field of the Void, burning and dissolving karmic patterns and tensions on all levels. Kundalini yoga, as Rudi taught it, is a very powerful vehicle of self-transformation, an alchemical Tantric process that can also be incredibly blissful especially as one enters the primordial Void.

Although I was a callow youth of twenty-three when I met Rudi and worked with him only in the four years prior to his death, he was able to transmit a kind of time-release capsule of the practices, which has greatly deepened and unfolded as I have continued to do his form of kundalini yoga. To be sure, there were periods in my life when I hardly practiced, but I kept coming back to Rudi's method—a very old lineage that probably goes

back to pre-Hindu India. Now I am continuing Rudi's lineage with my own group of hard-working students.

This book is dedicated to both Rudi and my students, who have kept me focused on the path. I also dedicate it to my wife, Jamie Brunson, for being there in those difficult moments when my old patterns, the ones that I have not succeeded in eliminating, surfaced. Thanks also go to Professor Russell Abrams and Professor Lanier Graham of California State University, East Bay, who read my manuscript; to Judith Dunham, who painstakingly edited my manuscript, enabling me to take the book to a much higher level; to Louise Chu, who meticulously proofread the book; and to Larry Bramble, my publisher.

Is the Void important or is it just nothing? Is it empty of meaning or full? Does it have presence or does it lack presence? As I plan to show in this book, in Eastern art the Void is represented as full, while, by and large, in Western art until the nineteenth and twentieth centuries, it is represented as empty. The Void is empty in the West because the role of the Void as the ultimate ground of being is usurped by a god or demiurge who usually assumes a human form. If God is reduced to a form, albeit a form that is superior to other forms, the Void is empty and lacks presence. If God is a formless field that permeates everything, the Void is full and has presence.

The idea of the Void or God as a formless field that at once is the source of all creation and is inextricably linked to all forms of creation is hard for most Westerners and even many Easterners to grasp. Imagine the Void as an infinite and completely tranquil lake. Ripples appear on the surface of the lake—something appears out of this Void, yet is the same stuff as the Void. The separation of something from the Void, which is Nothing or nothing, is an illusion but a necessary illusion if there is to be an existential or phenomenal world. The Void or Nothing is real. It is more real than individual things, which only have a transitory existence; the ripple will eventually be reabsorbed into the lake.

The reality of the Void is experienced in many ways. For some, the Void is active energy, like a field, although it is not energy in the usual sense because this energy cannot be apprehended

through the normal senses or by mechanical extensions of these senses, namely scientific apparatus. For others, the Void is not an active energy field, but a field of clear or luminous light, or a state of utter stillness, or even just a symbol or mental concept. Also, the Void may or may not be given spiritual associations by those who acknowledge its ultimate reality.

The Void as a field with divine or spiritual associations is largely relegated to the Western mystics and to very select members of the the avant-garde in Western art beginning with Romanticism in the early nineteenth century, and mainly to the esoteric meditation practices of Hinduism, Buddhism, and Taoism in the East and their artistic embodiments. Even those who follow esoteric meditation practices in the East, such as the Zen Buddhists, do not always link the Void with the divine or even the spriritual. This is also true of some of the avant-garde artists in this book who recognize the importance of the Void.

The Void can be directly experienced in the gap between thoughts. All sorts of activities and situations can bring about this gap, including art making, being in nature, physical exercise, and so forth. One does not have to be a meditator to access the Void, although in the East the experience of the Void is invariably linked with meditation, which I would define as the conscious attempt to expand the gap between thoughts. Most of the Western artists in this book did not or do not engage in formal meditation practice but have used whatever techniques at their disposal to get beyond thinking. I discuss these techniques in this book to the extent that the artists have revealed them. The spiritual overtones of the Void, the ultimate ground of being, became a very important subject in the work of these artists. Moreover, they have managed to embody the Void in unusual ways that equal or surpass the numinosity of the works of their Eastern counterparts who have engaged in meditation practice.

In the course of studying work that embodies the Void, I was first attracted to artists who used empty space in their works, but I soon realized that empty space is not always employed as a vehicle to present the Void. Also, there are artists who utilize empty space for purely artistic reasons and do not embrace the Void. These artists include Piet Mondrian,[1] Pablo Picasso, Jacques Lipchitz, and Alexander Archipenko in twentieth-century art before 1945, and Robert Rauschenberg, Barnett Newman,[2] Brice Marden, Richard Serra, Ellsworth Kelly, and Robert Ryman after 1945. Most of these artists are aligned with Minimalism or went through a Minimalist phase. A notable exception is Agnes Martin whose work, which I discuss later, goes beyond merely formal concerns. In this book, I write only about artists I consider to have a special relationship to the Void.

My goal is to write a comprehensive history of the Void in Eastern and Western art. Although I may have left out a person or a work that a reader may think should have been included, I have probably written about all the major Western artists who

---

[1] Given Mondrian's engagement with spirituality through the Theosophical movement, it might appear that the extensive use of white spaces in his abstract geometries of the 1920s and 1930s would have a spiritual significance. This is not the case. Mondrian intended the white geometries in his paintings to be seen as planes in relationship to the colored planes. The colored planes "determine" the white areas as a plane. "Natural space," said Mondrian, "is *empty* [his italics] without determination," and must be strictly avoided (Holtzman 1986, 316).

[2] Thomas Hess, in his catalogue of Newman's Museum of Modern Art retrospective of 1971, suggested that the voids in Newman's paintings have a relationship to the Void in the Kabbalah, the famous Jewish mystical text. Newman, however, argued, "I have always hated the void and in certain work of the forties, I always made it clear. In my work at that time, I noticed that I had a section of the painting as a kind of void from which all around life emanated. . . . When I started moving into my present concern or attitude in the mid-forties, I discovered that one does not destroy the void by building patterns or manipulating space or creating new organisms. A canvas full of rhetorical strokes may be full, but the fullness is just hollow energy, just as a scintillating wall of colors may be full of colors but have no color. My canvases are full not because they are full of colors but because color makes the fullness. The fullness thereof is what I am involved in" (Newman 1990, 249).

have significantly touched upon the Void. A single artist may have done so in just one or two works or in one or two types of works, such as the disks and scrim pieces in Robert Irwin's extensive oeuvre. In Eastern art I have chosen only those artworks that I consider to be representative of certain categories of art that embody the Void, such as particular images of Shiva, yantra, *enso*, Chinese landscape paintings, and Zen gardens. Since I tend to focus more on the best representatives of the categories for the presentation of the Void in the chapters on Eastern art, rather than a historical sequence of highly individual and disparate artists as in the Western sections, the overall treatment of Eastern art is shorter than my consideration of Western art and probably seems less comprehensive.

The number of artists and appreciators of the Void in both Western and Eastern art is minuscule measured against either the history of art or the history of sacred art. How many artists, Eastern and Western, are going to take the pursuit of ultimate reality as a goal? Even now, with the importation of Eastern spiritual teachings in the West, spiritual concerns or a search for ultimate realities are not a fashionable topic in leading art magazines and are not a viable subject for most artists seeking to forge a successful career. In the East, for serious adepts of Chinese and Japanese Zen, neither the process of making art, which has meditative elements in itself, nor the work of art itself, however close it may get to realizing the Void, is a substitute for the experience of the Void that the adept can attain in pure meditative practice. Art is an important but only a secondary means of awakening for nearly all the artists in the Zen sections of this book.

I would say that this belief is also prevalent among the most advanced Hindu meditators. Tantric diagrams assist the intermediate-stage practitioner but are unnecessary in the later stages. In the history of Indian art, more traditional Hindu sculptures, such

as the Shiva at Elephanta, were created by lower-caste artisans under the direction of high-caste Brahmin priests. These sculptures were intended to serve the Hindu devotee by bringing him or her closer to the divine presence of Shiva, although the works had esoteric meanings known only to the Brahmins and yogis.

Among Chinese Taoist artists, the attitude toward art and calligraphy is somewhat different than that of the Zen Buddhists and Tantrists. For the Taoists, the process of painting, when linked to correct breathing, can bring about an increase in chi that can lead directly to the Void, as I explain later in this book. In Chinese history, art generated by Taoist principles and methods was of benefit mainly to the artist and to only a small audience of fellow travelers with a deep understanding of Taoist practices. The Chinese painters I have chosen to include in this book, except for one artist whose work I use for comparison, were gentlemen-scholars and Taoists, the elite of Chinese society. They understood that the Void or Tao was the ultimate reality and wished to embody this reality by several means in their paintings, which they gave away or exchanged with friends.

While this book is largely about artists for whom the Void relates to the ultimate ground of being in art, I have encountered smaller voids, designated in lowercase, that do not have the metaphysical import of the Great Void or that refer to existentialist matters. The latter, including boredom, vertigo, depression, melancholy, and fear, are present in the works and the lives of the artists mentioned here, and I occasionally have cause to refer to them.

Spiritual growth entails an encounter with the Great Void and lesser voids; it is not all sweetness and light as the new agers would like us to believe.

## Brahman

In Eastern religions the Void is termed Dharmakaya in Buddhism, Tao in Taoism, and Brahman in Hinduism. Interpretations of the concept of the Void differ between the three religions and also within each religion. Tibetan Buddhist philosophy alone has sixteen types of greater and lesser voids.[1] Because I don't want to get bogged down in philosophical discussions that are not relevant to the visual analogues of the Void in these religions, I will summarize only a few of the possible meanings of these voids.

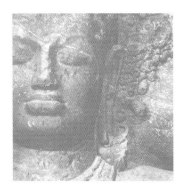

The Rig-Veda (circa 1500 B.C.E.), the oldest scripture of Hinduism, states that in the beginning, "there was neither non-existence nor existence then; there was neither the realm of space nor the sky which is beyond. What stirred? . . . That one breathed, windless, by its own impulse. Other than that there was nothing beyond. . . . The gods came later with the creation of the universe" (O'Flaherty 1981, 25).

---

[1] According to Lama Geshe Rabten they are as follows: "the voidness of internal entities," "the voidness of external entities," "the voidness of external and internal," "the voidness of voidness," "the voidness of immensity," "the voidness of the ultimate," "the voidness of the conditioned," "the voidness of the unconditioned," "the voidness of that which is beyond extremes," "the voidness of that which has no beginning or end," "the voidness of that which is not to be discarded," "the voidness of phenomenon's own nature," "the voidness of all phenomena," "the voidness of defining characteristics," "the voidness of the non-apprehensible," and "the voidness of non-things" (1986, 85–91).

The Void of the Rig-Veda has a nugatory existence—that is, it is meaningful mainly as a necessary philosophical concept, a virtual reality. This virtual reality Void is anterior to creation. In Hindu mythology it is sometimes envisioned as a Cosmic Egg that contains the seeds of creation. In modern theoretical physics, a black hole collapses into a singularity point and, upon exploding, creates another universe. To mix metaphors, this Big Bang is a crack in the Cosmic Egg. In the Upanishads, beginning in the seventh or eighth century B.C.E., the Void, now called Brahman, becomes an active field beyond ordinary space and time.

The Hindu poet Rabindranath Tagore calls Brahman "a bundle of negations" (Radhakrishnan 1924, xi), that is, without qualities. Yet Brahman, unlike the Void described in the Rig-Veda, can be apprehended through spiritual practice. Brahman exists; although being not merely a metaphysical abstraction, as in the Rig-Veda, it is not comprehensible in the normal sense. It is realized in meditation in a state that is compared in the Upanishads to dreamless sleep. The Upanishads imply that it is more like being conscious in dreamless sleep, unless the meditator goes too far into a realm of complete annihilation.[2] It is a paradox that there still can be consciousness when there is no subject/object distinction, no real sense of an individualized ego. Yet, as many advanced meditators including myself can attest, this is what happens in deep meditation. One actually feels that the physical, emotional, and mental bodies have dissolved into formlessness.

The Chandogya-Upanishad states, "Brahman is life, Brahman is joy, Brahman is the Void. . . . The Void, verily that is the same as

---

[2] Both Buddhist and Hindu sages warn that this state is one of spiritual suicide because there is no consciousness involved and no opportunity to burn off karma. It is like taking an anesthetic and then waking up exactly as you were before you took the anesthetic.

joy" (Radhakrishnan 1957, 66). The sages and commentators of the Upanishads also identify states of pure energy, consciousness, and bliss—called Sat, Cit, Ananda—with the Brahman/Void, which was for them the ultimate divinity. This is much more than the unattainable "virtual reality" of the Void in the Rig-Veda. Brahman, although unmeasurable, unmanifest, formless, and beyond normal space and time, is not virtual in that it can actually be experienced as an active field. The meditator feels that he or she has merged with energy, bliss, and consciousness that are so beyond normal awareness that Brahman becomes a higher being. However, one can experience deep states of *samadhi*, which can be defined as prolonged Sat, Cit, Ananda, without believing one has realized God.

## Shiva

How can there be a representation of Brahman in art if Brahman is the formless Void with no physical attributes? One way is simply to designate an image of a deity as the Absolute. The ninth-century sculpture Shiva Mahesvara (fig. 1), a three-headed sculpure with a somewhat androgynous face of Shiva at the center and a clearly male face on one side and a clearly female face on the other side, is an example. According to Stella Kramrisch, a prominent scholar of Shaivite imagery, this sculpture follows the Vishnudharmottara Purana, a sacred Hindu esoteric text, by showing the duality of phenomenal existence emanating from the Absolute (1981, 448). This is symbolized by the female head of Uma to the left and the male head of Bhairava to the right, flanking the central head of Mahesvara, who signifies the Absolute. The whole ensemble, sometimes refered to by scholars as the Shiva Trinity, is the Hindu equivalent of the famous Taoist yin/yang symbol. The latter shows the interpenetration of the fundamental, male and female energies that constitute the

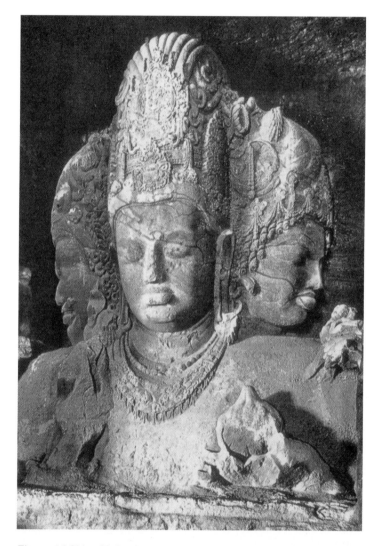

Figure 1 | Shiva Mahesvara

phenomenal world by a single curved line within a circle that here signifies the Absolute.

Heinrich Zimmer, another renowned scholar of Indian art, elaborates further on this head: "The central mask is meant to express the truth of the eternal in which nothing happens, nothing comes to pass, changes or dissolves again. The divine essence, the solely real, the Absolute in itself, our own innermost Higher Self, abides in itself, steeped in its own sublime Void, omniscient and omnipotent, containing all and everything. This is a portrait of Atman-Brahman" (1946, 150–51).

In contrast to the sweet and sensuous face of Uma and the angry countenance of Bhairava, the middle face is impassive. Mahesvara appears to be in deep *samadhi*, enjoying the experience of Sat, Cit, Ananda. Despite the blissful smile, Mahesvara's face is rather iconic; it is frontal and symmetrical, with standardized Gupta-style features: full lips, eyes and eyebrows shaped like a pulled bow, and a chin resembling a perfectly round mango. Shiva's face is a softer version of iconic images found in Western art, but has equivalents, for example, in Byzantine images of Christ and of the Virgin and Child, which attempt to expose the viewer to nonordinary realities through abstract formulae.

My visit to see the Shiva Trinity on Elephanta Island, off the coast of Mombai (Bombay), India, was a journey into nonordinary reality. It began with the departure of the ferry from the mainland and culminated in the awesome encounter with this large sculpture—measuring ten feet by ten feet—in the interior of one of the dark caves on the island. Despite the image's scale, blissful appearance, and iconic otherworldliness, the enormous stone mass of the Shiva Trinity seems at odds with an intention to indicate formless Brahman. For most Hindus, this Shiva was worshipped as a personal god and not a representation of the

Absolute. While this appears contradictory to the intentions of the creators of the sculpture, it is important to realize that Hindu sculptures often function on both an exoteric and an esoteric level.

In Hinduism, the act of *puja* (worship), which is conducted by the Brahmin priests, brings the energy of the deity into the statue, so that the devotee has *darshan* (direct communication) with the living presence of the deity. While *puja* and meditation can transmute lifeless stone or bronze into an active form, this does not mean that the devotee arrives at Brahman, the formless Void. In the course of meditation, many meditators, myself included, use images of deities and photographs of realized masters for *darshan,* to obtain specific kinds of energy. At Elephanta, I could feel the presence of Shiva after meditating in front of the sculpture. This was significant for me because Shiva is the founder and patron of kundalini yogis, but it was not an experience of Brahman and therefore of the Void. Yet, for a Brahmin or yogi who has read the esoteric texts from which this statue was derived, the Shiva Trinity represents the Void, if only symbolically.

Perhaps a more effective symbol of Brahman in Indian art is the bronze circle of flames that surrounds the eleventh-century bronze Chola sculpture of Shiva Nataraja (Dancing Shiva, fig. 2). The circle aptly indicates the endlessness of Brahman, while the flames that rise out of it may represent the active field of Brahman, or its metamorphosis into a more dynamic state. The evolution of phenomenal reality is the main subject of Shiva Nataraja. First there is Brahman, an infinite Void of unmanifest, undifferentiated, formless energy. This energy can actually be heard as a high-pitched vibration in *samadhi* or can be reproduced in a mantra (sacred syllables or symbols that evoke deities) with the *om* sound. From this active primordial energy Shiva creates the existential world with the different gyrations of his dance and vibrations of his drum. In one hand he holds

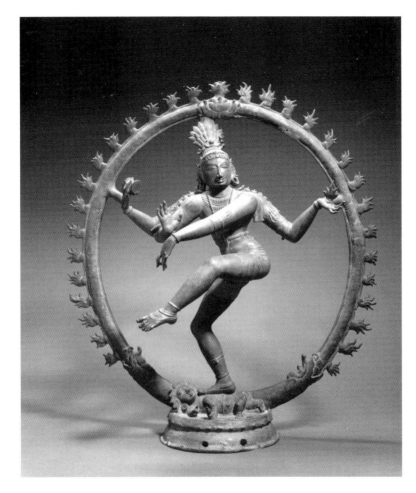

Figure 2 | Nataraja: Shiva as King of the Dance

a drum symbolizing this act of creation and in the other a flame symbolizing the destruction of everything within time. Without destruction there can be no creation—another set of linked polarities that constitute the existential world.

## Kali

As seen in sculptures of Shiva Nataraja, the phenomenal world emanates from and coexists simultaneously with Brahman/the Void. Endless discussions in Hindu philosophy involve why there should be a phenomenal manifestation of Brahman at all: Why did Shiva or Vishnu bother to create the universe?[3] How real or unreal is this phenomenal world? In Vedanta, one of the most sophisticated schools of Hindu philosophy, the phenomenal world is a dreamlike illusion; it is labeled maya, a form of deceit that hides the true reality of Brahman. In other words, what we think are real, solid objects are less real than Brahman, but we are continually sucked into this lesser reality and think or pretend that no other reality exists.

The foremost exponent of Vedanta was the sage Shankara (686–718 C.E.). Vedanta, a philosophical movement primarily for an intellectual and spiritual elite, deemphasizes *puja* (worship) and emphasizes the withdrawal of the senses in the practice of yoga as espoused by Pantanjali in the second century B.C.E. to attain the ultimate reality of Brahman.[4] In Tantra, which is more esoteric than Vedanta, maya is no less real than Brahman. This

---

[3] Someone asked Ramakrishna why Lord Shiva bothered to create the existential realm given all the pain and suffering there. Ramakrishna replied, "To thicken the plot."

[4] For Pantanjali, the practice of yoga or union with the Void involves difficult and laborious ascetic practices that cut off sensory input. In the highest state of yogic consciousness, which Pantanjali defines as "the restriction of the fluctuations of thought" (Feuerstein 1989, 26), even the "subliminal activators" of thought are completely at rest. Pantanjali calles this state of complete quiescence *nirbija samadhi* (seedless meditation).

can best be illustrated by a story from the life of the Tantric sage Ramakrishna. Ramakrishna was visited by Tota, a well-known yogi and exponent of the Vedantic tradition who claimed that one could reach Brahman only by detaching from maya through Pantanjali's yogic practices. Tantrists like Ramakrishna, however, practiced kundalini yoga, in which maya is transformed into Brahman.

Ramakrishna did not have to practice Tota's technique, although he did so to humor Tota after first asking permission from the divine mother goddess Kali. While Kali usually takes on a female form of either the Death Goddess[5] or the Divine Mother—another set of polarities—she is also regarded by Tantrists as indistinguishable from Brahman. Ramakrishna was the custodian and sole priest of an important Kali temple near Kolkota (Calcutta) so he had to ask permission from Kali, a Tantric goddess, to practice a non-Tantric technique. Within a short while, through Tota's technique, Ramakrishna achieved what had taken Tota decades to realize.

Some weeks later Tota fell ill with dysentery and decided to drown himself but failed. He wondered how it was that he could not even kill himself. Suddenly Tota had a vision that the energy of the Divine Mother, Kali Ma, appeared in everything. He exclaimed, "Ma, Ma, O, Ma the Mother of the Universe! Ma whose form is unfathomable Energy. Ma is in the water and in the earth. Everything I see, hear, think is Ma. As long as one is in the body, if she does not will something, no one is free from her influence" (Kripal 1998, 153). Tota realized there was no need

---

[5] Kali as Death Goddess is revered because she offers temporary release from the sufferings of this world. In a culture where reincarnation is an important concept, death is temporary and one may reborn in a higher reincarnaion. Kali as Death Goddess is simply the reverse side of the earth mother who frequently appears in both Eastern and Western art.

to withdraw from the senses, and Brahman was not separate from maya. Nor was it a comparatively austere and dry reality, a state of utter stillness and quiescence, which is the experience of Brahman in the Vedanta meditation practices. Ramakrishna said, "That one whom Tota had for so long been calling Brahman is this very Ma. . . . Brahman and the *shakti* of Brahman are non-different" (Kripal 1998, 153). Basically, what Ramakrishna was saying is that maya, undifferentiated formless energy, Kali Ma, and Brahman are exactly the same.[6] For Ramakrishna, Brahman is not inert, as it tends to be seen in Vedanta, but has an active energy presence. In Tantra, Shakti signifies energy, which is considered to have a female quality that is personified by Kali.

A rare Kali image in the collection of Tantric art scholar Ajit Mookerjee alludes to the unity of the Void, Kali Ma, and the phenomenal world (fig. 3). Created in Andhra Pradesh sometime during the nineteenth century, this sculpture is simply a rectangular frame with arms, ears, legs, and a crown. The frame encloses an empty space symbolizing both the Void and the body of Kali. The viewer can look though this empty space to encounter the existential realm of maya. Or by means of two small rings that hang from the upper horizontal of the frame, the devotee can

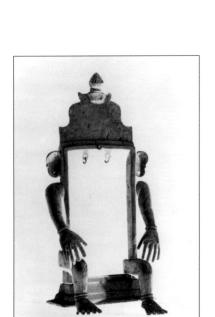

Figure 3 | Supreme Goddess as Void

---

[6] In his diaries, Ramakrishna wrote that he used to meditate with his eyes closed, as Tota did, but at a certain point in his spiritual development it became unnecessary. "I used to meditate with my eyes shut, but is the Lord not there if I open my eyes? When I open my eyes I see that the Lord dwells in all creatures, in man, in animals, the trees, sun, moon, the water, and the ground. In *samadhi* the face of his consciousness is turned inwards but when he turns this face outwards he still sees that She herself has become everything. I see both sides of the mirror as she" (Kripal 1998, 185). Ramakrishna seems to have reached a permanent state of *samadhi* in which everything appears as energy or energy patterns. It is very difficult to function in ordinary reality in this state, which may appear to an outsider as pure madness. Of course, in the Indian context, Ramakrishna's continual absorption in *samadhi* was regarded as a positive phenomenon that enhanced his stature. He had many devotees who took care of his physical needs and helped him contuiue his duties in the service of Kali.

even affix an image of Kali, if she or he requires a more personalized, anthropomorphic image for worship.

## Shiva/Shakti

In Tantric art, numerous examples show the goddess Kali standing on, or copulating with, a supine Shiva. In these instances, Shiva represents the pure consciousness of the Absolute, while Kali signifies the energy *(shakti)* of the Absolute. For the Tantrist, this is a complete picture of Brahman: Shiva's inert corpselike form requires animation by Kali, the incarnation of energy, or *shakti.* It is important to recognize that Kali and Shiva do not show the polarities of male and female energies that constitute the existential world.

This image of Shiva and Kali is not an anthropomorphic yin/yang symbol but indicates the three-fold nature of Brahman. This nature includes Sat, Cit, Ananda, the energy, consciousness, and bliss that result when they are combined. Sexual union is a metaphor for this type of bliss, but Tantric bliss in the most advanced stages of meditation is better compared to polymorphous sexuality—an extended orgasm that takes place when one is fully merged with Brahman. Ramakrishna described this polymorphous sexuality: "Sex with a woman, what pleasure is that? When one has a vision of the Lord one experiences bliss ten million times greater than the pleasure of sex. Gauri [Ramakrishna's friend] used to say that when the great love occurs, all the holes in the body, down to the hair pores—become great vaginas. In each and every hole one experiences sex with the Self" (Kripal 1998, 195).

Having practiced kundalini yoga for many years, I can attest that in deep meditation one sometimes has the experience of all the cells opening up simultaneously; every cell becomes a chakra, expanding with energy. This experience could be called erotic,

although it far exceeds normal sexual experience. The Buddhist Tantric yogis refer to this state as Mahamudra, the "Great Seal" that the prominent Tibetologist Robert Thurman defines as total orgasmic union with the Void.

The linkage of Mahamudra, kundalini yoga, and sexual union is found in a female image employed by both Hindu and Buddhist Tantric adepts. She is called Chinnamasta in Hindu Tantra and Vajrayogini in Buddhist Tantra. This female entity stands on a copulating couple with a blade in one hand and her cut-off head in the other (fig. 4). Three streams of blood issue from her neck; one pours into her bodiless head, the other two into the mouths of two female attendants. The central stream represents the central channel of energy that runs through the seven major chakras aligned vertically along the spine. The other streams represent the side channels that parallel the central one. They are all energized as the major chakras are opened.

In these images of Vajrayogini or Chinnamasta, the deity's severed head represents the necessity of cutting off the mind and the ego in order to experience the higher state of consciousness attained by opening the chakras and energy channels of the subtle body system. The copulating couple symbolizes the orgasmic bliss that may result after many years of continual practice.

Sexual couplings between deities and their consorts are also found in Tibetan Tantric Buddhist sculpture and painting, which I discuss in this chapter because Tantric Buddhism is actually much closer to Hindu Tantra than to other schools of Buddhism. On one level these couplings represent the union of wisdom (female) and compassion (male) in ultimate enlightenment. On another level they can indicate Mahamudra: orgasmic union with the Void. For example, Samanthabhadra is depicted in Tibetan painting as a deep blue-black figure whose darkness represents the formlessness of the Void (fig. 5). He is shown in ritual embrace

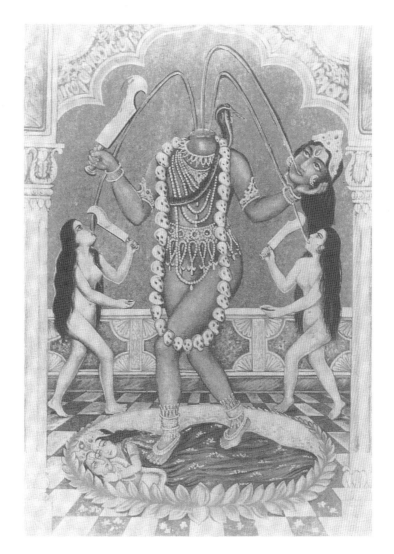

Figure 4 | Chinnamasta

Figure 5 | Samanthabhadra

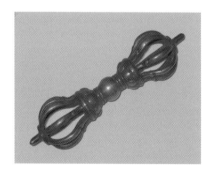

Figure 6 | Vajra

with his consort, Samanthabhadri, who represents *rupakaya,* the world of form. In Tibetan Tantric Buddhism, *rupakaya* is simply the luminous display of the Void, the manifestation of the phenomenal world that is inseparable from the Void. Together, Samanthabhadra and Samanthabhadri symbolize Dharmakaya, the Void body of the Buddha. Indeed, the Dharmakaya is the nearest Buddhist equivalent to Hinduism's Brahman, as it designates the pure formless consciousness of the enlightened one that seems closely related to, if not indistinguishable from, the bliss, consciousness, and energy of the Void/Brahman. This identity is particularly evident to the Tantric Buddhists and Hindus who practice kundalini yoga.

Vajrasattva, another physical embodiment of the Dharmakaya in Tibetan Tantric art, is usually shown embracing his consort with two arms, each holding a *vajra*. Derived from the thunderbolt of Zeus and Indra, the *vajra* (fig. 6) is a scepter with curved prongs that are associated with the vagina. The rod that runs horizontally through the center represents the male member. Here the reference is to the fusion of male and female elements, energy, and consciousness in the Void. The Void is symbolized in the *vajra* by the empty space enclosed by the prongs. The Tibetan name for *vajra* is *dorje*, or diamond scepter. The adamantine quality of the diamond refers to the indestructible, fundamental nature of the highest reality of the Void. While the *dorje* is used in many popular rituals in Tibet, it has more than just a symbolic and exoteric significance. I have witnessed the *dorje* in the hands of my guru, Swami Rudrananda, who used it to dissolve blockages and amplify the flow of energy in the subtle body systems of his students.

The mantra *om mane padme hum* is the auditory equivalent of the *vajra*. *Om* is the *mani* (jewel or male seed) that is in the *padme* (lotus/vagina). *Hum* is an energizer syllable. The chanted

sound *om* is a simulacrum of the primordial sound of the universe. When the heart chakra is fully opened in deep meditation, the actual primordial sound—identified by the Hindu sages as *nada* Brahman and identical with Brahman—can be heard as a high-pitched vibration. This sound is referred to as *nada* since it is "unstruck"; it is not a vibration that is normally apprehended in manifest time and space. Swami Rudrananda taught his students to tune into this primordial mantra of the universe instead of giving them mantras to chant. It was a way of merging with Brahman.

## Shri Yantra

In Tantra, special diagrams called yantra are also used to facilitate contact with the Void in meditation and ritual. Moreover the yantra (literally, "device" or "instrument") is a deity-evoking tool at the core of Tantric Hinduism and the paintings and sculptures known as mandalas. Yantra/mandala diagrams form the basic plan of several Hindu and Buddhist temples, which serve as the microcosmic body of both a divinity and the universe.

One specific yantra, the Shri Yantra, is a powerful diagram whose relative simplicity belies its importance in enabling the meditator to attain union with the ultimate reality of the Void. The Shri Yantra is a series of concentric geometric figures beginning with an outer square with four "gates," drawn with two parallel lines (fig. 7). These gates demarcate the sacred realm of the yantra. Within the square, three circles enclose a ring of sixteen lotus petals on the outer concentric tier and eight on the inner one. The lotus petals are metaphors for the spiritual unfolding that occurs with the use of this diagram. The petals surround five downward-pointing, interlocking equilateral triangles, symbolizing female Shakti elements, and four upward-pointing triangles, symbolizing male Shiva elements. Again, the ultimate

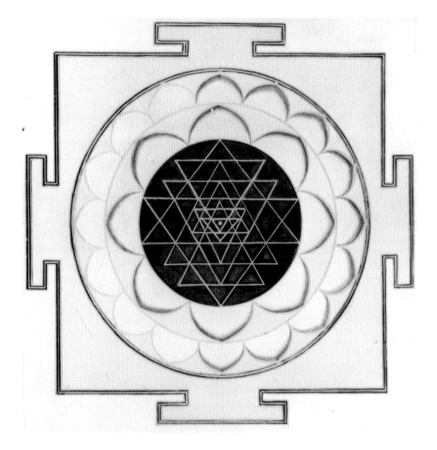

Figure 7 | Shri Yantra

reality of the Void consists of both Shakti (energy) and Shiva (consciousness). At the center of the ensemble of triangles is a dot, the *bindu*, symbolizing the Brahman/Void.

The adept uses mantras, breathing, and mudras (hand positions) in an effort to internalize the yantra. Of these practices, breathing is the most important. In the beginning stages of the meditation, breathing is linked to the pulsation of energy between the *muladhara* chakra at the base of the spine and the *sahasrara* chakra at the top of the head. As the kundalini energy flows upward in the spinal channel, it moves from the *shakti*/kundalini energy at the *muladhara* to the Shiva/Void at the *sahasrara*. The direction of energy is reversed down the front of the body from the *sahasrara* to the *muladhara*. In the later stages of meditation, the pulsation between the *muladhara* and *sahasrara* chakras occurs independently of breath. Eventually, as the meditation progresses, the pulsations cease. The energy is in the *sahasrara* and *muladhara* chakras simultaneously, as well as in all the other major and minor chakras and *nadis,* as the breathing quiets. At this stage of practice, the meditator is resting in the deep *samadhi* of the unmanifest Void.

While the meditator practices this breathing, the yantra is coordinated with the physical body so that the two lines of the outer square correspond to the feet, knees, and thigh, the three circles to the belly, the sixteen-petaled lotus to the body below the navel and the eight-petaled lotus to the navel, and the equilateral triangles to the head region. In most Hindu Tantric texts the *bindu* point relates to either the third-eye chakra of the forehead or the thousand-petaled lotus chakra at the top of the head. In the Buddhist Tantric mandalas of Tibet, the innermost point of the mandala is aligned with the heart chakra. That has been my experience in kundalini meditation. In Tibetan Tantra,

opening the heart chakra enables the yogi to experience the connection between the physical body (Nirmanakaya), the subtle body (Sambogakaya), and the causal body, the extremely subtle mind/body of the Dharmakaya. For Tibetan Buddhists, the heart chakra also contains an immaterial imprint, a "virtual reality" seed of the self that is transported after death through the *bardo* (the period in between physical death and rebirth) and transferred to a new physical body.[7]

It is important to recognize that when the Tantric adept is doing the special breathing and alignment exercises, he or she becomes the primordial goddess Shri who unfolds the universe from her womb, the *bindu* point, in a spontaneous expression of joyful energy and then brings it back into the unmanifest. The *bindu* point is also considered by Hindu Tantrists to be the seed of the universe, which unfolds through the creative play of Shri, and I think this notion of the seed is similar to the concept of the Void in the Rig-Veda. The *bindu* of the Shri Yantra, while alluding to the Brahman of the Upanishads and Tantras, also suggests a compression of space and time into a cosmic seed anterior to creation beyond all space and time. The *bindu* is a symbol of the "virtual reality" seed, which I compare to the singularity point in modern physics and the Cosmic Egg in Hindu mythology in Chapter One.

According to the Tantric texts, the number of universes that Shri creates is infinite, and they are appearing and disappearing at every moment. On the microcosmic level of our existential universe, for example, quantum physicists have shown that electrons blink in and out of existence millions of times in a second. These vibrating particles can be said to exist and not exist simultaneously,

---

[7] According Nawang Gehlek, a Tibetan Buddhist master, this seed can be accessed in meditation to change karmic patterns that can affect the choice of one's next life (2001, 162).

but are frozen by perception into the appearance of solid matter. One cannot see the particles or the world composed of these particles vibrating in and out of existence unless one is an advanced yogi.

Using the Shri Yantra, the adept becomes Shri, who dissolves the universe into herself and re-creates it from herself. This pulsation or oscillation, called *spanda* in the Tantric texts, can be an instantaneous moment of consciousness or a duration of breath when the universe is created at the exhalation and withdrawn at the inhalation. There is no real difference between the *spanda* of the meditator, the *spanda* of the goddess, and the *spanda* of the actual universe, although the *spanda* of the goddess makes possible all the others. The identity of the meditator's *spanda* and of the others is by no means a matter of ego inflation. The meditator's ego dissolves into the Void with the universe. The Shri Yantra, through the practice of *spanda,* gives the meditator the opportunity to realize the fragility and transience of the material world and therefore to lighten the load of suffering it creates.

## Zen Buddhist Landscape Paintings and Paintings of Objects

Zen began as as an esoteric school of Buddhism in China during the sixth century and later spread to Japan and eventually the West. In China, it is known as Ch'an, a word taken from the Sanskrit *dhyana*, meaning "meditation." Bodhidharma, the founder and first patriarch of Zen, considered this type of Buddhism as a purely meditation lineage that originated directly from the Buddha and deemphasized ritual and the chanting of sacred Buddhist texts. An early Chinese Zen Master, Nan Chuan, defined Zen as follows:

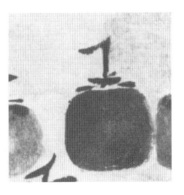

> A special tradition outside the scriptures
> No dependence on words and letters;
> Direct pointing at the soul of man;
> Seeing into one's own nature, and the
>     attainment of Buddhahood.
> (Dumoulin 1963, 67)

It is highly ironic that there are now more words written about Zen Buddhism than any other school of Buddhism. Yet the essential iconoclasm of Zen, the refusal of its adherents to worship images, created a context that was conducive to the embodiment of the Void in paintings.

In Ch'an landscape paintings, as seen in *Mountain Village in a Clearing Mist,* one section from the Eight Famous Views of

Hsiao-hsiang by Yu Chien (fig. 8), a thirteenth-century painter, the world of solid objects seems to dissolve and re-form according to the slow rhythm established by the breath. Subjects of varying definition—houses, walking figures, mountains, a bridge—gradually emerge from, or dissolve into, the empty space that occupies most of the paper. The scene is only a pretext for the object/Void pulsation, with the empty space of the work providing the symbolic equivalent of the Void.

Because the forms are weightless and evanescent, surrounded and permeated by the space of the white ground, the viewer acutely feels their essential lack of substance. Along with the Hindus, the Mahayana Buddhists, who include the Zen Buddhists, consider matter to be empty of substance. The Mahayana Buddhists and the Hindu Tantric philosophers would also agree with contemporary physicists that matter is a quantum soup, a vibrating field of varying densities in constant flux. According to the Zen Buddhist point of view and that of

Figure 8 | Yu Chien: *Mountain Village in a Clearing Mist*

the Tantric schools of Tibetan Buddhism, these densities are an illusion promulgated by the mind. When the mind ceases its activities, these densities also evaporate.

As Huang Po, the third Zen Patriarch in China, said: "And so when thoughts arise, all sorts of *dharmas*[1] arise but they vanish with thought's cessation. We can see from this that every sort of *dharma* is but creation of Mind. . . . If only you would learn how to achieve a state of non-intellection, immediately this chain of causation would snap" (Blofeld 1958, 88).

Another type of voidness is present in *Mountain Village in a Clearing Mist:* the voidness of self-identity or existence as the forms merge and interpenetrate with one another. This type of voidness is discussed in the Vajracchedika Prajnaparamita Sutra, also known as the Diamond Cutter Sutra, a favorite sutra of the Zen Buddhists. A disciple of the Buddha named Subhuti exclaims:

> If particles of dust had a real self-existence, the Buddha would not have called them particles of dust. What the Buddha calls particles of dust are not, in essence, particles of dust. That is why they can be called particles of dust. World-Honored One, what the Tathagata [the Buddha] calls the 3,000 chiliocosms [each complete chiliocosm is a universe from beginning to end in time and space] are not chiliocosms. That is why they are called chiliocosms. Why? If chiliocosms are real, they are a compound of particles under the conditions of being assembled into an object. That which the Tathagata calls a compound is not essentially a compound. That is why it is called a compound.

---

[1] Dharmas are discreet entities and include things as well as doctrines, thoughts, and emotions.

The Buddha replies, "Subhuti, what is called a compound is just a conventional way of speaking. It has no real basis. Only ordinary people are caught up in conventional terms." (Hanh 1992, 24)

What appears as the commonsense or conventional reality of objects is actually emptiness because the objects have no self or independent identity; they are merely compounds of other objects, which are themselves compounds, ad infinitum, until no thing remains. As the Buddha exclaims at the end of the sutra, "All composed things are like a dream, a phantom, a drop of dew, a flash of lightning. That is how to meditate on them, that is how to observe them" (Hanh 1992, 25).

The impermanence, instability, and intangibility of matter, as well as the interpenetration of forms, are also found in Sesshu's *haboku* (flung ink) landscapes. His late fifteenth-century Japanese Zen Buddhist painting (fig. 9) was greatly influenced by Yu Chien's work. Here, it is even more difficult to separate and distinguish the objects and atmospheric elements of the landscape than in *Mountain Village in Clearing Mist*. Both paintings appear to have been painted very rapidly with the tip of a wet brush. The swiftness of execution has been linked by scholars of Zen painting to the notion of sudden enlightenment.

Although the Zen adept practices dissolving the world in meditation, enlightenment in some schools of Zen occurs instantly, and in some cases more or less permanently, when the adept realizes on a very deep level all these emptinesses and is able to understand simultaneously the identity of the phenomenal world and that of these emptinesses.

For Hindu and Buddhist Tantrists as well as Zen Buddhists, this realization does not mean that the world goes away. Huang Po said, "If ever you should allow yourself to believe in the more

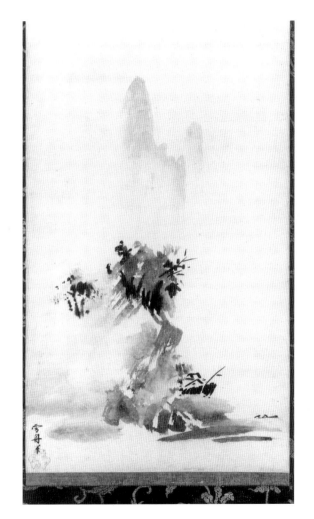

Figure 9 | Sesshu: *Landscape*

than purely transitory existence of phenomena, you will fall into the grave error known as the heretical belief in eternal life; but if on the contrary, you take the intrinsic voidness of phenomena to imply mere emptiness, then you fall into the heresy of total extinction" (Blofeld 1958, 104).

Perhaps the best-known verbal expression of the identity of the Void within the phenomenal world is in the following passage from the Hridaya (Heart Sutra), circa 500 C.E., a part of the Buddhist text, the Prajnaparamita: "Here, O Sariputra, form is emptiness and the very emptiness is form; emptiness does not differ from form, form does not differ from emptiness; whatever is form, that is emptiness, whatever is emptiness, that is form, the same is true of feelings, perceptions, impulses and consciousness" (Conze 1958, 81).

The Heart Sutra echoes Huang Po's statement that the realization of emptiness does not make the material world disappear, although the material world is apprehended in a radically different way. Hence the phrase "emptiness is form" is part of the central equation of this sutra. This phrase has been interpreted by Mahayana Buddhists to mean the identity of the phenomenal world with the Absolute Void, but it also proclaims the voidness of experiencing existential reality as it is, without conceptualizing it and without projecting emotions on it. To experience a leaf purely as a leaf over a period of time is viewed by most Mahayana Buddhist meditators as an advanced state of meditative practice. "If you can only rid yourselves of conceptual thought, you will have accomplished everything," says Huang Po (Blofeld 1958, 33). I think this is the meaning behind the famous Zen saying that "before meditation mountains are mountains, during Zen mountains are not mountains, after Zen [enlightenment] mountains are mountains."

Mu Ch'i, a thirteenth-century Zen master, painted one of the excellent allusions to what Zen adepts call "everyday suchness," the voidness of experiencing the world without projections, along with other kinds of Void/voids, in his *Six Persimmons* (fig. 10).

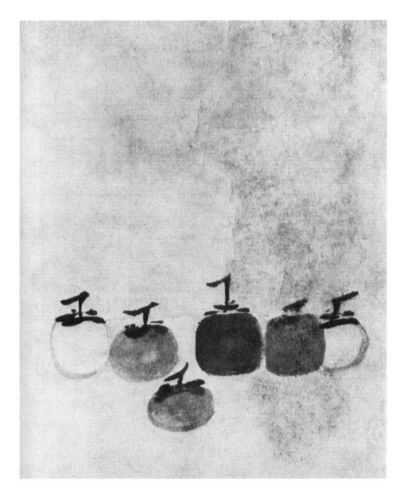

Figure 10 | Mu Ch'i: *Six Persimmons*

Five of the persimmons are on one horizontal level; the sixth is dropped below. There is no ground plane for the persimmons, and the six figures are surrounded and interpenetrated by the empty space of the paper. If one can experience these six persimmons without distraction, which Mu Ch'i encourages by isolating the figures in space, one can see them as they are.

But what are they? They are momentary configurations of energy, densities in the vibrating field. As in the previously discussed Zen paintings, the looseness and indistinctness of the brushstrokes suggest the fragility of the figures. Yet the Mu Ch'i painting has a more subtle progression of tones as they shift from darkness to transparency, from black to gray and white.[2] This sequence mirrors the progress of the advanced meditator from the voidness of everyday suchness to the voidness of substance, to the Great Void.

During the experience of everyday suchness, objects maintain their clarity. They have a sharp, glowing, almost hyperreal presence—the radiance of their essential reality, which is experienced when emotional and mental projections are dropped. In the meditative experience, the voidnesses of self-identity, of everyday suchness and of substance, connect with the Great Void of the Dharmakaya. As two of the persimmons in the Mu Ch'i painting are transparent, enclosing the blank, empty space of the paper instead of being inked in—appearing to dissolve into a larger energy field—there is a suggestion that the underlying essence of an object, the highest reality, is the Great Void of the Dharmakaya.

---

[2] The greatest Chinese masters believed that color either cloyed or excited the senses and therefore was not appropriate to suggest the purity (ching), clarity (tan), and simplicity (chien) of the ultimate Tao. Moreover, colors are not required because the colors of ink, tonalities from black to white, are a sufficient approximation of actual color in the hands of a capable master.

Still another type of emptiness is manifest in Mu Ch'i's *Six Persimmons*. The spaces between the persimmons are of different sizes, making the viewer acutely aware of the importance of interval for the existence of objects. Without intervals, there would be no objects. I believe that the concern for interval was a direct intention of Mu Ch'i, a Chinese Zen monk who probably had a knowledge of Taoism and therefore this famous passage from Lao Tzu in the *Tao Te Ch'ing*:

Thirty spokes are made one by holes in a hub
By vacancies joining them for a wheel's use;
The use of clay in molding pitchers
Comes from the hollow of its absence;
Doors, windows, or in a house,
Are used for their emptiness:
Thus we are helped by what is not
To use what is.
(Lao Tzu 1992, 30)

Form requires the absence of form for its existence. In Taoism as well as Buddhism, vacancy is not nothing.

## A Zen Garden

My favorite artistic example of identity with the Void/Dharmakaya body is the South Garden of Daisen-in, dated 1513, at the Daitoku-ji monastery complex in Kyoto (fig. 11).

The dry garden near the abbot's quarters at Daitoku-ji consists of two cones of white gravel emerging from a flat bed of the same white gravel. Of remarkable simplicity, this installation works on many levels both to simulate and to further *zazen*.

On one level this garden creates the illusion of an immense landscape in a very small space, with the cones suggesting

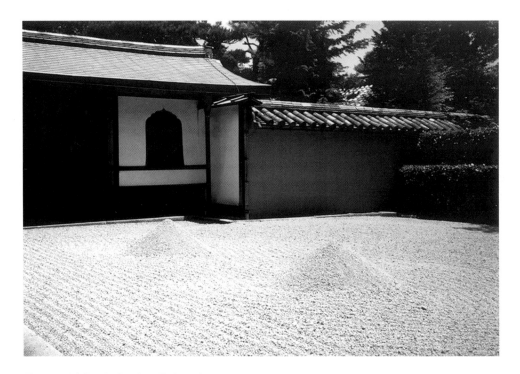

Figure 11 | South Garden, Daisen-in

mountains in a vast sea. A Zen monk—or even a person with no background in meditation—who contemplates this simulacrum of an infinite landscape from the wooden verandah enclosure begins to lose the sense of self. The experience of being in a vast space is also found in the early stages of meditation. Then, at a further stage, as noted in relation to Mu Ch'i's *Six Persimmons,* the cones of gravel in the garden seem to dissolve into the pure energy of the Great Void. The experience of pure energy in meditation is even better embodied by the gravel in the Zen garden than by the blank paper in Mu Ch'i's painting, because the gravel has an iridescent quality, particularly in sunlight or moonlight, that suggests the dynamic energy of the Void.

As when one views the Mu Ch'i painting, a Zen monk experiencing the garden would also be reminded of the famous phrase from the Heart Sutra: "emptiness is form, form is emptiness." This emptiness is not in the sense of everyday suchness, the voidness that results in the cessation of projections, but is the fundamental simultaneous identity of the Void with the existential world, apparent in Tantric art. In Zen and Tantra practice, the realization that the world still exists despite its impermanence and insubstantiality evokes a compassion for all objects and living beings. At the same time the realization that form is emptiness reduces the attachments that cause suffering. The very dilution of form by space, which occurs in meditation and through observation of such works as this garden, lightens the pressure created by the apparent solidity of the world. Space is a great mental balm, as Zen Buddhists past and present, as well as contemporary psychologists, have noted.[3]

---

[3] In the 1970s, Chogyam Trungpa Rimpoche, a Tibetan Buddhist master, established the Maitri project to treat psychological conditions of neurosis by means of "space therapy." The idea was to use the space created in meditative practices to loosen the fixed patterns that cause emotional and intellectual suffering (Trungpa 1972, 71–73; Casper 1972, 69–70).

## Enso

Other expressions of the Void and voids in Zen painting are the *enso*, ink circles drawn by Zen masters in Japan, usually accompanied by inscriptions. According to the Zen master Shibayama Zenkei (1894–1974), "Zen priests often draw a circle with one stroke of the brush. The empty circle of course symbolizes the spiritual world. A Zen priest thought that even this drawing of an empty circle was an impurity, and added an inscription 'Never a ring on a circle!' He thus tried to show the transcending character of truth" (Seo 1998, 186).

The circle is a symbol of the Void and is not the Void itself, so the circle is a kind of impurity for a strict Zen master. Continuous, with no beginning or end, the circle alludes to the infinite and empty space of the Void. An *enso* by the Zen master Kojima, created in 1995 when she was ninety-seven, makes this clear: the circle encloses the character *mu*, Japanese for "emptiness."

The single brushstroke used to create some *enso* seems to dissolve into the Void. A good example is the *enso* by the thirteenth-century Zen master Torei Enji (fig. 12). Enji used the "flying white brushstroke," a broad, quick mark that leaves traces of dark ink interspersed with lighter ink and blank space. This *enso* appears both to be interpenetrated with the Void and to fade out into the Void. It also has a dot at the center so that it looks like a stripped-down yantra with a *bindu* point.

In their inscriptions, the makers of *enso* compare the circle to a heart, a full moon, a dumpling, a rice cake, something to be eaten with a cup of tea, etc. Shibayama felt that an *enso* without an inscription was like "flat beer" (Seo 1998, 187). For him, *enso* were important teaching devices. To compare an *enso* to a heart, for example, is to indicate that the true understanding of the Void is not an intellectual matter but a heart matter. Or, in a more

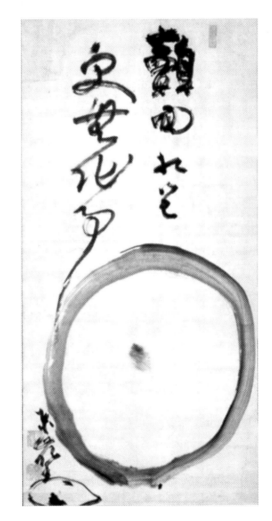

Figure 12 | Torei Enji: *Enso*

tongue-in-cheek fashion that reflects the Zen spirit of irreverence, comparing the Void to a tea cake may be a way of saying that the Void/voids need to be eaten and digested properly.

Kazuaki Tanahashi, who was born in 1933, is keeping the practice of making *enso* alive in creative new ways. Not only does Tanahashi use color, but he also employs brushes of broom size and even larger, to increase the size of his *enso* well beyond traditional proportions. His connection of the spiritual aspects of *enso* with social and political actions is also quite unorthodox. He has lived in California since 1977, which gives him the freedom to experiment with the *enso* tradition.

As a boy of thirteen living in a village in rural Japan, Tanahashi became a student of O-Sensei, Morei Ushiba, the founder of the martial art aikido. O-Sensei emphasized the ki (chi) aspects of moving internal and external energies, which Tanahashi later found important as a calligrapher and creator of *enso.* Indeed, stimulated by correct breathing, Tanahashi becomes well aware of his ki energy, as it moves from his subtle body into his chosen brush. For Tanahashi, this awareness of ki is part of being fully present, the key element when making an *enso.* His ongoing practice of *zazen*, which emphasizes relaxed one-pointed concentration, also contributes to being present.

Tanahashi's understanding and practice of *zazen* has been greatly influenced by the Japanese Zen master Dogen (1200–53), whom he much admires. Feeling that he had reached an impasse in his art in the early 1980s, Tanahashi ceased making art and embarked on the difficult task of translating some of Dogen's writings into English. The result is Tanahashi's *Moon in a Dewdrop: Writings of Dogen* (1985), which for me and many others was the first book in English to illuminate Dogen.

In the writings Dogen emphasizes the moment-to-moment practice of *zazen*, either in formal sitting meditation or while

engaging in any other pursuit. For Dogen, the dropping off of "mind and body" in *zazen* is enlightenment, no more and no less. In a similar way, body and mind drop in the moment or moments during which Tanahashi makes an *enso*. "One stroke painting leaves little room for thinking; the moment it is started it is already done," he says (1987, 270). In the making of *enso* there is also no room for corrections, and for Tanahashi, this awareness enhances the alertness required to make an authentic one-stroke painting.

From the uninformed Western point of view, making *enso* seems to involve not only a lack of thinking but also little imagination, labor, effort, and even technique. "To be thoroughly lazy is a tough job, but somebody has to do it. Industrious people build industry. Lazy people build civilization," argues Tanahashi (1987, 146). Actually, he has done much preliminary work, namely formal *zazen* sitting and aikido, as well as studying and copying the great masters of calligraphy, to make what he considers honest *enso*. All this work is seamlessly integrated in Tanahashi's consciousness in the moment or moments of creating an *enso*. The goal is to do the work, yet hold it lightly at the moment or moments of creation. "We can be most creative," says Tanahashi, "when we having nothing in hand, nothing in mind" (1987, 76).

Tanahashi's *enso,* like traditional Japanese *enso,* are an appropriate symbol for the Void. Yet for him the circle is also an important symbol of social unification and solidarity. To celebrate the fiftieth anniversary of the founding of the United Nations in San Francisco, for example, Tanahashi created an *enso* with a brush six feet tall and 150 pounds in weight, consisting of a white felt "bristle" on an octagonal copper shaft. The performance took place on June 3, 1995, surrounded by two hundred people holding the flags of many nations. After a preliminary

drumming and dance ritual, seven artists—four women and three men from different parts of the world—applied the brush to strategically placed acrylic paint concentrations of six different colors as they moved slowly around a twenty-foot-diameter circle marked with pencil on a canvas measuring twenty-three by twenty-eight feet. Tanahashi, holding a handle on the brush, helped direct the bristle on the pencil line. Thus a one-stroke circle was accomplished in about ten minutes. It was later hung on the War Memorial Building, where the United Nations had its first meeting. The colors of the circle and the canvas fluttering in the wind suggested the waving flags of the participants, establishing an active symbol of unity among diversity that mirrored the credo of United Nations.

In a radical departure from traditional *enso*, Tanahashi began using colors in a 1993 project for the Zen Hospice in San Francisco. He believed that a multicolored *enso* would better facilitate healing than a black-and-white one. Nevertheless, I think that just presenting the Void by means of an *enso* offers a powerful healing message. The core practice of Mahayana Buddhist is to realize the empty nature of all phenomena, even suffering. In the context of a hospice, suffering can be alleviated if one can realize it does not have an inherent self-identity or fixity but is conditioned by mental and emotional projections.

Tanahashi recounts the making of the Zen Hospice *enso* in his Berkeley studio:

> After priming the canvas [seven feet high by five feet wide] with gesso, I put together strips of felt with raffia straws, enough to draw a line over one foot wide, and bundled them up around a wooden shaft. I poured generous amounts of acrylic paint here and there on the canvas. Overlapping spots of paint altogether formed a

circle, which touched the sides of the canvas. The top of the circle was red, yellow and golden, and the bottom had darker colors. I wet the "brush" with light parchment-colored paint, stood on the canvas, and traced over the circle with the brush almost in one breath. The paints washed together, forming a complex mixture of all colors, yet retaining an uninterrupted flow of the brush movement. I thought it was a magnificent representation of a world with joy and hope.

While I cleaned up and went away for a cup of tea the paint on the canvas was still moving slowly, creating marblelike patterns. The very dark blue puddle in the bottom found a path into the center of the circle and started running toward the upper right. I could have stopped the traveling of paint by vacuuming or blotting it, but I just watched it. It seemed that the circle was sending a message. After several hours the circle stopped changes, having become as sort of Q shape. The painting was no longer pleasing or healing but disturbing or alarming. (Zelazny 1995, 422)

From this statement, it is obvious that "accident" is an important element in Tanahashi's *enso*. Accident also occurs in traditional black-and-white *enso* because the artist cannot fully control the ink with a brush. For Japanese Zen Buddhists, both the conscious and the accidental elements of the *enso* reveal the creator's state of consciousness. Tanahashi's *enso* for the Zen Hospice indicated his desire to create positive healing energies but also his sense of despair in this place for the dying. I think this despair is found at the end of his account of this *enso:* "the painting was no longer pleasing or healing but disturbing or alarming."

In addition to using colors and letting them run for an extended period of time—which makes for a much richer and variegated surface than is usual for *enso*—Tanahashi often turns the brush around in the process of making a circle. In traditional *enso* the brush is not tilted or twisted but is held perpendicular to the paper, as in calligraphy. Experts consider tilting or twisting the brush to indicate a wobbling and inattentive mind. This is not the case in Tanahashi's *enso,* where twisting the brush is a conscious attempt to add the illusion of a third dimension and of movement within the movement of the circle. A good example is the *enso* from the Miracles of Each Moment series of 2003 (fig. 13). To my mind, adding an extra dimension enhances the fullness of the Void.

The fullness of the Void is readily experienced in Jeff King's extraordinary *enso* sculpture (fig. 14). Given its solidity and substance, sculpture is not usually considered an appropriate medium for *enso.* In 2001 King, who was born in Boulder, Colorado, in 1965, participated in the Bedford Tree Project in which artists were invited to create works from the remains of a three-hundred-year-old oak tree that had to be removed from the courtyard of an elementary school in Bedford, California. Although much of the wood had been taken away before he was able to come to the site, King obtained a curving branch about three feet long. In an unpublished statement about the project, he wrote, "I had already been making pieces by thinly slicing a log, either in cross section or longitudinally, and then reassembling the log in a new or slightly altered form. I chose a curving piece because I thought it might pose an interesting problem in the reassembling."

The next stage was cutting the log longitudinally into slices one-eighth inch thick and assembling the pieces before they could dry. "I am very interested in incorporating chance into my working process and the warp occurring when wet wood dries quickly

Figure 13 | Kazuaki Tanahashi: *Miracles of Each Moment*

Figure 14 | Jeff King: *Enso*

is an element of chance that I like to use in all my work. As I was trying out different possible assemblies, I found that six slices of the log arranged end-to-end would make a complete circle. This was unexpected and very exciting. I immediately thought of the *enso* drawings made by Zen monks and the circular auras drawn or sculpted around the bodies of divinities in Hindu and Buddhist art." As King has remarked to me in conversation, the grain patterns on the wood are analogous to the flying white brushstrokes of inked *enso*.

King devised an internal structure of plywood and steel bolts to hold the thin slices of oak in place. This allowed him to assemble the thirty slices into five circles layered one on top of another. Eventually he found that the best presentation for this *enso* was to hang it several feet from the floor on a single cable attached to the ceiling. Thus the Void has an active three-dimensional presence as it slowly moves in space. In a similar way, King believes that a traditional *enso* comes alive with the meditative energy of the Zen master who creates the circle. Although King has done formal sitting meditation in India and Japan, his main meditative pursuit now is the creation of works of art with full absorption in each moment of the process. Like Tanahashi's *enso*, King's *enso* arise from the place of no-mind, where there are no preconceptions and therefore no predictable results.

Every day between 2000 and 2001, King made three to five ink-on-paper *enso* as meditation. This body of work includes traditional single-circle *enso;* an *enso* composed of three stacked circles of different sizes resembling a snowman; and mandala *enso* of squares, and squares and circles, multiple concentric circles and overlapping circles, and asymmetrical compositions of circles (fig. 15). King varies the thinness and thickness of the line as well as amount of ink used for each circle. The complexity, playfulness, and exuberance of these circles go well beyond traditional

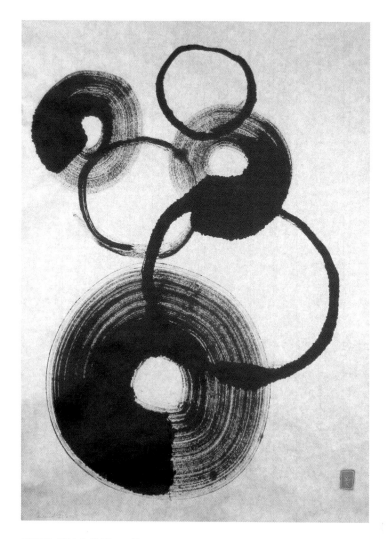

Figure 15 | Jeff King: *Enso*

Japanese *enso,* yet reveal a very relaxed and attentive mind. For me, King's *enso,* the brushed circles as well as the wooden ones, are informed by the high level of consciousness and quirkiness of authentic Zen. King has shown that an American artist can successfully absorb and reinvent this genre.

## The Tao and Chi

The Tao, the Chinese version of the Great Void, is as conceptually elusive as Brahman and the Dharmakaya. The reader is continually reminded of the impossibility of discussing the Tao in verbal terms in the famous *Tao Te Ch'ing*. Written by Lao Tzu in the sixth century B.C.E., this is the most important Taoist text that has been translated into English. Lao Tzu says:

> The Tao that can be told is not the eternal Tao
> The unnamable is the eternally real
> Naming is the origin of all particular things.
> (1992, 1)

> Look and it can't be seen
> Reach and it can't be grasped.
> (1992, 14)

Moreover, the Tao is refered to by Lao Tzu as both a virtual reality, a seed that is anterior to space and time like the Void of the Rig-Veda, and a kind of energy field that flows through all things like Brahman or the Dharmakaya:

> There was something formless and perfect
> before the universe was born
> It is serene, empty

Solitary, unchanging
Infinite. Eternally present
It is the mother of the universe
for a lack of a better name, I call it the *Tao*
It flows through all things,
inside and outside, and returns
to the origin of all things.
(1992, 25)

The best-known Taoist symbol, called the Tai Chi, is the circle enclosing a curvilinear line that divides the interior of the circle into two interpenetrating halves. Each half represents the polarities of the existential world: yin and yang. This yin/yang symbol parallels the meaning of the Shiva at Elephanta, as I have already mentioned; it represents the unfolding of the Absolute into the phenomenal world and the identity of the Void/Absolute with the phenomenal world.

Like Brahman and the Dharmakaya, the Tao/Void is a field or ground that can only be apprehended in Taoist meditation or other Taoist yoga exercises. The Tao is beyond the normal senses, but the only way one can reach the Void/Tao is in the phenomenal world, through opening up the subtle body in one's own body. Pantanjali and the Vedandists, as well as some Buddhist schools, tend to forget the body, but certainly not the Taoists, the Zen Buddhists in China (many of whom practiced Taoist techniques), and the Tantric Buddhists and Hindus.

Taoist yoga has important similarities with kundalini yoga as I can attest, since I have practiced the former for ten years for primarily health reasons. In Taoist yoga, the adept opens up the "energy gates," which more or less correspond to the chakras of the subtle body system in Tantra, by means of moving and breathing exercises known as tai chi, and qigong, and through

meditation. These practices enhance the body's chi, defined in the Taoist texts as "breath," "vapor," or "energy." As of yet, however, chi cannot be measured scientifically, although Chinese medicine leaves no doubt that there is a connection between the amount and quality of chi and the body's physical and mental state. There is also a connection between the chi of an individual person or any object, natural or unnatural, and the Great Void of the Tao. Chi is a condensation of the Tao on the subtle body level, and the physical world is still a further condensation of the Tao/Void and chi. The ultimate reality of any object is the Void/Tao.

For the traditional Taoist artist, the ideal method of creating art is to connect his or her own chi body with the chi body of the subject, with the Tao, the Great Void, through the intermediary of the brush and make the viewer feel this connection. The artist is to make contact with the Tao at the beginning of the artistic process and maintain the connection with this ultimate Void at every brushstroke. This connection is voiced by many Taoist artists throughout history. Chang Yen-yuan of the Six Dynasties period states: "On the subject of collaborating the work of creation through the intermediary of the brush, it has been said: the idea [of emptiness] must precede the brush. In the same way, it must extend [to emptiness] once the stroke has ended. A stroke not executed according to the rule is a dead stroke. The only painting that is real is that in which the brush is guided by the spirit and is concentrated on the one" (Cheng 1994, 69).

Wang Wei of the Tang dynasty advises: "By means of a slim brush, re-create the immense body of emptiness" (Cheng 1994, 62). Pu Yen-t'u of the Qing dynasty: "When the divine magic is working, the brush-ink attains the Void. Then there is brush beyond brush and ink beyond ink" (Cheng 1994, 69). I think what Pu Yen-t'u is saying is that once the artist has connected with the Void, he has transcended his media.

Here are some further instructions on Chinese painting. According to Su Tung-po, the great poet and painter of the Song dynasty, "Before you can paint bamboo it first must grow in your inmost heart" (Cheng 1994, 67). This requires meditation to drop off mental and emotional projections that obscure the chi body or energy essence of bamboo. It also requires what the Taoist artists Shi-tao and Cheng Yao-tien of the Ming dynasty referred to as *hsu wan* (empty wrist). According to Shi-tao, spirit is present only when the wrist is empty (Cheng 1994, 124). This means that there are no blockages in the wrist, thereby allowing an unimpeded flow of chi through the wrist.

The philosophy is elaborated by Cheng Yao-tien: "Emptiness acts on all levels of the body when one does calligraphy [or paints]. At each level, fullness, once it is ripe, leads to emptiness, and that takes place in the following order: the lower limbs * the upper limbs * the left side of the body * the right side of the body * the right shoulder * the right arm * the wrist * the fingers * the brush. . . . Emptiness has a double effect. Owing to it, the force of the stroke penetrates the paper to the point of going right through it, and also everything on the surface of the paper comes alive, moved by the breath" (Cheng 1994, 70–71). By "emptiness" I think that Cheng Yao-tien means chi flow, and in order to have this "emptiness" one must first generate or ripen chi: "fullness leads to emptiness."

Not having practiced Chinese calligraphy or painting, I am unable to say how the process described by Cheng works in these media. Unfortunately, his remark and the other somewhat cryptic statements that I have quoted above are all you can expect from a typical Chinese text or manual on painting. These texts provide only a secret shorthand reminder for the student; they are a verbal minefield for the uninitiated and even more confusing in English translation. You can only have the experience of how

"brush ink attains the Void" by long practice under the supervision of a Taoist master. Having said this, however, I think the practice of Chinese painting on the highest level is similar to the practice of Taoist yoga.

In the Wu style of Taoist yoga, which I pracitice, one begins by attempting to release mental, physical, and emotional blocks in the energy gates and the channels connecting the energy gates. Then the flow of chi through these channels is amplified by means of a combination of breathing and special movements. Breathing and the movements of the brush in painting and calligraphy—the brush has to be held in a very particular manner to convey the flow of chi from the artist—mirror the same process. The artist's every breath and brushstroke should reverberate with the primordial breath of creation that emanates from the Supreme Void and is inextricably linked to this Void. Shen Tsung-ch'ien of the Qing dynasty said, "The painting only attains excellence when the breaths emanating from the brush ink so harmonize with the universe that they are one with them" (Cheng 1994, 68).

Accompanied by Taoist breathing, painting has the capacity to revitalize the Taoist artist in the same way that Taoist yoga practices do. Under these circumstances, painting can also transmit the energies embodied in the brushstrokes—the chi of the artist and of nature, and the energy of the Void—to the viewer for his or her revitalization.

## The Chi of Bamboo

The chi of bamboo can be felt even in a reproduction of the Taoist master Li Kan's painting, *Bamboo,* dated 1308 (fig. 16). Compared with *Doves and Pear Blossoms* (fig. 17) by Chien Hsuan, also from the Yuan dynasty, Li Kan's painting is looser and more abstract, and conveys a greater sense of movement, as

Figure 16 | Li Kan: *Bamboo*

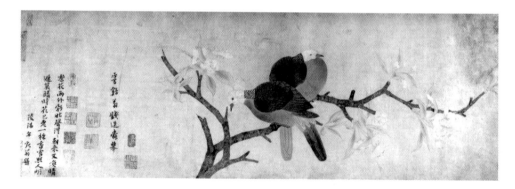

Figure 17 | Chien Hsuan: *Doves and Pear Blossoms*

the bamboo leaves seem to rustle in a light breeze. This movement should not be confused with the artist's ability to embody the chi of the bamboo, the essential life energy of the plant. This can only be felt; it cannot adequately be described in relationship to any formal characteristics of the painting.

Unlike Chien Hsuan's pear tree, Li Kan's bamboo leaves gradually fade out, taking the viewer into the empty space of the painting that alludes to the Void. The figure/ground configuration becomes indistinct in certain areas, referring to the identity of the Void and the phenomenal world. Li has concentrated on the internal reality of bamboo, the chi of bamboo, and the Void, whereas Chien Husan has focused on external reality. As a result, Chien Hsuan's pear flowers are relatively inert and lack significance. The subjects of Chien's painting are not poorly rendered, but this is not the work of a Taoist. Like most of Western painting, *Doves and Pear Blossoms* is a still life or, as the French say, *nature morte* (still life). By the standards of elite scholar/artist class, the backbone of the bureaucracy that ruled China for centuries, paintings such as *Doves and Pear Blossoms* that do not have chi are of inferior quality to those that do. Indeed, the artist's ability to embody the chi of the object, its internal essence and not its external appearance, is the sine qua non of Chinese painting for the scholar/artist elite. Moreover, bamboo is a principal subject of the paintings of elite class because the flexibility of the bamboo is a metaphor for the superior individual who bends but does not break. Since bamboo has a hollow core, it is also a symbol for the underlying presence of the Void in all things.

## The Void/Tao in Northern and Southern Song Painting

Chinese landscape painting in which empty space serves as a vehicle for the Tao/Void existed for a relatively short time in Chinese history. According to George Rowley, one of the great

early Western experts on Chinese painting, in the Song and Yuan dynasties (960–1368) "artists [of the elite class] transformed the neutral voids found in the landscapes of earlier periods to spirit voids"—meaning those voids connected with the Void/Tao (Rowley 1970, 8). "By Ch'ing times [beginning 1644]," Rowley continues, "these spirit voids had degenerated into meaningless blank paper because the painters had lost their touch with the profundities of the Tao and had begun to indulge in 'art for art's sake'" (8).

In northern Song paintings, vertically formatted hanging scrolls are an appropriate mode of presentation for the subject of mountain landscapes. These landscapes reflect the setting of the northern capital at Kai Feng from 960 to 1127. Although solids such as mountains, trees, and rocks predominate over voids in these paintings, the viewer is taken on an imaginary journey through the landscape into infinite space suggested by the gradual fading of the mountains, the atmospheric mists, or the white space of the ground.

In southern Song painting (1138–1229), the atmospheric mists become much more extensive, in part because of the lake environment of the new capital at Hang Chou. Together with the blank spaces of the paper, the voids often occupy about two-thirds of the composition. Writing about southern Song painting, Chang Shih, a Qing dynasty Taoist painter, said, "On a piece of paper three feet square, the part visibly painted only occupies one third. On the rest of the painting there seems to be no images at all; nevertheless the images are eminently existent there. Thus emptiness is not nothing. Emptiness is picture" (Cheng 1994, 89).

Fan Chi, another Qing dynasty Taoist scholar/painter, also wrote about southern Song landscapes:

People generally believe that it is enough to arrange to have a great deal of unpainted space in order to create emptiness. What interest does this emptiness have if it is just inert space? It is necessary that true emptiness be in some way fully inhabited by fullness. It is emptiness in the form of hazes, mists, clouds or invisible breaths—that carries all things, drawing them into the process of hidden change. Far from diluting space, these forms of emptiness confer on a picture the unity in which all things breathe as in an organic structure. (Cheng 1994, 90)

I think Fan Chi is saying that mists are an intermediate stage of condensed chi or breath, which makes the viewer acutely aware that empty space is really full.

In the famous northern Song painting *Early Spring* by Kuo Hsi (fig. 18), the viewer moves upward, starting from a rock at the bottom that projects into the viewer's space. The bottom of the painting has more solids than voids, but as the eye moves upward, empty spaces and mists grow larger. This may echo the gradual progression into the Void in Taoist mediation or Taoist Wu School yoga practice by which the adept transforms physical, emotional, and mental blockages in the chi body into water, then vapor, then void, and then makes contact with the Great Void/Tao. Ma Yuan's *Walking on a Mountain Path in Spring* (fig. 19), a southern Song painting, has the same progression, although the format is horizontal since the landscape around Hang Chou does not contain high mountain ranges. Here, a scholar, accompanied by a servant carrying the scholar's zither, walks on a path that extends diagonally into a misty void. The horizontal branch of a willow tree also leads the viewer's eye into this void, a symbol for the Great Void.

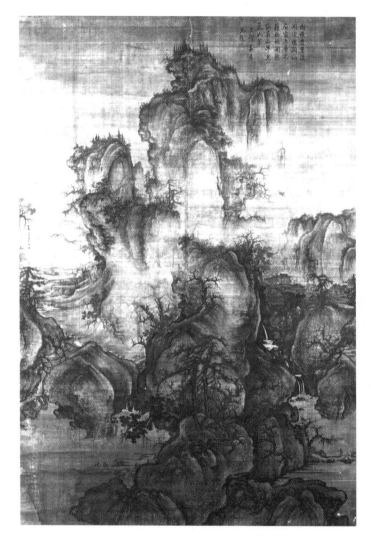

Figure 18 | Kuo Hsi: *Early Spring*

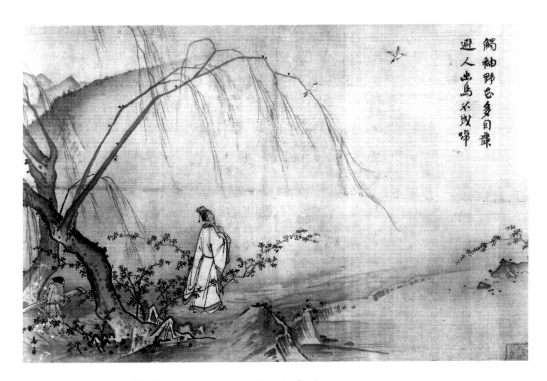

觸袖野花多自舞

避人出鳥不成啼

Figure 19 | Ma Yuan: *Walking on a Mountain Path in Spring*

## The Painting of Ni Tsan

For the later Taoist scholar/artist/elite, Ni Tsan of the Yuan dynasty became the new model, for his nonconformist aristocratic lifestyle as well as for his unconventional manner of painting in which he eschewed the mists and empty spaces of northern- and southern-style landscapes. A typical Ni Tsan landscape consists of a riverbank in the foreground with a few sparse trees or a tiny uninhabited hut, an expanse of water in the middle ground, and some relatively small hills in the top background (fig. 20). Unlike northern and southern Song paintings, *Rongxi Studio* does not direct the viewer to the Void, and the voids and solids are almost equally balanced. The empty huts are the only symbolic reference to the Void/Tao in his paintings. Nevertheless, Ni Tsan connects to the Void by means of his brushstrokes.

Ni Tsan followed the *kan-pi* method of ink application where the brush is only lightly soaked in ink. To casual observers, especially those who have only seen Ni Tsan's paintings in reproductions, these brushstrokes may seem undistinguished and even flavorless. Yet, as François Cheng remarks in *Empty and Full,* her excellent book on the theory of Chinese painting, "The stroke [*kan-pi* in Ni Tsan's painting] strikes a balance between presence and absence, substance and spirit, and thus creates an impression of reserved harmony, as though impregnated with emptiness" (71). Being there and not there at the same time, the *kan-pi* brushstroke is remarkably like the sensation of Void/chi/Tao in most Taoist meditation and Taoist yoga practices. Void/chi/Tao are unmistakably there, but they are subtle presences. The ninth-century Taoist/Buddhist Chinese poet Po Chu-i may just as well be commenting on Ni Tsan's painting when he said about his own work, "What I must learn is that all substances lack true substance, to linger on the extinction that leaves no trace is to make

fresh traces. Forget the word even when it is spoken and there will be nothing you don't understand" (Conze 1954, 281).

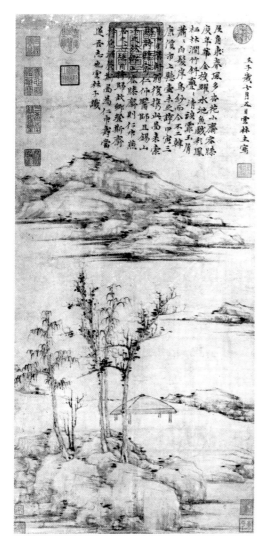

Figure 20 | Ni Tsan: *Rongxi Studio*

# FOUR | The Void through the Eighteenth Century

## Ancient Attitudes

Western attitudes toward the Void and other voids differ significantly from Eastern attitudes. In Mesopotamia and Egypt, the world was seen to have issued from chaos. Void and chaos were regarded as essentially equivalent—and essentially negative—entities.

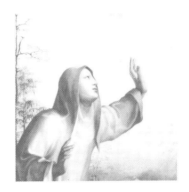

For ancient Hebrews accustomed to the harsh realities of the vast and seemingly empty desert, nothingness was not a positive reality. The source from which life was created was not the Void. Instead, the creative matrix was an absolute God who stood outside his creation. The Void was in opposition to God.

The early Greeks, following Hesiod's *Theogony* of the ninth century B.C.E., which is in accord with the cosmology of Egypt and Mesopotamia, envisioned a primordial realm anterior to time, space, and matter. From this realm the Gods and men emerged. Hesiod associates the primordial realm with "chaos" and "night." Beginning with pre-Socratic philosophers such as Parmenides in the sixth century B.C.E., the Greeks posited an idea of Being without beginning or end, thus precluding a concept of Nothing. Parmenides proposed, "To Be is possible, and Nothingness is not possible. . . . Nor shall I allow you to speak or think of it [Being] as springing from Not Being; for it is not expressible nor thinkable what is Not is" (Freeman 1971, 43).

John Barrow points out in *The Book of Nothing* (a text mostly about the importance of Nothing in mathematics and physics)

that Plato (ca. 428–348 B.C.E.) affirmed Parmenides' negative attitude toward the void in the *Theaetetus:* "The great Parmenides . . . constantly repeated in both prose and verse: Never let this thought prevail; that not being is. But keep your mind from this way of investigation" (2000, 42).

In the dialogues, the *Republic* and the *Symposium,* Plato posits an idea of a One that "is beyond Being." The One "transcends existence" and could only be known through "sudden illumination." Plato does not believe the One can be described. It is the Absolute or the Godhead, but is not a creative principle. Nor does Plato identify it with the greater Nothing. In the dialogue of *Timaeus,* for example, Plato describes the origin of the cosmos as the work of a divine artisan (Demiurge) who fashions the universe from ideas that somehow enter the Void and in so doing create the four elements necessary for the existential realm: earth, fire, air, and water.

Plotinus (205–270 C.E.), a follower of Plato, shares the belief that the One is "beyond existence and beyond knowledge" (Inge 1948, 134). Plotinus says that to reach the One, the spiritual seeker must "strip himself of everything. We must not be surprised that that which excites the keenest of longings is without any form, even spiritual form" (Inge 1948, 134). Plotinus's descriptions of the formless nature of the One as his principal subject approach descriptions of the Void in Eastern philosophy. Also, in Plotinian philosophy as in Eastern philosophy, the One is the creative principle. Eliminating Plato's concept of the Demiurge, Plotinus asserts that it is the superabundance of the One's energy that generates the existential world.

Plotinus's positive attitude toward the Void is an anomaly in Western tradition. The reality that was important to Aristotle (384–322 B.C.E.) and most later Western thinkers was neither the Void nor the Platonic realm of abstract ideas, but the world

of perceptible material objects. To be sure, Aristotle envisioned a primary cause for the material world that was devoid of substance, without motion and timeless—a supreme form he called God. But this absolute being is more the result of the logical necessity in Aristotle's system for a first cause than any spiritual belief.

## Christian and Renaissance Attitudes toward the Void

Monotheistic Christianity, like Judaism, postulates a single transcendent God the Father in the place of the Void as the creative principle. The Christian God wills existence into being ex nihilo, out of nothing, but this dark nothingness is "without form and void" (Genesis 1:20).

St. Augustine (354–430 C.E.) went further by arguing in his *Confessions* that formless and formed matter did not exist independently at the origin of the universe (1998, 40). Moreover, for Augustine, Nothing was evil because it marked the absence of God. Christian thinkers such as Augustine placed their emphasis on a Logos, or divine wisdom incarnated in the human body of Jesus Christ for the purpose of eventually bringing mankind back to its divine source. With Jesus Christ as the principal intermediary to a God who is imagined as having a human resemblance, the Void has little place in Christian cosmology.

In the medieval and Renaissance periods, natural theory closely echoed religious attitudes. It is not surprising, given the influence of Aristotle on St. Thomas Aquinas (ca. 1224–74) and the Scholastics, that these churchmen believed that all physical states of the Void were lacking in thing-ness and therefore were *nihil*—without significance. Roger Bacon (ca. 1220–92), English Scholastic philosopher and early proponent of empiricism, argued that the Void, because it is nothing, could not be the

primary cause of the universe. Medieval proponents of physics were even convinced that nature had a *horror vacui*, "horror of the void," and that it fled from the void, *fuga vacui*. E. J. Dijksterhuis has remarked on thirteenth-century science in *The Mechanization of the World Picture*, "The fact that throughout the Middle Ages people remained so generally and readily convinced that a void cannot occur in nature has to be regarded as an outcome of the Platonic conception that nature has been designed as effectively as possible by the Demiurge, so there is no room in it for anything that may disturb the harmony of the whole" (1961, 144). As late as the seventeenth century, René Descartes (1596–1650) believed that if an attempt were made to make a vacuum in a vessel, the sides would touch for a vessel cannot be emptied.

Renaissance thinkers and poets were also deeply influenced by both Hesiod's *Theogony* and the account of Roman poet Ovid (ca. 43 B.C.E.–18 C.E.) in *Metamorphoses* of a primordial chaos prior to the beginning of the world. In *The Faerie Queen*, for example, Edmund Spenser (1552–99) envisioned a "huge eternal chaos" from which all living things emerged. Ovid's interpretation of chaos as "the warring seeds of things" is also echoed in Renaissance treatises on cosmogony and in John Milton's *Paradise Lost* (1667).

## Giotto, da Vinci, and Beccafumi

The medieval and Renaissance antipathy toward the Void is epitomized in *Expulsion of Joachim from the Temple,* circa 1305 (fig. 21), by Giotto (1266/67–1337), in the Scrovegni Chapel, Padua. This scene from the cycles of the lives of the Virgin Mary and Jesus Christ shows Joachim, father of Mary, outside the walls of the synagogue. Inside, a rabbi is blessing a man. Joachim is pushed away from the synagogue by a second rabbi because of his failure to produce a child. Giotto is a master at constructing

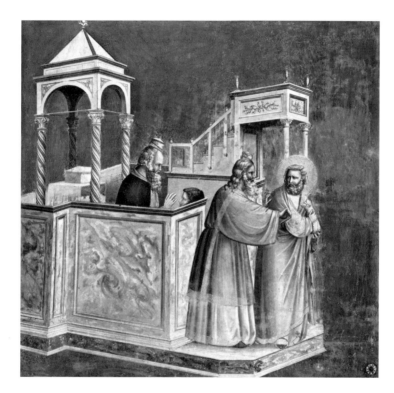

Figure 21 | Giotto: *Expulsion of Joachim from the Temple*

stylistic metaphors for psychological and spiritual conditions. He accentuates the drama between acceptance and rejection by pairing the figures; one is protected by the synagogue and the other is about to fall off into deep space. Joachim looks as though he would be forced to step from the platform into nothingness. I think this empty space symbolizes the spiritual emptiness and chaos that Joachim must experience in the absence of his acceptance by the traditional Jewish religion.

In *St. John the Baptist* (fig. 22), the last surviving painting by Leonardo da Vinci (1452–1519), the Void endows the painting with great power. A smiling and youthful John the Baptist partially emerges from a black field. The many layers of glazing create a luminous sfumato, giving this emptiness an inviting richness. Is John a messenger from another world, beckoning Leonardo to enter this realm with his upward-pointing hand? The cross John holds in his other hand seems an afterthought. Leonardo's idea of heaven is both a peaceful, dark nothingness and a place peopled with beautiful boys. The Void is given a more positive meaning in this painting than in nearly all sixteenth-century works. Leonardo's attitude is revealed in an aphorism from his notebooks: "Amid the greatness of the things around us the existence of nothingness holds the first place" (MacCurdy 1955, 73). This is not the typical Greek or Christian view of the Void, but Leonardo was not a doctrinaire Christian.

Another sixteenth-century artist who appears to have an interest in the Void is Domenico Beccafumi (1485–1551). His *Stigmatization of St. Catherine of Siena* (fig. 23) has some eccentric features in what purports at first glance to be a traditional religious painting. At the center middle ground, St. Catherine is receiving, or is about to receive, the stigmata. Although her gaze is directed to a small and fairly inconspicuous crucifixion covered in shadows by a column to the side of the painting, her left hand

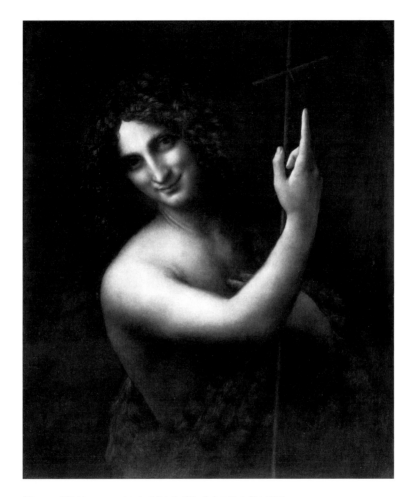

Figure 22 | Leonardo da Vinci: *St. John the Baptist*

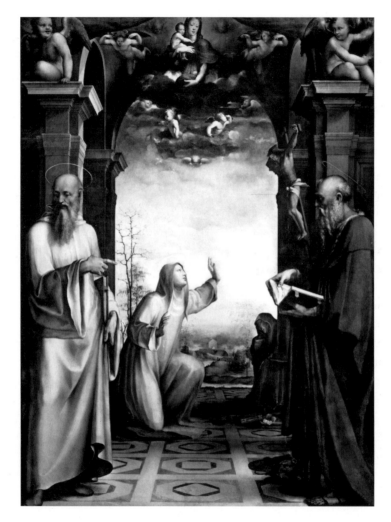

Figure 23 | Domenico Beccafumi:
*Stigmatization of St. Catherine of Siena*

extends behind her into a deep, mostly empty space filled with light—a possible metaphor for the Void. The perspective of the tiled floor, as well as her arm, leads viewers into the Void rather than to Christ. This idiosyncratic use of the deep space filled with light as the central focus of the painting and other features of the painting, such as the arbitrary light sources, suggest a link with mannerism in its quirky rebellion against Renaissance conventions. I do not think that Beccafumi's use of the Void, however, is unconventional for the sake of being unconventional; here it has a deeper meaning.

## Caravaggio and Zurbarán

Michelangelo Caravaggio (1573–1610), despite his violent temper and taste for debauchery, was very much a Christian in his employment of the dark void as a symbol of evil in his work. In *The Calling of St. Matthew* (fig. 24), Matthew, a tax collector, is seated around a table with his flamboyantly dressed friends, who, like him, are frequenters of taverns. The group is shrouded in darkness except for a shaft of light that follows Christ's outstretched hand and illuminates the face of Matthew and one of his friends. One fop swivels his body to face Christ and Peter, but is separated from them by a dark void. The moral significance of these dark and light passages is obvious.

In *The Crucifixion of St. Peter* (1600–01) Peter is about to be raised upside down on a cross because he does not want to compare himself with Christ. The ensemble of figures is enclosed in a black void. The implication is that to be left alone in this nothingness is the worst fate that can befall anyone. In *The Conversion of St. Paul* (fig. 25), Paul is knocked off his horse by a shaft of light, having been redeemed from the dark void that surrounds him. The darkness is a possible metaphor for his ignorance of Christ. The great shaft of light that converted Paul took place at midday,

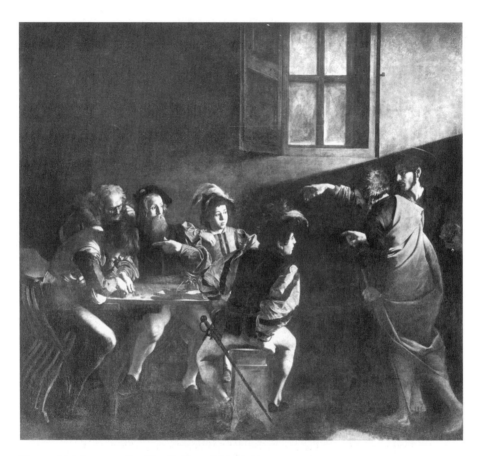

Figure 24 | Caravaggio: *The Calling of St. Matthew*

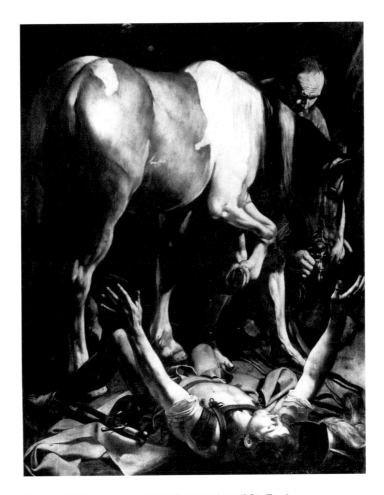

Figure 25 | Caravaggio: *The Conversion of St. Paul*

according to Paul in the Acts of the Apostles (22:5–11). There is little doubt that the darkness is used for its symbolic significance as well as for its dramatic effect.

Notwithstanding the symbolic significance of the dark voids that take up increasing space in Caravaggio's work (the void occupies about three-fourths of the *Beheading of the St. John the Baptist,* 1609), these voids are very enticing and provide a calming respite from the violent action in his paintings. I can understand Caravaggio's attraction to the dark, restful silence of these voids. In the three centuries since Caravaggio's death, however, art historians have ignored the voids and concentrated on his dramatic lighting effects and "realistic" figures.

A keen sense of the dark void also informs many paintings by Francisco de Zurbarán (1598–1664), who, like many of his contemporaries in seventeenth-century Spain, was influenced by Caravaggio. As Jonathan Brown points out in his excellent monograph on the artist, "Zurbaran's use of strong light . . . illuminates the figure but contrary to natural law does not reach the darkened background" (1974, 24). His use of light and the dark void, like Caravaggio's, carries moral implications. Unlike Caravaggio, he probably was influenced by sixteenth-century Spanish mystic St. John of the Cross's concept of the dark night of the soul.

According to St. John, darkness is a metaphor for two stages of the soul's journey toward contemplation of the divine: the purgation of the senses and the consequent "aridity" before a state of spiritual contemplation takes place. "Aridity occurs," says St. John, "when a soul finds no pleasure or consolation in the things of God, it also fails to find it in any thing created; for as God sets the soul in this dark night to the end that He may quench and purge its sensual desire, He allows it not to find attraction and sweetness in anything whatsoever" (St. John of the Cross 1976, 58).

For St. John, this state of aridity, while difficult to experience, is essentially a positive phenomenon:

> It gives the soul an inclination and desire to be alone and in quietness, without being able to think of any particular thing or having the desire to do so. If those souls to whom this comes to pass knew how to be quiet at this time and troubled not about performing any kind of action, whether inward or outward, neither had any anxiety about doing anything, then they would delicately experience this inward refreshment in the ease and freedom from care. So delicate is this refreshment that ordinarily, if a man have desire to care or to experience it, he experiences it not; for as I say, it does its work when the soul is most at ease and freest from care; it is like the air which, if one would close one's hand upon it, it escapes. (1976, 60)

St. John comes close to a description of the beginning stages of *samadhi* experienced by the Eastern meditator who practices withdrawal of the senses.

St. John goes on to say, ". . . This peace, being spiritual and delicate, performs a work which is quiet and delicate, solitary, productive of peace and satisfaction and far removed from all those earlier pleasures, which were very palpable and sensual. This is the peace which, says David, God speaks in the soul to the end that He may make it spiritual" (1976, 61). St. John's emphasis on the nonphysical quality of the spiritual is typically Christian in its denial of the body.

St. John's account of the dark night of the soul corresponds to Zurbarán's depiction of solitary saints in meditation or ecstasy. *St. Francis in Meditation* (fig. 26) shows a kneeling St. Francis dressed in a tattered robe and holding a skull. The saint emerges

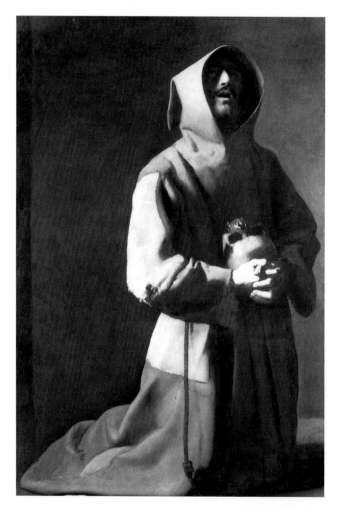

Figure 26 | Francisco de Zurbarán: *St. Francis in Meditation*

from a void that covers about two-thirds of the canvas, including most of his face except for a shaft of light that illuminates the saint's nose and open mouth. This open mouth is Zurbarán's visual metaphor for St. Francis's moment of divine inspiration. I think Zurbarán has forged a link between St. Francis's poverty and asceticism, symbolized by his robe and gaunt appearance, and the dark emptiness, which could also refer to St. John's concept of the purgation of the senses and/or "aridity." There is also a sweetness about this void, for it helps create a sense of meditative calm in the painting.

## Enlightenment Attitudes to the Void

From the seventeenth through the eighteenth centuries, the progressive domination of empiricism and rationalism contributed to the negative attitudes about the Void that existed prior to this time in Western civilization. Descartes' attitude toward the Void is symptomatic of the period: he doubted everything except his ability to doubt. Thus he arrived at the notion of *cogito ergo sum*: "I think, therefore I am." If Descartes had continued to doubt, as the Buddha did, doubting both his reason and the self that reasons, for example, he would have arrived at Nothing. Of course, given the abhorrence of the Void in the seventeenth century, Descartes was not ready to go that far.

British empiricist David Hume (1711–76) went further than Descartes in denying the self. Hume said the self is "nothing but a bundle or collection of different perceptions, which succeed one another with an inconceivable rapidity, and are in a perpetual flux and movement" (Hume 1959, 239). Not only did Hume deny the concept of personal identity, but he also came close to denying the existence of an external world given the ephemerality of human perceptions. Hume echoes the Buddhist idea of a mind continuum whereby the illusion of a material reality arises

through the bundling of sensations and perceptions. According to one story, Hume, in a moment of extreme doubt, had to leave his study and meet his friends in the billiard room to prove to himself that the world actually existed. This does not mean, however, that Hume had any real interest or concern for the Void.

A notable exception to the seventeenth- and eighteenth-century lack of interest in the Void was Blaise Pascal (1623–62). Pascal's initial experience of the Void was entirely intellectual and abstract. As a mathematical prodigy, he was acutely aware of the significance and relationship of zero and infinity, nothing and everything. Pascal's experiments as a physicist also were devoted in part to showing that nature does not abhor a void. He constructed a syringe with a movable piston, which he used to demonstrate that it was possible to create the existence of a void in nature.

Later in his life, Pascal was traveling on a coach that nearly spilled him into a chasm near the road. This event supposedly heightened his awareness of Nothing and led him to a fear of infinite spaces and their "eternal silence," which he wrote about in the *Pensées* (1958, 61). In *Pensées*, Pascal also wrote about the existential void: "Nothing is so insufferable for a man as to be completely at rest, without passions, without business, without diversion, without study. Then he feels his nothingness . . . his emptiness. . . . And from the depths of his soul come boredom . . . despair" (1958, 38). For Pascal the beliefs and rituals of Christianity offered a refuge from the terrors of infinite spaces and internal emptiness.

Two centuries later, Charles Baudelaire (1821–67) wrote a wonderful poem about Pascal's void:

Pascal had his abyss, it followed him, but the abyss is
        All-action and dream.
Language, desire—and who could count the times
the wind of Fear has made my blood run cold!
Each way I turn, above me and below,
tempting and terrible too the silence, the space.
By night God traces with a knowing hand
unending nightmares on unending dark
I balk at sleep as if it were a hole
filled up with horrors, leading God knows where;
my windows open on Infinity,
and haunted by its vertigo my mind
envies the indifference of the void
will Numbers and Beings ever set me free.
(1983, 174)

# FIVE | The Void in Nineteenth-Century Painting

## Caspar David Friedrich

The bloody aftermath of the French Revolution shattered the belief in progress among many European artists and intellectuals who formed the Romantic revolt against the Enlightenment. Part of their revolt entailed a spiritual revival, though not through conventional Christian modes of worship, which the Romantics considered moribund and irrelevant to contemporary realities. One of the key philosophoical foundations of Romanticism was *naturphilosophie*—developed by Friedrich Schelling. For him the absolute or God is an infinite Being beyond form, but is nevertheless immanent in nature and the representation of nature in art. The Romantic belief that nature could have a divine presence is foreign to the orthodox Judeo-Christian belief in the essential corruption of the material world and the essential independence of God from his creation. It also runs counter to the Deist notion, held by Enlightenment thinkers, that nature is a machine, set in motion by a God who has departed from the scene of his creation.

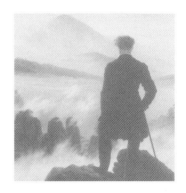

Caspar David Friedrich's use of natural metaphors such as a vast, cloudy sky to suggest a transcendental divine in place of traditional religious symbols was a radical departure in the history of Western art. Friedrich's use of these metaphors was probably based on the *naturphilosophie* of Schelling, whom he knew. Schelling also was teacher of Friedrich's close friend, Gotthilf Heinrich Schubert.[1] (page 84)

Friedrich (1774–1840) was also influenced by Protestant theologian Friedrich Schleiermacher, who argued in *On Religion: Speeches to Its Cultured Despisers* that Christ was not the only mediator between God and man. For Schleiermacher, "the spirit of the world which is God reveals itself visibly and completely in nature" (Schenk 1969, 41). He also celebrated *Eigentlichkeit,* the concept that every individual fashions from his or her "inner perceptions and feelings" a unique image of God, and *Selbstmitteilung,* the revealing of these private images as a cathartic activity (Schenk 1969, 113).

In the *Monk by the Sea* (fig. 27), Friedrich has probably depicted himself or his friend and mentor, poet/pastor Ludwig Kosegarten, as a Capuchin monk alone on a thin strip of beach against a gloomy sky. The idea that the artist now becomes the authentic holy man—the intermediary between spiritual reality and his audience in a society where priests and preachers have lost this role—is an important current that runs through nineteenth- and twentieth-century art.[2] It is the artist, in isolation from the

---

[1] Many contemporary viewers of Friedrich's paintings had trouble understanding the use of natural metaphors for the communication of spiritual contents. Neoclassical critic Friedrich von Ramsdohr, for example, had a negative response to Friedrich's *Cross in the Mountains* (1807–8). In this painting the landscape elements of mountains, trees, and sky overpower the symbol of the crucifix. Ramsdohr said in a review that it was not "a happy idea to use landscape for allegorizing of a particular religious idea, or even for the purpose of awakening devotional feelings" (Rosenblum 1975, 24). He goes on to write that it was "an impertinence for landscape painting to seek to worm its way into church and crawl upon the altar" (24). Friedrich replied: "Jesus Christ, nailed to a tree, is turned here towards the sinking sun, the image of the eternal, life-giving father. With Jesus' teaching an old world dies—the time when God the Father moved directly on the earth. The sun sank and the earth was not able to grasp the departing light any longer. There shines forth in the gold of the evening light the purest, noblest metal of the Savior's figure on the cross, which thus reflects on earth in a softened glow" (Borsch-Supan 1974, 78). Instead of rebutting Ramsdohr's criticism, Friedrich relates the rays of light to God. Although the vast cloudy space in this work probably also refers to the ultimate divine, Friedrich does not mention this relationship in his sparse writings on art.

[2] See Mark Levy, *Technicians of Ecstasy: Shamanism and the Modern Artist.*

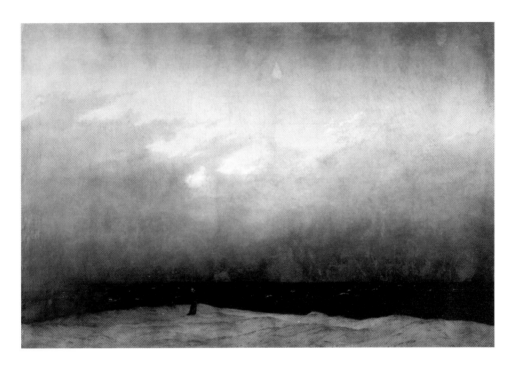

Figure 27 | Caspar David Friedrich: *Monk by the Sea*

rest of humanity, who has a vision of the divine in this barren landscape.[3]

Kosegarten, in an autobiographical poem, *Arkona,* tells of a poet/pastor walking along the desolate beach of Arkona in Rugen and looking "far over land and sea into the Boundless, into the Immeasurable" (Boime 1986, 61). Art historian Albert Boime believes that *Monk by the Sea* is actually a depiction of the poem and the monk is a doppelgänger for Kosegarten. Boime has identified the spot of land in the painting as the place where Kosegarten preached open-air sermons to his congregation.

According to Boime, "Kosegarten claimed that the 'vast boundlessness' of the surrounding scene heightened the devotional character of his outdoor services even without the sermon and solemn chanting of the congregation" (1986, 60). I do not find Boime's arguments entirely convincing. The painting lacks sufficient visual evidence to support his contention that the monk is Kosegarten and not Friedrich, especially as the figure looks like Friedrich,[4] and the strip of land in the painting is too small to be identified as a specific locale. Nevertheless, Kosegarten, along

[3] Zhukovsky, a friend of the artist, asked Friedrich if he could accompany him on a sightseeing trip. Friedrich replied, "You want to have me with you but the 'I' that you like would not be with you. I must be entirely by myself and know that I am alone, in order to see and perceive nature completely. Nothing should stand between her and myself. I must give myself to my surroundings, must merge with my clouds and cliffs in order to become what I am. Should my very closest friend be with me, he would destroy me. And were I to go with you, I would be of no use either to you or to myself. I happened once to spend a whole week in the Utterwalder Grund, among cliffs and fir trees, and all that time I did not meet a single living being. I admit I would not recommend this method to anybody, even for me it was a bit too much. One could not help being invaded by melancholy. This should convince you that my company would not be pleasant for any one" (Vaughn 1972, 108). For Friedrich and for many other Romantics, isolation was the prerequisite for the spiritual experience of nature and was worth the melancholy of separation from other people.

[4] According to Borsch-Supan, "the thick fair hair, the sprouting beard, the round shaped skull and the gaunt stature are features of Friedrich's appearance as it is known from authenticated portraits and written descriptions" (1972, 624). See Borsch-Supan's 1972 article for further evidence that the monk is indeed Friedrich.

with Scheleiermacher, preached that the essence of spirituality was the surrender of the self to the infinite. The result was a blissful experience of oneness with the universe. I have little doubt that Kosegarten's and Schleiermacher's pantheism and their belief in religious ecstasy, which incurred the wrath of conservative Christian authorities, inspired Friedrich.

Physician and painter Karl Gustav Carus, Friedrich's friend and student, also addresses the surrender of the self that occurs in boundless spaces in the second of his *Nine Letters on Landscape Painting* (1815–24). "Stand then upon the summit of a mountain and gaze over the long rows of hills. Observe the passage of streams and all the magnificence that opens up before your eyes and what feeling grips you. It is a silent devotion within you. You lose yourself in boundless spaces, your whole being experiences a silent cleansing and clarification. Your I vanishes, you are nothing, God is everything" (Koerner 1990, 194).

In another of his letters on landscape painting, Carus makes an association between the sky and the infinite, which comes close to the equivalence between the sky and the Western concept of God.

> The clear sky, the quintessence of air and light, is the true image of infinity, and since our feeling has a tendency toward the infinite, the image of the sky strongly characterizes the mood of any landscape beneath its lofty vault. The sky is, indeed, the most essential and magnificent part of the landscape. When clouds or towering mountains restrict the view of infinity more and more, and finally obscure it altogether, we sense a growing oppression. But when these heavy layers dissolve into small silvery clouds, or when they are pierced by the calm clear light or the rising moon or sun, then out gloom

vanishes, and gives way to thoughts of the victory of the infinite over the finite. (Eitner 1970 , 50)[5]

In Friedrich's landscape painting, rather than obscure the sense of infinity, the clouds and fog intensify the troubling awesomeness of the Void. The dark skies also reflect his moodiness. On one level, Friedrich's paintings are mindscapes that mirror his psychic condition and his spiritual yearnings for union with the infinite, not landscapes that solely mirror nature.

In *Monk by the Sea,* the monk is slightly bent over while holding his head in one hand. He does not appear to be looking at the landscape. Perhaps the divine infinity of boundless nature is only in his head. Some of Friedrich's statements on art appear to support the primacy of an interior mental conception of nature. In *Observations* he states, "Close your eyes, so that your picture will first appear before your mind's eye. Then bring to the light of day what you saw in the inner darkness, and let it be reflected back into the minds of others" (Eitner 1970, 53). Elsewhere he notes, "A painter should not merely paint what he sees in front of him, he ought to paint what he sees in himself" (55). To be sure, the externalized and the internalized infinite come together in Friedrich's vast, relatively empty landscapes.

This fusion between externalized and internalized infinite is also present in Friedrich's *Wanderer Overlooking the Fog* (fig. 28). Here, a man with his back toward the viewer, possibly the poet Kosegarten, has reached the top of a promontory and is rewarded by the sight of a vast sky and a misty mountain landscape. The implication is that the artist has to make a journey—the

---

[5] This statement echoes Wilhelm Wackenroder's contention that "infinite Nature raises us through the immensities of space, into the presence of God himself" in his famous 1797 *Confessions of an Art Loving Friar* (Wackenroder 1975, 62). Friedrich probably read this work as Wackenroder was a key forerunner of the Romantics in Germany.

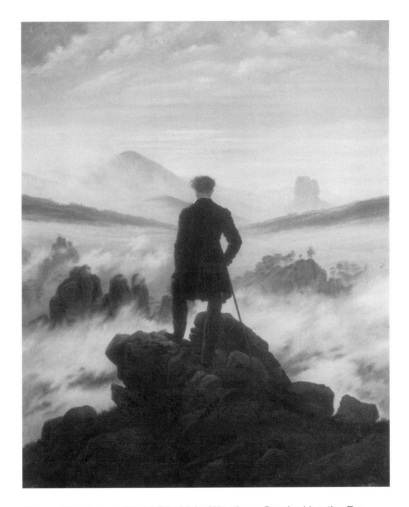

Figure 28 | Caspar David Friedrich: *Wanderer Overlooking the Fog*

physical journey being a metaphor for the internal journey—to reach the Void. This is a necessary, but difficult, part of the artistic and spiritual process.

I am reminded of the painting by Shen Chou (1427–1509), *Poet on a Mountain Top* (fig. 29). A tiny figure has ascended a huge precipice to observe the Void beyond a mountain range and clouds. In both paintings, the figure's face is not visible. Friedrich's wanderer has his back to the viewer, and Shen Chou's poet has a simple minuscule face that is basically an abstraction. Both artists go beyond individualized depictions of the human form to reach a more universal type that supports their metaphorical statements. Even their styles offer comparisons. Shen Chou's approach owes much to the crisp, bare simplicity of Ni Tsan, and Friedrich's is, for the most part, also very clear and linear, unlike the looser style of the French Romantic painters. Although Friedrich and Shen Chou share a love of nature, in their paintings nature is a vehicle for conveying metaphysical ideas.

In reference to Friedrich's *Monk by the Sea, Mist,* and *Wanderer Overlooking the Fog,* art historian Joseph Koerner argues in his monograph that "before Caspar David Friedrich, no major western artist had fashioned canvases as empty as these" (1990, 15). He writes that many "contemporary viewers wondered at the disorienting barrenness of Friedrich's paintings" (15).

For example, Marie Helen von Kugelgen, wife of Friedrich's friend Gerhard von Kugelgen, wrote in a letter about her experience of seeing *Monk by the Sea*:

> I saw, too, a large painting in oil, which does not please my spirit at all. A broad endless sky. Beneath it a restless sea and in the foreground a strip of light-colored sand, on which prowls a hermit in a dark habit or cloak. The sky is clear and insipidly calm, no tempest, no sun,

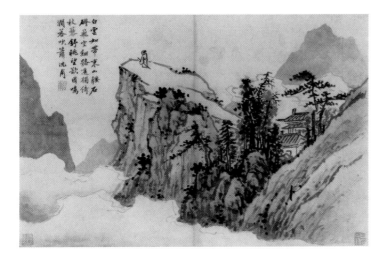

Figure 29 | Shen Chou: *Poet on a Mountain Top*

no moon, no thunderstorm—indeed a thunderstorm would have consoled and delighted me, then somewhere after all one would see life and movement. No ship, not even a sea monster is visible on the eternal surface of this sea; no blade of grass sprouts in the sand, only a few gulls flap about and make the solitude yet more lonely and more dreadful. (Borsch-Supan 1972, 626)

Von Kugelgen's fear of the Void is echoed by Romantic playwright Heinrich von Kleist, a good friend of Friedrich's:

Nothing could be sadder or more discomfited than just this position in the world [the solitary monk on the seashore]; the single spark of life in the vast realms of death, the lonely center in the lonely circle. The picture with its two or three mysterious objects lies before one like the Apocalypse, as though it were thinking Young's *Night*

*Thoughts,* and since in its uniformity and boundless-ness it has no foreground but the frame, the viewer feels as though his eyelids had been cut off. Yet the painter has doubtless opened a new path in the field of this art. (Miller 1974, 208)

Although von Kleist is more sympathetic to this painting than von Kugelgen, elsewhere in his appreciation of Friedrich's seascape he identifies with the monk and experiences the boundless Void as an apocalyptic death. Even Koerner judges Friedrich's work as "a celebration of subjectivity bordering on solipsism, often coupled by a morbid desire to become lost in nature's various affinities" (1990, 23).

Friedrich may have been thinking about death when he was working on *Monk by the Sea.* X-rays reveal that at some point he painted out two boats tilting in the wind. The boat is a typical symbol of death, a ferry to another reality, in many of Friedrich's paintings. It has a similar meaning in von Kleist's play *Friedrich von Homburg* (1801–3), where death is envisioned "as a ship driven by a gentle wind" out to sea (Siegel 1974, 198).

Yet, I think the death to which Friedrich is alluding here is not a physical death but an ego death: the dissolution of individual space into cosmic space. The merging of the little self with the big self usually occurs only in deep meditation, although it can occur spontaneously to exceptionally sensitive individuals who are open to the spiritual realm. It takes an act of considerable courage to risk the surrender of the self to the Void, and few of Friedrich's contemporaries managed to do it. Meditators, too, are not exempt from this fear of the Void; a meditator will encounter over time his or her deepest fears, including ego death.

Empty space in *Monk by the Sea* and in other paintings by Friedrich is not merely a symbol of the divine but the product of what the Romantics called *Erlebnis,* a lived experience. This

accounts for the power of the Void in Friedrich's painting to attract and delight those who have merged with it and to terrify those who are afraid of losing themselves in it.

Although the experience of the Void/voids in meditation, in the vast spaces of nature, and in psychological states of dread, joy, and boredom are usually more profound than the expressions of the voids in works of art, the work of art can go a long way in providing an equivalent experience. Given the size of Friedrich's *Monk by the Sea,* only a small area of relatively empty space is depicted. Yet if viewers imagine themselves in the painting, as many who enjoy or are terrorized by Friedrich's painting do, they suspend their disbelief and transform the empty space into a Void of enormous scale. At this moment, the language of the work of art becomes transparent, disappearing as the viewer has a transcendental experience in front of the work. This transcendental experience also occurs in viewing many of the Chinese and Japanese paintings discussed in this book, and many of the other Western works discussed later.

Other splendid representations of the Void can be found in Friedrich's oeuvre. In *Mist* (1807) there is a gradual dissolution of form from the shore to the fuzzier image of a small rowboat, to the mere silhouette of a larger sailboat, and then into pure gray nothingness. As Koerner pithily summarizes, "Friedrich was a master of all transitions between the visible and the invisible" (1990, 92). Friedrich's subtle fade-outs are reminiscent of those in Chinese painting, particularly the watery atmospheric landscapes of the southern Song dynasty where the gradual deliquescence of form into empty space symbolizes the meditative process.

Helmut Borsch-Supan interprets the painting as follows:

*Mist* can be described as an allegory of death itself. A small boat has left the rocky shore that symbolizes the terrestrial world and is bringing a passenger to the ship

anchored a little farther out which is about to sail. The anchor lying on the shore denotes the hope of life after death. Lying on the ground to the right there are two poles like those used by fishermen to string up their nets to dry. These are a sign that the time of work and effort is over. Presumably, it is no coincidence that the poles resemble discarded crutches, a motif that Friedrich used again later to indicate man's liberation from the problems and difficulties of life. Death is conceived as a breakthrough to a happier existence, and for this reason is compared with an awakening morning landscape. (1974, 68–69)

Although *Mist* is probably an allegory of physical death, as Borsch-Supan suggests, Friedrich perhaps is alluding again to the extinction of the ego as the artist or observer merges with the Void.

## J. M. W. Turner

Like Friedrich, Joseph Mallord William Turner (1775–1851) beckons the viewer to contemplate vast empty spaces in his landscapes and seascapes. Turner's interest in the Void raised critics' hackles. In 1816, in an essay on pedantry in the arts, critic William Hazlitt wrote the following:

We here allude particularly to Turner, the ablest landscape painter now living, whose pictures are however too much abstractions of aerial perspective, and representing not properly the objects of nature as the medium to which they were seen. They are a triumph of the knowledge of the artist and of the power of the barrenness of the subject. They are pictures of the elements of air, earth

and water. The artist delights to go back to the first chaos of the world, or to the state of things when the water were separated from dry land, and light from darkness, but as yet no living thing nor tree bearing fruit was seen on the face of the earth. All is without form and void. Someone said of his landscapes that they were pictures of nothing and the very like. (Gowing 1966, 13).

Hazlitt's statement that Turner's chaotic empty spaces recall the period before the creation reflected the negative perception of the Void in England since the Renaissance. Upon seeing Turner's *Burning of the Houses of Lords and Commons* (1834), another critic, E. V. Rippingelle, similarly remarked that it was "without form and void, like chaos before the creation" (Finberg 1961, 351). For Hazlitt and Rippingelle, the void prior to creation is a vast "barreness" and "chaos," which are also void of meaning and are not a worthy subject for the landscape painter. Hazlitt, Rippingelle, and many of his contemporaries held Neoclassical tastes that eschewed the chaotic void in favor of light-filled landscapes that were harmonious, balanced, and calm. They considered the "beautiful" landscapes of French painter Claude Lorraine, who influenced Turner's early work, to be the great exemplar of the neoclassical style. Turner's departure from the "beautiful" in his later landscape painting was an egregious reversal for Hazlitt. In a number of works—such as *Staffa, Fingal's Cave* (1830); *The Slave Ship* (1840; fig. 30); *Shade and Darkness—the Evening of the Deluge* (1843); *Light and Color (Goethe's theory)—the Morning after the Deluge—Moses Writing the Book of Genesis* (1843); and *Rain, Steam and Speed* (1844)—nature is not a quiet benevolent force that soothes the psyche, as it is in Neoclassical landscape painting. Rather, it is an active entity that is independent of human control and is overwhelming and awesome.

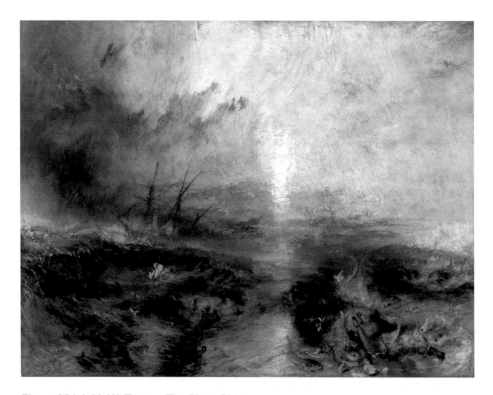

Figure 30 | J. M. W. Turner: *The Slave Ship*

Turner's conception of the Void was probably directly inspired by John Milton's *Paradise Lost* (1667). Turner even provided three illustrations of *Paradise Lost* for Macrone's edition of Milton's *Poetical Works*, published in 1835. In *Paradise Lost,* Milton wrote:

Before their eyes in sudden view appear
The secrets of the hoary deep, a dark
Illimitable Ocean without bound,
Without dimension, where length, breath and height,
And time and place are lost; where eldest Night
and chaos, Ancestors of Nature, hold
Eternal anarchy, amidst the noise
of endless wars, and by confusion stand,
For hot, cold, moist, and dry, four Champions fierce
Strive here for Maistry, and to Battle bring
Their embryon Atoms; they around the flag
of each his faction, in their several Clans,
Light-arm'd or heavy, sharp, smooth, swift or slow,
Swarm populous, unnumber'd as the Sands
Of Barca or Cyrene's torrid soil,
levied to side with warring Winds, and poise
their lighter wings. To whom those most adhere,
He rules a moment; Chaos Empire sits
And by decision more imbroils the fray
By which he Reigns: next him high Arbiter
Chance governs all. Into this wild Abyss,
The Womb of nature and perhaps her Grave
Of neither Sea, nor Shore, nor Air, nor Fire
But all these in their pregnant causes mixt
Confus'dly and which thus must ever fight
Unless th' Almighty Maker them ordain

His dark materials to create more Worlds,
Into this wild Abyss the wary fiend
Stood on the brink of Hell and look'd a while
Pondering his voyage.
(1962, 55)

In Milton's cosmology, the world of chaos is a turbulent world of warring elements that exists in an intermediary zone between hell and the created world. Turner's whirling vortices of sea and sky are visual equivalents of Milton's words. Horace's doctrine of *ut pictura poesis* (as in poetry so in painting), which celebrated the idea that painting is essentially an illustration of a written text, was still very much alive in early nineteenth-century England.

Turner often relied on Milton and others for inspiration and to clarify his thoughts, which, as his lectures and letters attest, he had great difficulty verbalizing.[6] If Turner was inarticulate, he was not unintelligent. A fellow member of the Royal Academy, George Jones, said in his recollections of Turner, "Turner's thoughts were deeper than ordinary men can penetrate and much deeper than he could at any time describe" (Gage 1980, 7). Indeed, although not verbally adept, Turner had the unique ability to express these thoughts in a compelling visual language.

In *The Pleasures of the Imagination,* Mark Akenside (1721–70), another of Turner's favorite poets, wrote about the Void in describing the workings of an artist's mind.

---

[6] John Ruskin, Turner's principal contemporary biographer, once described him as follows: "Generally respecting all the movements of his mind, as silent as a granite crest (Gowing 1966, 31).

At length his plan
Begins to open, Lucid order dawns;
And as from Chaos old the jarring seeds
Of nature at the voice divine' repair'd
her fragrant bosom, and the joyful sun
Sprung up the blue serene, by swift degrees
Thus disentangled, his entire design
Emerges, colours mingle, features join.
And lines converge: the fainter parts retire;
The fairer eminent in light advance;
And every image on its neighbour smiles.
Awhile he stands, and with a father's joy
Contemplates, then with Promethean art
Into its proper vehicle he breathes
The fair conception; which, embodied thus,
And permanent, becomes to eyes or ears
An object ascertain'd: while thus inform'd
the various organs of his mimic skill
The consonance of sounds, the featured rock,
The shadowy picture and impassion'd verse
Beyond their proper powers attract the soul
By that expressive semblance, while in sight
Of nature's great original we scan
The lively child of Art; which line by line
And feature after feature we refer
To that sublime exemplar whence it stole
Those animating charms.
(1835, 58)

Not only did Turner quote parts of this passage in his lectures
while serving as professor of perspective at the Royal Academy,

but he also cribbed words for his own poem, "Art Reclaims," in his unpublished manuscripts.

> Reclaims their fleeting footsteps from the waste
> Of Dark Oblivion; thus collecting all
> The various forms of being to present
> Before the curious aim of mimic Art
> To that sublime exemplar when it stole
> Those animating charms: thus
> colors mingle, features join,
> and thus coverage: the fainter parts retire and
>     fairer eminent in
> light advance and every image on its neighbour smiles.
> (Lindsay 1966, 128)

The vast churning space in Turner's oil paintings works on several levels. It refers explicitly to storm scenes that Turner witnessed, but it is also an allegory of nature as a divine force and the Void before creation as envisioned by Milton and others. In the eighteenth century "terrible" entities such as vastness were associated with the "sublime" by Edmund Burke in *A Philosophical Enquiry into the Origin of Our Ideas of the Sublime and the Beautiful* (1757). For Burke, these terrible qualities included light, darkness, infinity, vastness, vacuity, silence, obscurity, and suddenness. For the Romantics these qualities could be a source of pleasure if the observer's life was not actually endangered. The qualities of Burke's sublime apply to Turner's paintings as well, and Turner uses the word *sublime* in his poem "Art Reclaims."

In a few of Turner's late oils and in many of the watercolors, a different concept of the the Void emerges, one more in keeping with Eastern concepts. In works like *Sun Rise with a Boat between the Headlands* (oil, 1835–40), *Landscape, with Water* (oil,

1835–40), *Norham Castle Sunrise* (oil, 1835–40), *Lake Lucerne* (watercolor, 1842), and *Boats at Sea* (watercolor, not dated; fig. 31), a tranquil Void emerges as the painted passages gradually recede into the white ground of the paper or canvas, leaving large open white spaces. This effect in the watercolors is quite similar to Chinese and Japanese ink paintings because the medium of watercolor allows a subtler manipulation of the gradation of tones than oil. Turner achieved this gradation through delicate washes and minute touches with a fine brush.

In conjunction with the emergence of the calm Void is an increased obscurity of form beyond what is experienced in Turner's earlier works. It is very difficult, for example, to make out the subject matter in *Boats at Sea:* two luminous black brushstrokes in an empty white space. In the twenty-five years that I have shown this painting to students in modern art history classes, not one has correctly identifed the subject without knowing the title.

A few students, however, have made comparisons to the Japanese Zen ink paintings of Sesshu, particularly to the flung-ink *Landscape* of the late fifteenth century, which is comparatively less abstract than *Boats at Sea.* As in Sesshu's landscape, Turner's black brushstrokes charge the Void. They also seem to illustrate the Buddhist concept that matter is ultimately an illusion, as substance dissolves into nothingness. Turner had no knowledge of Buddhism, so what could he have intended in *Boats at Sea?* This painting is obviously many years ahead of his contemporaries' work. Even Turner's most sympathetic patrons and supporters regarded his late work with growing incomprehension. Certainly, Turner was experimenting with the problem of how to reach the maximum incandescence of light in oil and watercolor media. It is also likely that the sea merging seamlessly with the sky in the white spaces of his late watercolors has a metaphysical

Figure 31 | J. M. W. Turner: *Boats at Sea*

significance. At the very least Turner offers an interior vision of nature rather than external one.

In "Childe Harold's Pilgrimage" (1812), a poem Turner illustrated, Lord Byron (1788–1824) wrote:

> To merge with the universe and feel
> What I can ne'er express, yet cannot all conceal.
> (1975, 137)

For Byron, merging with the universe was achieved by being in proximity to nature, particularly to the ocean.

Byron rhapsodized in another passage:

> Thou glorious mirror, where the Almighty's form
> glasses itself in tempests, in all time
> calm or convulsed-in breeze or gale and storm
> Icing the pole, or in the torrid clime
> Dark-heaving, boundless, endless and sublime
> The image of Eternity, the throne of the invisible.
> (138)

Turner and Byron were less interested in physical perception than in intuitive or emotional understanding of nature as a divine force. Turner, like Byron, felt the need "to merge with the universe," and for them, the sea was divine, "an image of eternity, and the throne of the invisible."

In an untitled poem, Turner wrote:

> Foam's Frail Power
> The gay occident of saffron hue
> In tenderest medium of distance blue.
> While the deep ocean heaves [in] a smooth trance
> Calm foamless far distance
> The beauties and the wonder of the deep

While the blanch[']d spots of canvas creep
Upon the dark medium as village spires
Point as in foam where Hope aspires
The blanch[']d sand within the reach of tide
Glim[m]ers in lucid interval the washing pride
With little murmurs breaks along the shore
In treacherous smoothness scarcely whited o'r
With foams frail power undulating.
(Lindsay 1966, 116)

Here, Turner tries to express the wonders of the deep ocean, freely associating it with "trance," "power," "blanch[']d [white] spots," and "Hope." This is the closest he comes verbally to manifesting his desire to find solace in the Void. In *Boats at Sea,* he goes much further with these associations: sea and sky become a seamless Void that engenders trance and bliss as well as divine connections.

Hugh Blair, one of the eighteenth-century British essayists who wrote about the sublime in nature, albeit differently than Burke, argued in *Lectures on Rhetoric and Belles Lettres* (1787) that the sublime "consists in a kind of admiration and expansion of the mind; it raises the mind much above its ordinary state, and fills it with a degree of wonder and astonishment, which it cannot well express" (1965, 46). These are the effects of the calm, empty spaces in Turner's late paintings, although none of his contemporaries could see them.

## Kazimir Malevich

Following Romanticism, in the mid- to late-nineteenth century realist and Impressionist artists affirmed the physical world at the expense of the spiritual; they were interested in social and perceptual realities respectively. Their concern for material reality is not surprising given the steady advance of science with its attendant philosophical underpinnings of logical positivism and empiricism. Toward the end of the nineteenth century, the Symbolists reacted to the materialism of their predecessors by returning to inward spiritual concerns, but of all the Symbolist artists and poets, only Stéphane Mallarmé (1842–98) showed an authentic interest in the Void.

Kazimir Malevich's interest in the Void in the early twentieth century was quite anomalous. Malevich (1878–1935) exhibited his first empty black square on a white field at the 0.10 exhibition in Petrograd (St. Petersburg) in 1915. It is significant that this black Void was placed in an upper corner of the room, a location in the Russian home usually reserved for icons.

As Malevich noted in a 1916 letter to critic Alexander Benois, "The square is the single bare and formless icon of our time" (Douglas 1994, 280). In 1920, he wrote to another critic, Pavel Ettinger, "I see in it what people at one time used to see in the face of God" (Simmons 1978, Part 1, 128). Indeed, Malevich was very much aware that "there are no traditional [Russian] icons on which the saint is a zero" (Douglas 1975, 128). He believed he

was alone in breaking with the Eastern Orthodox tradition of the figurative idol.

In another passage, Malevich wrote, "If religion has comprehended God it has comprehended Nothing. If anyone has comprehended the absolute he has comprehended Nothing" (Malevich 1969, 224). These statements express an iconoclastic view of God that does not accord with the anthropomorphic concepts of God in the Western or Eastern tradition of Christianity but is closer to Hindu and Buddhist ideas of a nonpersonalized absolute deity.

Malevich recognized that the creation and exhibition of an abstract black square would be very disquieting to most of the art-going public. "Here is a device," Malevich wrote to his friend Mikhail Matiushin in 1916, "that creates havoc timelessly. Most importantly Nothing creates havoc" (Demosfenova 1991, 105).

Although the 0.10 exhibition was a remarkable event in the history of art, it was not an arbitrary development in Malevich's evolution as an artist. By 1915 he had gone through Neo-Primitivism, Cubism, and Cubo-Futurism, before eliminating figurative forms completely in his Suprematist phase. As the art historian Charlotte Douglas has pointed out, one of the most important influences on Malevich's art was the Cubo-Futurist theory called zaum language, posited by poet Alexia Kruchenykh. For the latter, zaum language was not yet clearly formulated but would be some type of future nonrational language corresponding to superconscious and nonperceptual meditative states of *samadhi*. Kruchenykh's and Malevich's ideas were probably derived from a popular book by M. V. Lodyzhenski, *Sverkhsoznanie i putti k ego dostizheniuu* (*The superconsciousness and the ways to achieve it*). First published in 1911, this book explained how to reach *samadhi* states in the raja yoga tradition (Douglas 1989, 186–87).

Malevich referred to the philosophy behind zaum language in a 1913 letter to Matiushin: "We have come as far as the rejection of reason, but we rejected reason because we conceived of something else, which to compare it to what we have rejected, can be called 'beyond reason,' which also has law, construction and sense, and as soon as we come to know it we will have work based on the law of the truly new, the beyond reason" (Douglas 1994, 270).

At one point in his career, Malevich believed that Cubism could provide the visual equivalent of zaum but found a problem in the Cubist adherence to the vestiges of figurative language, a result of Cubists' desire to maintain the tension between representation and abstraction. Malevich was also an enthusiast of P. D. Ouspensky's *Tertium Organum* (1912). Ouspensky describes mathematician C. Howard Hinton's concept of a three-dimensional cube passing through a plane, which creates a flat square on the plane (1970, 55). In his Suprematist phase, Malevich used the square as a symbol for the experience of a dimension that cannot be visualized, but it was not just a third dimension but a fourth dimension also. For Malevich, the square was also the simplest pictorial device for presenting pure sensation, from zero to one unit, as suggested by the title of the exhibition, 0.10.

In his essay on Suprematism published by the Bauhaus in 1927, Malevich wrote, "The black square on the white field was the first form in which non-objective sensation came to be expressed. The square-sensation, the white field, the void beyond this sensation" (Herbert 1964, 96). Malevich believed that the artist must purify the senses of sight and sound. This, he says, is accomplished "by breaking away from the earthly sphere" (Douglas 1994, 276) and by "transforming himself into a zero" (Malevich 1969, 119).

In his writings, Malevich claims that in a state of super-intuition he had merged with this divine essence and become a

deity: "This is how I reason about myself and elevate myself into a Deity saying that I am all and besides me there is nothing and all that I see, I see myself, so multi-faceted and polyhedral is my being . . . I am the beginning of everything, for in my consciousness worlds are created. I search within myself for myself. God is all seeing, all knowing, all powerful. A future perfection of intuition as the ecumenical world of supra reason" (Malevich 1978, 10).[1] Unfortunately Malevich fails to say in his writings how he achieved this perfection of intuition.

Douglas believes that the philosopher Henri Bergson, whose major works were widely available in Russian translation by 1914, influenced Malevich's practice of intuition. In *Creative Evolution* Bergson describes the process of intuition:

> I am going to close my eyes, stop my ears, extinguish one by one the sensations that come to me from the outer world. Now it is done, all my perceptions vanish, the material universe sinks into silence and the night. I subsist, however, and cannot help subsisting, I am still there, with the organic sensations which come to me from the surface and from the interior of my body, with the recollections which my past perceptions have left behind them—nay with the impression, most positive and full of the void I have just made about me.
> (Douglas 1994, 278)

---

[1] Malevich may have been inspired here by a quotation from philosopher Plotinus in Ouspensky's *Tertium Organum* of 1912: "You can only apprehend the infinite by a faculty superior to reason, by entering into a state in which you are your finite self no longer—in which the divine essence is communicated to you. This is ecstasy. It is the liberation of your mind from finite consciousness. Like can only apprehend like; when you thus cease to be finite, you become one with the infinite. In this reduction of your soul to its simplest self, its divine essence, you realize this union in this identity" (1970, 218).

This is a good account of the first stages of formless meditation as practiced by students of Hinduism and Buddhism. At this point in meditation the practitioner begins to drop the perception by which form is distinguished and identified. This identification process, which is based on recollection and acculturation, is the objectification of the more basic sensory events. As the meditator gets further and further into the Void, sensation quiets down, except in kundalini practices.

It is open to question whether Bergson or Malevich practiced intuition with sufficient concentration to attain the state of higher consciousness where one is "full of the void." *The Black Square* is an attempt at a pictorial approximation of the *samadhi* experience. Of course, it is a flat, two-dimensional painting; it can only hint at the 360-degree experience of the Void in meditation.

For Pantanjali, the author of the Yoga Sutras, the state of *nirodhah samadhi* is one of ultimate refinement. The empty space in Malevich's painting varies in refinement. In *The Black Square* the black oil paint is textured, while the white frame beyond the square is a smoother matte surface. Perhaps Malevich is distinguishing two different types of Void as in his description: "The square—sensation, the white field, the void beyond this sensation."

In *Suprematist Composition: White on White* (book cover)—a white square tilted diagonally on a white ground—Malevich goes even further in approximating the experience of the Void in *nirodhah samadhi*. The sensation of black on white is much stronger than the sensation of white on white, where sensation is further stilled.

In a letter to Matiushin on the need for a book on the "New Gospel of Art," Malevich said, "Christ revealed heaven on earth, which put an end to space, established two limits, two poles,

wherever they may be—in oneself or 'out there.' But we will go past thousands of poles, just as we pass by millions of grains of sand on the banks of a sea or river. Space is bigger than heaven, stronger, more powerful, and our new book is a teaching about the space of emptiness" (Douglas 1994, 24). Malevich's black and white squares and white on white squares go past "thousands of poles." They are a profound "teaching about the space of emptiness" in a radically avant-garde formal language that is unprecedented in Western or Eastern art (Douglas 1994, 24).

## Alberto Giacometti and Samuel Beckett

The early work of Alberto Giacometti (1901–66) has an obvious relationship to Surrealist magical objects while showing the formal influence of the Cubist sculpture of Picasso, Lipchitz, and Archipenko. In the works of all these artists, the solid materials are shaped around empty spaces so that the empty spaces become sculptural elements. In *Man and Woman* and *Spoon Woman* (1926), for example, Giacometti creates a volume, instead of a mass, in the concave oval-shaped women in order to represent the curves of the subjects. The proportion of volume to mass increases in the later sculptures of Giacometti's Surrealist period to the point where the masses become merely lines in space. This can be seen in the small *Man* (1929), a flat grid of lines fully interpenetrated by space. The reduction of the figure to a network of spatial openings is in keeping with Surrealist *humor noir*.

In *L'object invisible (Mains tenant le vide)* (1934), a slender figure with an abstract, masklike face turns its outstretched hands to hold an invisible object: a ball of empty space. The empty space, despite being a principal part of the sculpture, is not particularly charged with meaning. *Mains tenant le vide* is a Surrealist pun on the phrase *maintenant le vide,* which I translate as "and now vacancy or blank space," although Giacometti may

also be satirizing the Surrealist penchant for objects that allude to nonordinary reality.

The feeling of *Palace at 4 AM* (1933), also a sculptural drawing in space, differs greatly from that of the Surrealist sculptures. The palace is a fragile cage of wooden lines thoroughly penetrated by open space. Here the voids have a content. They are not just a witty stylistic conceit as in Cubism or Giacometti's earlier Surrealist work represented by *Man.*

Renowned photographer Brassaï said, "When I photographed the famous *Palace at 4 AM,* Alberto told me that he had visualized all these objects in almost final form, that he had executed them without any thought about their significance, and that their meaning was revealed to him only later. The fragile palace, he told me, with its wooden backbone, bird skeleton, doll and a ball fixed to an oval plate, was a remembrance of a recent love affair" (Hohl 1971, 250).

Giacometti described the love affair as all-consuming: "For six whole months, I passed hour after hour in the company of a woman who, concentrating all life in herself, magically transformed my every moment. We used to construct a fantastic palace at night—days and nights had the same color, as if everything happened just before daybreak; throughout the whole time I never saw the sun—a very fragile palace of matchsticks. At the slightest false move a whole section of this tiny construction would collapse. We would always begin it over again" (Hohl 1971, 250).

In *Palace at 4 AM* Giacometti used the voids to create a metaphor for a love affair that was constantly threatened by disintegration and nothingness. Without knowing the background of this sculpture, the immediate reaction of most viewers is anxiety, and I think the essential emptiness of the sculpture is what causes it.

In the following decades, Giacometti's thin, elongated, and sometimes tiny figures isolated against empty space brought about emotional reactions. Jean-Paul Sartre and Simone de Beauvoir viewed Giacometti's fragile figures, which are surrounded and penetrated by empty space, as expressions of the existential condition of human aloneness and loneliness. For them, the empty space was a metaphor for the separateness of individuals and the emptiness of meaning in the universe. Sartre wrote, "Between things, between men, the connections have been cut; emptiness filters through everywhere, each creature secrets his own void, Giacometti became a sculptor because he was obsessed with the void" (1955, 26).

It is not difficult to see how a Giacometti sculpture such as the bronze *City Square (La Place)* (fig. 32) relates to Sartre's statement. Five small, thin figures, battered and isolated in space, are shown on a rough plinth. They appear to echo Pascal's idea that man is "a thinking reed" (1958, 97) suspended in a Void of both nothingness and infinity—an idea that probably influenced Sartre. Only the figures' glutinous wedge-shaped feet give them a measure of groundedness. Yet these very appendages also lift the figures off the earth and emphasize their attenuation and verticality. I am further reminded of a passage from the novel *Murphy* (1938*)* by Samuel Beckett (1906–89), Giacometti's friend, describing the character Mr. Kelly: "already he was in position, straining his eyes for the speck that he was, digging in his heels against the immense pull skyward" (1976, 141). Indeed, the condition of being pulled upward in space can cause vertigo as Baudelaire indicates in the "Abyss," his poem about Pascal's Void in *Les Fleurs du Mal* (1983, 174). Giacometti alluded to the fragility of existence several times in discussions about his work. In 1954 he maintained, "I am always conscious of the weakness and frailty of living things and it seems to me that they

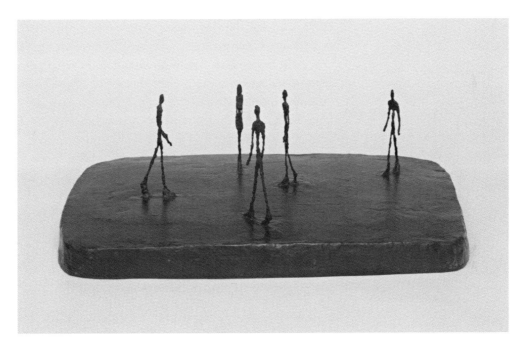

Figure 32 | Alberto Giacometti: *City Square (La Place)*

need tremendous powers just to hold themselves upright from moment to moment" (Hohl 1971, 28).

On the whole, however, his statements do not support these associations with existentialist concepts. In an interview with critic Pierre Schneider in 1962, Giacometti stated, "When working, I've never thought of the theme of loneliness, and I never think of it now. But if so many people feel it, then there must be a reason. It is hard to say whether this interpretation is right or wrong. In any case there is no intention on my part to be an artist of loneliness—I don't have the slightest tendency in that direction. I should say rather that, as a thinking man and citizen, I believe that all life is the opposite of loneliness, because it exists as a net of relationships (Hohl 1971, 283).

In another interview, in the Italian magazine *Epoca* in 1963, Giacometti specifically denied the importance of existential anxiety:

> People talk about the discontent in the world and about existential anxiety as if it were something new! Everyone at every period in history felt it. You have only to read the Greek and Latin authors! . . . It is not true that the individual with his emotional life no longer feels himself the center of the world! What do you think really interests people from morning to night if it isn't their feelings, their work and love—especially love. . . . And as for loneliness in the big city goes, it isn't any more oppressive than earlier in the medieval cities, where nobody went out at night without a knife to defend himself. (Hohl 1971, 284)

If the emptiness in Giacometti's post-Surrealist oeuvre is not a metaphor for existential anxiety and loneliness, it is still an

important part of his sculpture. There is a Void in Giacometti's sculpture that is largely the result of the artist's rigorous phenomenological pursuits wherein solids gradually got smaller and smaller until they almost dissolved.

When Giacometti was eighteen or nineteen, he drew a still life at his father's studio. Although he placed the objects at the usual distance for still-life rendering, they became diminished as he worked. "My father got irritated and said, 'Now start doing them as they are, as you see them.' And he connected them to life size. I tried to do them like that, but I couldn't help rubbing them out, I rubbed them out and half an hour later my peas were exactly as small to the millimeter as the first ones" (Hohl 1971, 77).

Although Giacometti largely suspended his perceptual investigations during his Surrealist period, he began them again in earnest in 1935 with his focus on the human head. "At first," said Giacometti, "I saw nothing . . . Nothing was as I imagined it. I only saw the uncountable details of the head. The more I studied the model, the thicker the veil between its reality and me became. I ran into insuperable difficulties" (Hohl 1971, 106). The main difficulty, as Giacometti pointed out, was that the visual content of the human head is inexhaustible—the longer you look at it, the more information appears. Any mark or series of marks can only embody part of the information that is available to perception. Giacometti wrote in a letter to his dealer Pierre Matisse:

Finally, in order to accomplish at least a little, I began to work from memory, but this was mainly to know what I had gotten out of all this work. But wanting to create from memory what I had seen, to my terror the sculptures became smaller and smaller. They had a likeness only when they were small, yet their dimensions

revolved around me and tirelessly I began again, only to end several months later at the same point. A large figure seemed to me false and a small one equally unbearable and they often became so tiny that with one touch of my knife they disappeared into dust. But heads and figures seemed to me to have a bit of truth, only when small. All of this changed a little through drawing. This led me to want to make large figures, but then to my surprise they achieved a likeness only when tall and slender.
(Selz 1965, 26–28)

In another statement to Francis Stahly, shortly before World War II, Giacometti clarified why his small heads "have a bit of truth. . . . I'm trying to give the head the right size, the actual size it appears to a person when he wants to see the head all at once with complete visibility. What impresses us about its appearance can only be seen from a distance" (Hohl 1971, 207). Distance is part of Giacometti's sculpture. One views the work, even at close proximity, as if it were surrounded by an enormous space, and the figure seems to be subsumed in this space.

At a certain point in Giacometti's process of seeing, the figure began to disintegrate. Giacometti wrote to Pierre Matisse, "But if, on the other hand, one began by analyzing a detail, the end of the nose, for example, one was lost. One could have spent a lifetime without achieving a result. The form dissolved, it was little more than granules moving over a deep black void, the distance between one wing of the nose and the other is like the Sahara, without end, nothing to fix one's attention on, everything escapes" (Selz 1965, 18).

For Giacometti, this dissolution also occurred when looking at the whole person. "When I see a person looking at them [his sculptures at the 1965 Tate Gallery show in London], the person

has no thickness, indeed is like an appearance which is almost transparent and light. The very weight of the mass is false" (Tate 1965, 7). Meditators have attested that objects viewed while in a deep state of concentration become increasingly transparent. The illusion of mass or thingness, while an important philosophical concept in Hinduism, Buddhism, and Taoism, is a direct result of profound empirical observation.

For the uninitiated, this perception of reality can be terrible. In 1946 Giacometti wrote, "when I awoke this morning, I saw my napkin for the first time, that weightless napkin in a never-before perceived immobility, as though suspended in a dreadful silence. The napkin no longer had any relationship to the bottomless chair or to the table whose legs stood on the floor, but barely touched it. There were no longer any relationships between the objects which were separated by immeasurable gulfs of empty space. I stared around my room in horror, and a cold sweat ran down my back" (Giacometti 1974, 54).[2]

De Beauvoir wrote of Giacometti in her autobiography, "For an entire period, when he was walking down the street he had

---

[2] The fear inspired by the experience of the Void is beautifully described in the journals of Portuguese poet Fernando Pessoa, whose work has become more accessible in English translations in the past fifteen years. In *The Book of Disquiet*, his journals from 1915 until 1935, Pessoa writes: "I'm falling through a trapdoor, through infinite, infinitous space, in a directionless, empty fall. My soul is a black maelstrom, a great madness spinning about a vacuum, the swirling of a vast ocean around a hole in the void, and in the waters, more like whirlwinds than waters, float images of all I ever saw or heard in the world: houses, faces, books, boxes, snatches of music, and fragments of voices, all caught up in a sinister, bottomless whirlpool. And I, myself, am the centre that exists only because the geometry of the abyss demands it; I am the nothing around which all this spins, I exist so that it can spin, I am a centre that exists only because every circle has one. I, I myself, am the well in which the walls have fallen away to leave only viscous slime. I am the centre of everything surrounded by the great nothing. And it is as if hell itself were laughing within me instead of the human touch of diabolical laughter, there's the mad croak of the dead universe, the circling cadaver of physical space, the end of all world's drifting blackly in the wind, misshapen, anachronistic, without the God who created it, without God himself who spins in the dark of darks, impossible, unique, everything" (9).

to test the solidity of the house walls with his hand to resist the abyss that had opened up next to him. Then again he had the impression that nothing had weight: in the streets and squares the passerby floated through the air" (1960, 502).[3]

Given Giacometti's perception and experience of the Void, it is not surprising that at one point, while in exile in Switzerland during World War II, his sculptures became so small that he carried his entire work around in six matchboxes in his pocket. In de Beauvoir's words, he barely saved these figures from "vertiginous dispersion in space" (501).

It is not simply the lack of mass that causes the dissolution of his figures, but also the rough pinched surfaces, which do not offer a crisp boundary to the surrounding Void. The contour lines in Giacometti drawings and paintings are similarly broken and amorphous. Furthermore, the gray tonalities of his sculptures, paintings, and drawings present a washed-out appearance consistent with the perceptual shift from bright, clear vividness to transparency.

Writing about two paintings, *Annette Seated* and *Elongated Head of Diego* (1955), Jean-Paul Sartre said, "These extraordinary figures are so completely immaterial that they often become transparent, so totally and fully real that they affirm themselves like a blow of the fist and are unforgettable, are they appearances or disappearances. Both at once. They seem so diaphanous that one no longer dreams of asking questions about their expression, one pinches himself to be sure they really exist" (1955, 65).

Giacometti's process of perception led him to the conclusion that the material world was an illusion. In contrast, Sartre focused on why the illusion existed, although he could not arrive

---

[3] I have used Hohl's translation here (205), although de Beauvoir's "resister au gouffre" could also be translated as "resist the vortex."

at an answer to this question. Giacometti did not concern himself with finding an answer, but attempted to mirror what he saw. He likened his method of work to that of a scientist: "Every work of art is born for absolutely no reason at all—unless it is because of the immediate sensation of the present the artist feels when he looks reality in the eye. Whether he does it as a scientist or as an artist, the process is the same" (Hohl 1971, 190).

Giacometti's intense sensation of the present—a present inextricably linked with the Void in his work—gave added meaning to his sculptures, paintings, and drawings. Although his work received little attention until late in his career, the artist was indifferent. "Whether an artwork is a failure or success," he said, "in the end it is of secondary importance. If I have learned to see a little bit better, then I will definitely have gained something and the world around me will be far richer" (Hohl 1971, 190). Giacometti also discounted the importance of the art object. "A sculpture," he wrote, "is not an object, it is an interrogation, a question, a response" (Giacometti 1990, 79).

As mentioned earlier, Giacometti and Samuel Beckett were friends, and Beckett influenced Giacometti's development as an artist. The latter designed a spartan set for the 1961 production of *Waiting for Godot* at the Odeon Theater in Paris, consisting of a single, barren tree against an empty backdrop.

Beckett, like Giacometti, subscribed to the philosophy "man [is] a vapour" (Beckett 1958, 79). He progressively unraveled the ego and the world in his criticism, plays, novels, and poetry in order to find an essential nothingness at the core. Beckett viewed the ego and the world as illusions, a series of unreal, evanescent moments. "I have been nothing but a series or rather a succession of local phenomena all my life," said Malone in *Malone Dies* (1965a, 234). This is very close to the radical empiricism of both David Hume and Buddhism. Beckett even mentions the Buddha

in a statement on the painter Henri Hayden. "Gautauma said that one is fooling oneself if one says that the I exists, but in saying it does not exist one is fooling oneself no less" (Foster, 1989, 27). Beckett and the Buddhists understood that the I is not completely real but is not completely unreal either.

For the Buddhists and Beckett, habit made evanescent moments seem real. "Habit," wrote Beckett "is a screen to spare its victim the spectacle of reality" (1965b, 21). The spectacle of reality is the spectacle of the Void: *Nothing is more real than nothing*," said Malone in *Malone Dies* (1965a, 192).

How did one arrive at this ultimate reality? Beckett was fond of quoting the Latin axiom, *sedendo et quiescendo et anima efficitur prudens* (sitting quietly and doing nothing one arrives at wisdom). He even wrote a parody of this statement in a short story titled *Serendo et quiesciendo* (1931). In the fourth Canto of *Purgatorio,* Dante's character Belaqua quoted the original Latin axiom to justify his laziness. Beckett's character Belaqua in *More Pricks than Kicks* (1970) is modeled after Dante's character. Beckett identified with this figure.

"Sitting quietly, doing nothing" is often used to describe meditation in the annals of Zen Buddhism. Nevertheless, the Zen version of what Beckett deemed laziness is anything but lazy because it involves acute concentration on one's internal mental and emotional condition. The character Murphy, who endlessly rocks himself in an armchair, is perhaps a better exemplar of the meditative process than Belaqua:

> Murphy began to see nothing, that colourlessness which is such a rare postnatal treat, being the absence (to abuse a nice distinction) not of *percipere* but of *percipi*. His other senses also found themselves at peace, an unexpected pleasure. Not the numb peace of their own suspension,

but the positive peace that comes when the somethings give way, or perhaps simply add up to the Nothing, than which in the guffaw of the Abderite, naught is more real. Time did not cease, that would be asking too much, but the wheel of rounds and pauses did, as Murphy with his head among the armies continued to suck in, though all the posterns of his withered soul, the accidentless One-and-Only, conveniently called Nothing. (1957, 246)

In his later works, Beckett reduced the blissful trance state of Nothing that Murphy achieved into an experience of boredom. The Void was downgraded by Beckett into a little void that was not as terrifying for him as it was for Pascal and Giacometti. Beckett expressed his new attitude about the void in a passage from *Waiting for Godot.* The passage also parodies Pascal's idea of diversion—that the majority of humans escape the void through mindless activities. "Vladimir: We wait. We are bored *(He throws up his hand).* No, don't protest, we are bored to death, there's no denying it. Good. A diversion comes along and what do we do? We let it go to waste. Come, let's get to work *(he advances towards the heap, stops in stride).* In an instant all will vanish and we will be alone once more, in the midst of nothingness" (1976, 459).

For Beckett, art, "that insane barrel organ that always plays the wrong tune" (1965b, 68), is an ineffectual means to express his earlier concept of Nothing and his later idea of the void, as well as an ineffectual escape from them. Yet it was also as futile to be silent as it was to write. "It is all very well to keep silence, but one has to consider the silence that one keeps (1965a, 311).

## Yves Klein

Samuel Beckett's ambivalent feelings toward the Void were not shared by Yves Klein (1928–62). Klein exuberantly pursued and

celebrated the Void and wished to become its principal artistic exponent in post–World War II France by means of his paintings, conceptual art, and performance works. Klein's wholehearted embrace of the Void was largely the result of his practice of Rosicrucianism and judo.

Klein's interest in Rosicrucianism, particularly Max Heindel's *The Rosicrucian Cosmic-Conception* (a French translation was published in 1931), which he read intensively for at least ten years, has been well documented. Suffice it to say that Rosicrucianism is a technique of transformation by which the initiate, through breathing exercises and meditative techniques, becomes sensitized to increasingly finer energies, culminating in an experience of pure spirit. In its most rarefied form, this experience is present in the "empty" space of the Void. Accompanying the experiences of these energies is a dissolution of the ego and its attendant emotional dependencies.

My impression of Rosicrucianism, from reading Heindel's *The Rosicrucian Cosmic-Conception,* is that it is a combination of watered-down Eastern spiritual practices and Christian doctrine. The book was written in the early twentieth century for a predominantly American audience who sought to go beyond orthodox Christianity but was not ready to accept Eastern religions. Although Klein took many of Heindel's ideas very seriously and practiced the breathing techniques mentioned in the book, it is evident from his increasingly agitated and angry emotional state, in part the result of taking of amphetamines in his last years, that the depth of his spiritual experience was limited.

The rewiring of the nervous system, which is required for real spiritual transformation, is a difficult, delicate, and lengthy process. It cannot be learned from a book and must be overseen by a master at various stages in the student's development. Although Heindel claimed that practicing the Rosicrucian breathing exer-

cises for a period of seven years could actually 'transfigure" the physical organization of the body into more refined energy patterns, Klein more likely achieved a greater experience of subtle energies from his involvement with judo.

Klein was awarded the degree of fourth Dan in judo from the Kodokan in Japan in 1953, an unprecedented attainment for a Westerner at this time. The awareness of the Void/void is also an important component of judo as I have learned from my own practice.[4] In order to sense the energy of an opponent and use it, one must empty the mind and focus on the subtle energies that exist in the space between oneself and the opponent. "Judo," said Klein, "is in fact the discovery by the human body of a spiritual space" (Klein 1974, 25). Indeed, judo had an important effect on his work: "Judo has helped me to understand that pictorial space is above all the product of spiritual exercises" (25).

Klein's artistic endeavors were informed by an attempt to present the subtle energies of the Void by means of the most immaterial vehicle possible. For the Rosicrucians and Klein, "empty" space was spirit, a living dematerialized substance. "In rejecting nothingness," Klein wrote, "I found the void. The meaning of immaterial pictorial zones issued from the depths of the void . . . I seek above all . . . to create in my realization this transparency, this void immeasurable, in which lives the Spirit permanent and absolute, free from all dimensions" (Institute for the Arts 1982, 241).

Klein considered blue the color most appropriate for depicting the Void. In 1946, at the age of eighteen, Klein attached a blue disk to the notebook he used for his Rosicrucian studies. He told his friend, sculptor Arman, "This is what the paintings of the future will look like" (Institute 1982, 30). A few years later,

---

[4] I was awarded a brown belt in New York City in 1964.

while working at a frame shop in London, he created blue pastel monochromes fixed on small squares of cardboard. This was the start of his blue paintings and sculptures, which occupy a major part of his oeuvre.

For Heindel and Klein, the color blue symbolized pure spirit manifest in an indefinable, boundless space. "To experience spirit without explanation," Klein wrote in 1957 in the *Monochrome Adventure,* "without a vocabulary and to represent the sensation, it is this that had led me to [the blue] monochrome" (Institute 1982, 220) Although Klein's interest in blue started well before he came into contact with Gaston Bachelard's *Air and Dreams* in 1958, his reading of Bachelard reified his love for the color. Bachelard was also an authority Klein could cite who was more acceptable to the French intellectual and art world than Heindel (Institute 1982, 251). In *Air and Dreams,* Bachelard argued that the aerial and dimensionless qualities of blue appealed to the Symbolist poets, who associated blue with solitude, transparency, dematerialization, and reverie. Klein's use of blue was similar to that of the Symbolist poets, although with more consciously spiritual intentions than Bachelard assigned to the Symbolists.

Also, Klein's blue did not have the melancholy associations of the Symbolist poets and painters. For example, during Picasso's Blue Period, his Symbolist phase, the blue voids in the backgrounds of his depictions of suffering individuals provoked feelings of sadness and poverty not found in Klein's monochromes. On the whole, Klein resisted psychological associations in his works, aiming at more transcendental goals. In 1960 he argued, "I am in a spiritual state which grows from day to day: my only problem is to keep it pure and authentic and not allow it to be contaminated by the psychological domain" (Institute 1982, 56).

Color embodied a spiritual quality for Klein: "For me, art in painting is to produce, to create freedom in its raw state. Color,

in nature and man, is saturated with the cosmic sensitivity, a sensitivity without recesses, like humidity. For me, color is sensitivity 'materialized'" (Institute 1982, 220).

At first, Klein preferred the medium of pastel because its incandescence appeared suitable for the presentation of the Void. "Yet," he wrote, "it was depressing to see such glowing powder, once mixed in distemper or whatever medium intended as a fixative, lose its value, tarnish, become dull . . . the color magic had vanished" (Institute 1982, 222).

Klein's creation of International Klein Blue, consisting of pure dry pigment and clear synthetic resins, gave him a matte medium that retained the brilliance of the dry blue pigment. A rectangular shape for the blue pigment was also important:

I decided to retain the classic, rectangular shape so as not to shock the onlooker who thus would see a color surface rather than a flat color form. My desire at that time was to present, with an effect of slight artificiality, an opening on the world of the color represented, an open window on one's freedom to saturate oneself, in an infinite, unlimited way, with the immeasurable state of color. I wanted to offer the public a possibility of the illumination of pictorial, essential color matter, impregnated with which all physical things, stones, rocks, bottles, clouds, become pretext for the voyage of human sensitivity in the cosmic sensitivity, unlimited, of everything. Before one of my color surfaces the ideal onlooker would become, only as regards his sensitivity of course, "extra dimensional" to the point of being "all in all" saturated with the sensitivity of the universe. (Institute 1982, 223)

I think Klein hoped that the ideal viewer, one sensitive to subtle energies, would have an ecstatic experience in front of his work, and that the viewer's energy would merge with the universal energy field. He also tried to create an enticing vision of the blue world, which in Heindel's cosmology represented a future Edenic state. In this state, the Rosicrucian student, having fully transcended his or her physical body, would inhabit his or her astral body alone. Klein hoped that through the practice of Rosicrucian techniques he would be the first to attain this level of "immaterial sensibility."

The power of the blue world in Klein's paintings was predicated on the ability to provide the viewer with a sense of infinite expansion. Klein was against "line and all its consequences: contours, forms, compositions. All paintings of this type, whether figurative or abstract, seem to be windows of a prison of which the lines themselves are bars. Far away, where color dominates, is freedom! The viewer of a painting with lines, forms and composition remains the prisoner of his senses" (Institute 1982, 244).

The true work of art for Klein was invisible. It extended beyond the senses. "The physical painting has a right to exist because people believe only in the physical even while they feel obscurely the essential presence of the other thing" (Institute 1982, 246).

Klein believed that the white paintings of Malevich, Robert Rauschenberg, and Wladyslaw Strzeminski (an early twentieth-century Polish artist) moved beyond the pictorial, but lacked the essential presence of the spiritual. Klein observed a Strzememski exhibition at the Galerie Denise René in December 1957 and remarked:

> In the presence of these monochrome white paintings,
> but with forms accentuated in relief, I realized to what

extent this suggestion brought by the roughness of the material on the surface of the painting, this retreat before space, this holding on inspired by a fear of the void, weakened the real pictorial power. Although I do not think, in any case, that there was anything pictorial to weaken in this painting of Strzememski. The painting has no radiation, no life, no autonomous charm in itself. For me, a painting must create around itself, permanently a deep, immense joy, a great illuminating, delirious, and especially immaterial happiness of the surface of the canvas. (Stich 1994, 76).

Given Klein's quest for an immaterial art that best presents spirit, it was not surprising that he moved away from the medium of painting and attempted to create a Void in the empty space of a gallery. "My monochrome pictures," he wrote in 1957, "are not my definitive works, but the preparation for my works, they are left over from the creative process, the ashes" (Klein 1974, 35). "My pictures," he continued, "after all are only title deeds to my property which I have to produce when I'm asked to prove that I'm a proprietor" (35). Klein believed that he had purified his sensibility to the point that he had earned a special relationship with the Void and the right to be its proprietor.

For his 1958 exhibition at the Iris Cert Gallery in Paris, titled *The Void*, Klein removed all the furnishings from the small, twenty-meter-square gallery, cleaned it thoroughly, and painted the walls white. He did a similar installation called *Room of Emptiness* in 1961 in a room at Museum Haus Lange in Krefeld, Germany (fig. 33). His friends claimed that he meditated intermittently in the space for forty-eight hours (Institute 1982, 247). "My presence in action during the execution of this gallery space," he argued, "will create that radiant pictorial climate

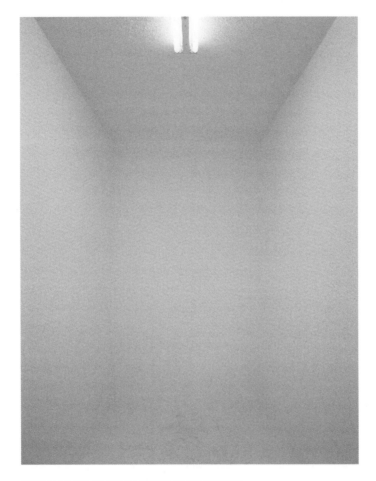

Figure 33 | Yves Klein: *Room of Emptiness*

that usually reigns in the studio of any artist endowed with true power; a sentient density, abstract but real, will exist and live, in and of itself within the given confines" (Institute 1982, 226). Klein was determined to charge the gallery space with his own "immaterial sensibility."

Klein was acutely aware that while he was shaping the Void with his own sensibility, he was also opening himself to the immeasurable energy of the Void, and this was not to be taken lightly. He told his Aunt Rosa that owing to the potentially dangerous power of the Void, it would be necessary to visit the shrine of his patron saint, St. Rita, the patron saint of lost causes. Klein went to her shrine in Corsica shortly before the exhibition.

Klein's prayer may have helped. The exhibition turned out to be a triumph, judging from the number of people who attended the opening, the extension of the exhibition for another week, and the positive remarks of viewers, several of whom understood that Klein was trying to appropriate the powers of the Void. Albert Camus, for example, wrote in the guest book, "with the void, full powers" (Institute 1982, 247).

In 1959 Klein again "participated immaterially" in a group show at the Hessenhuis gallery in Antwerp, Belgium, by standing for a short time in the space allocated for his work. He hoped to imbue the space with his spiritual presence, which would be felt by the sensitive viewer after his departure.

I think that when Klein was impregnating his immaterial sensibility in the monochromes and gallery spaces such as Hessenhuis, he was leaving traces of his etheric or chi body in which the ego is relatively attenuated. As in Chinese painting, where the chi of the artist merges with the chi of the subjects (landscapes, figures, and voids), Klein was energizing the empty spaces of his installations and hoped to energize the viewer as well.

Following these installations of 1959, Klein declared, "I want to go beyond art, beyond sensibility, beyond life, I want to go into the void" (Institute 1982, 51). His entrance into the Void would be accomplished by a dramatic leap into space from the second story of a house inhabited by a friend, gallery owner Colette Allendy. As the self-proclaimed proprietor of the Void and master of Heindel's dematerialization techniques, Klein deluded himself into thinking he could fly.[5]

On one attempt he twisted his ankle; on the next he broke his shoulder. Not wanting to injure himself again, he decided to stage a mock repeat in front of photographers on October 12, 1960. The event, titled "The Artist of Space Hurls Himself into the Void," was as close to the Void as Klein was to get on a spiritual level in his later life. Yet he continued to experiment with other artistic expressions involving the Void, namely the fire sculptures.

The fire columns, installed at the Museum Haus Lange in January 1961, were three-meter geysers of flame that seemed to issue from the earth's surface. Three colors appeared in these geysers: blue in the center, gold surrounding the blue, and pink in the surrounding sparks. Witnesses said they looked particularly spectacular at night. The fire wall, also at Krefeld, was a brilliant field of fifty Bunsen burners suspended on a grid that became almost invisible when the burners were lit.

Klein wrote in a 1961 manifesto, "I believe that fires burn in the heart of the Void as well as in the heart of man" (Restany 1992, 6). In the Krefeld fire columns, Klein was finally able to embody the great energy that lies at the heart of a Void. In alchemy and yoga, particularly kundalini yoga, the fire energies of the Void are used to burn away the egos. In Taoist yoga, water

---

[5] See Levy, 1993, 228–332, for a more elaborate analysis of Klein and flying.

energies lie at the heart of the Void and are used to dissolve the ego in the process of spiritual development. For the Taoists, yin water energies are no less powerful than yang fire energies.

Also at Krefeld, Klein exhibited plans for combined water and fire sculptures. In one of these, a wall of flames would intersect the top of a waterfall, causing fire and water vapors to mix. Here, and in several later fountain projects, Klein acknowledged the presence of water energies in the Void. Unfortunately Klein was not willing to use fire or water energies to bring about his own transformation. Klein struggled to keep his ego in check, particularly late in his career when he stopped practicing judo and lost his ability to center and ground himself. Indeed, his ego was at odds with his desire to have a greater relationship with the Void. After Krefeld, his career and the quality of his personal life began a sharp decline. Klein died of heart failure on June 6, 1962, at the age of thirty-four.

## Mark Rothko

The paintings of Mark Rothko (1903–70) manifest a more highly evolved spiritual state than he was able to achieve in his turbulent personal life. The Void figures prominently in his works. Robert Motherwell, a friend of Rothko's, recounted that he "loved the memory of Michelangelo Antonioni, the film director, telling him through an interpreter that they both had the same subject matter, 'nothingness'" (Motherwell 1992, 199). Yet, Antonioni's nothingness, a powerful existentialist cocktail of boredom and anxiety that informs films such as *La Notte* and *L'Eclipse,* differs greatly from Rothko's nothingness.

Rothko's work progressed through several stages: quasi-human forms in the early 1940s, more abstract biomorphs in the late 1940s, and complete abstraction by 1947. In 1950, he arrived at the format he was to pursue almost to the end of his

life: soft, blurry rectangles aligned horizontally over a background color (frontispiece). My focus here is on Rothko's work of the late 1950s and the 1960s. Rothko felt that painting was a transcendental experience. He argued, "The Romantics were prompted to seek exotic subjects and to travel to far-off places. They failed to realize that, though the transcendental must involve the strange and unfamiliar, not everything strange and unfamiliar is transcendental" (Rothko 1947–48, 84).

For Rothko, the exotic transcendental was not an exotic, far-off place but a distinctly interior experience that went beyond the world of objects, although he was able to embody it in sensuous abstract forms. Motherwell remarked that Rothko was "the only important artist that I ever met who was wholly indifferent to objects. Which may not be unrelated to his notion of art" (Motherwell 1992, 196). In fact, toward the end of his life, Rothko lived alone with few possessions in squalid conditions that belied his bank account and Upper East Side address in New York City.

Rothko's Orthodox Jewish background undoubtedly predisposed him to regard the spiritual as being separate from the world of objects. His refusal to embody the spiritual in recognizable images can also be seen as a product of the traditional Jewish disdain for graven images.

In the context of the New York art scene of the late 1940s and early 1950s, Rothko's iconoclastic attitude toward the image marked him as an outsider, a status he considered an advantage. "The unfriendliness of society to his activity," he wrote, "is difficult for the artist to accept. Yet this very hostility can act as a lever for true liberation. Freed from a false sense of security and community, the artist can abandon his plastic bank book, just as he abandoned other forms of security. Both the sense of community

and of security depend on the familiar. Free of them, transcendental experiences become possible" (Rothko 1947–48, 84).[6]

Another reason for Rothko's outsider status was his refusal to talk about his paintings. For Rothko, painting possessed an "utmost power and concreteness" that went beyond description and was commensurate with transcendental experience (Breslin 1993, 392). He argued, "A painting doesn't need anyone to exclaim what it is about. If it is any good, it speaks for itself" (Fischcher 1970, 20).[7]

Music, the most abstract of the arts, offered Rothko a parallel for his efforts in the visual arts. There is no evidence that Rothko read Arthur Schopenhauer. However, in *The Birth of Tragedy,* one of Rothko's favorite books, Friedrich Nietzsche quoted a passage from Schopenhauer's *World as Will and Representation*, where the latter discussed music:

---

[6] Later in his career, after reading Kierkegaard's *Fear and Trembling, and the Sickness unto Death*, Rothko found an important justification for his outsider status in the parable of Abraham's willingness to sacrifice his son Isaac. In a 1956 conversation with writer Alfred Jensen, Rothko said, "Last year when I read Kierkegaard, I found that he was writing almost exclusively about the artist who is beyond all others. And as I read him more and more I got so involved with his ideas that I identified completely with the artist he was writing about" (Breslin 1993, 392). Kierkegaard believed that Abraham's readiness to become a social pariah in order to obey God's commands indicated the precedence of spiritual over moral concerns. Rothko regarded painting as a spiritual mandate that had to be maintained whatever the cost. These costs for Rothko included marital difficulties and a general lack of critical and public comprehension of his work. "No one is so great as Abraham! Who is capable of understanding him?," Kierkegaard wrote (31–32).

[7] In Kierkegaard's *Fear and Trembling* there was a justification for his silence. "Another problem of Abraham was whether to tell Sarah," said Rothko to Alfred Jensen. "How could Abraham explain to the mother of his son the necessity for sacrificing his son to a god who was surely an abstraction to her? Words are ineffective in the communication of profound spiritual truths that go beyond rational and moral understanding" (Breslin 1993, 392).

Music therefore, if regarded as an expression of the world, is in the highest degree a universal language, which is related indeed to the universality of concepts, much as they are related to particular things. . . . All possible efforts, excitements, and manifestations of will, all that goes on in the heart of man and that reason includes in the wide, negative concept of feeling, may be expressed by the infinite number of possible melodies, but always in the universal, in the mere form, without the material, always according to the thing-in-itself, not the phenomenon, the inmost soul, as it were, of the phenomenon without the body. This deep relation, which music has to the true nature of all things, also explains the fact that suitable music played to any scene, action event or surrounding seems to disclose to us its most secret meaning. (Nietzsche 1967, 101–2)

In Nietzsche, Rothko found an important justification for his attitude toward form and color. He regarded himself not as an Apollonian artist whose primary concern was the creation of forms appropriate to the expression of balance and serenity, but as a Dionysian artist who, in a state of ecstasy and intoxication, becomes one with primordial nature, "the phenomenon without a body," the Void.

In an unpublished essay on Nietzsche, Rothko wrote, "I found in the fable [*The Birth of Tragedy*] the poetic reinforcement for what I inevitably knew was my inevitable course: That the poignancy of art in my life lay in its Dionysian content, and that the nobility, the largeness and exaltation are hollow pillars, not to be trusted, unless they have as their core, unless they are filled to the bulging by the wild" (Breslin 1993, 357).

Nietzsche described Dionysian festivals as events where "the individual, with all his restraint and proportion, succumbed to the self-oblivion of the Dionysian states, forgetting the precepts of Apollo. Excess revealed itself as truth" (1967, 46). He admitted, however, that the world of Dionysus, if it were to be expressed, had to take on form.

Rothko hoped to create a formal abstract language that would embody the "inmost soul of things," like the full-bodied music of the German composers he admired. In a 1958 lecture at Pratt University Rothko declared, "Sensuality is our basis of being concrete about the world. It is a lustful relationship to things that exist" (Breslin 1993, 390). Paradoxically, Rothko downplayed technique, the carrier for sensuality in his work.[8] In a well-known statement to Sheldon Rodman, Rothko argued against concentrating on color relationships:

> I am not interested in the relationships of color and form or anything else. I am interested only in expressing the basic human emotions, tragedy, ecstasy, doom and so on, and the fact that lots of people break down and cry when confronted with my pictures shows that I communicate with those basic human emotions. The people who weep before my pictures are having the same religious experience I had when I painted them. And if you say they are moved only by the color relationships, then you miss the point. (Rodman 1957, 93–94)

---

[8] Rothko's disparagement of technique may have initially come from Max Weber, his professor at the Art Students League, which Rothko attended in the 1920s. In 1916 Weber wrote, "Always it is expression before means. The intensity of the creative urge impels, chooses and invents the means. Means alone cannot build up an art.… The wonder and blessing of the spirit is that it can manifest itself best through the simplest means and it knows no technique.… The imagination or conception of an arrangement of forms or of a particular gamut of color in a given rectangle is not a matter of means, but an inner spiritual vision" (Weber 1916, 27–29).

Rothko believed that when his painting worked, his language became transparent, disappearing at the epiphanic moment that the viewer began to have a transcendental experience.

In his manuscript on Nietzsche, Rothko mentioned several times that Apollonian concern for form makes Dionysian states "endurable." In a 1948 letter to his friend Clay Spohn, Rothko wrote, "the question of form while it involves the image shape, resolves itself into the question of measure, of how much can be revealed before the reality becomes unendurable." (Breslin 1993, 358)

Rothko employed several techniques to express his transcendental experience of the Void. His paintings ranged in size from just over eighty-one inches by sixty-seven inches for *No. 18,* a standard painting of the 1950s, to ninety-six inches by one hundrerd eighty inches for a panel in two of the Houston Chapel triptychs. Despite this variety, the scale of the works, for the most part, supported the power of the Void. Rothko felt that scale was of great importance because it gave weight to his paintings. "Feelings have different weights. I prefer the weight of Mozart and Beethoven," he said (Breslin 1993, 396).

Rothko described listening to Mozart and Beethoven as a Dionysian experience that took him outside himself. He was overwhelmed by the weight of the music, its emotional and spiritual gravitas. This preference for weightiness is perceptible not only in the scale of his paintings but also in their association with infinite landscapes. Rothko's rectangular lozenges are connected to images of a horizon that stretches into infinity, although they do not touch the frame. As art historian Robert Rosenblum argues in *Modern Painting and the Northern Tradition,* Rothko's paintings are successors to Friedrich's landscapes and seascapes, although they are larger in size and scale

than Friedrich's, enhancing the effects of the former's work on the viewer.

Weight is also linked to both dark and light color fields in Rothko's paintings. The color fields appear to have an indefinite depth, created by applying many layers of glaze and by fading out the color density at the edges of the rectangles. The viewer contemplating a Rothko painting gradually becomes immersed in luminous emptiness. The sensation of being fully subsumed in diaphanous space is heightened at very close proximity to the painting or in the center of a room full of the artist's works. While the subsequent loss of the self in a Rothko painting can bring about feelings of lightness and release bordering on ecstasy, it can also elicit an emotional response of profound fear and sadness, as Rothko described. Meditators often encounter the same feelings when they move progressively into the interior Void, as I have already mentioned—the ego reacts fearfully when faced with the prospect of being obliterated.

Rothko's final works, commissioned by John and Dominique de Menil, were fourteen panels for an octagonal chapel that was specially designed for them in Houston, Texas. He worked on these panels from 1965 to 1967, although the chapel was not completed until 1970, after the artist's death. Rothko had a three-wall mock-up of the projected chapel constructed in his Sixty-ninth Street studio in New York where he worked on the panels with his assistants, Roy Edwards and Ray Kelly. His assistants painted the grounds for all fourteen panels. Seven of the works remained grounds, so Rothko did not touch half of the panels. All the panels have two primary coats of dry pigments, alizarin crimson and ultramarine blue, mixed in hot rabbit-skin glue and then a secondary coat of bone-black dry pigment that turned the colors darker.

Although all the panels work together to create an atmosphere conducive to prayer and meditation, I will discuss only the triptych on the chapel's west wall, which Rothko completed himself: three hard-edged black rectangles on a maroon ground, with the central panel rising several inches above the side panels. The maroon ground also serves as a frame of several inches for the black rectangles. Not only are these hard-edged panels a departure from the soft-bordered rectangles in previous work, but Rothko has compressed his diaphanous color fields into three black, essentially monolithic forms. Although the black forms have as many as five layers of paint—an egg-oil emulsion resembling egg tempera that Rothko long admired in Renaissance painting—and the thin black paint is influenced by the maroon ground underneath, the forms do not have the depth of his earlier paintings and they barely show the marks of the very fine brushes Rothko used on the work. The black forms are forbidding in their density and opacity. James Breslin, in his monograph on Rothko, finds this triptych "oppressive" (1993, 481) and uses words that Rothko employed in another context to describe them: "something you don't want to look at" (476).

For me, however, Rothko has traveled far into the Void. In the mystical Jewish tradition of the Kabbalah, a tradition that Rothko was most probably aware of, there is the concept of the Ein-Sof, God as an infinite ground of Being beyond categories or form. The Ein-Sof has similarities with the Buddhist Dharmakaya, the Chinese Tao, and the Hindu Brahman, but it is approached with fear and trembling. The Void of the Ein–Sof is a *mysterium tremendum ac fascinans,* a "horrific but fascinating mystery."[9]

---

[9] These Latin words were a favorite expression of the theologian Rudolf Otto to define the innermost essence of the holy in his famous book *Das Helige (The Idea of the Holy).*

Although Rothko was not an observant Jew—he once referred to himself as the "last rabbi of Western art" (Breslin 1993, 460)—I believe that the triptych was his last attempt to embody the Absolute. As Gershom Scholem, the great scholar of Jewish mysticism, wrote, "There are those who serve God with their intellects and others whose gaze is fixed on Nothing"[10] (Scholem 1960, 5).

## Ad Reinhardt

Ad Reinhardt (1913–67) had an intense interest in Eastern art and its philosophical underpinnings, which he taught along with painting for many years at Brooklyn College. It is not surprising, therefore, that his gaze would be fixed on Nothing. By the early 1960s, Reinhardt arrived at his late style (fig. 34), summarized as "classical black-square uniform five foot timeless evanescence" (Rose 1991, 10).

Reinhardt further described this style, which occupied him for the rest of his life:

> A square (neutral, shapeless) canvas, five feet wide, five feet high, as high as a man, as wide as a man's out-stretched arms (not large, not small, sizeless) trisected (no composition), one horizontal form negating one vertical form (formless, no top, no bottom, directionless) three (more or less) dark (lightless) non-contrasting (colorless) colors, brushwork brushed out to remove brushwork, a mat, flat, free hand painted surface (glossless, textureless, non-linear, no hard edge, no soft edge) which does not reflect its surroundings—a pure abstract non-objective,

---

[10] Scholem goes on to say, "He who is granted this supreme experience loses the reality of his intellect but when he returns from such contemplation to the intellect, he finds it full of divine and inflowing splendor" (Scholem 1960, 5).

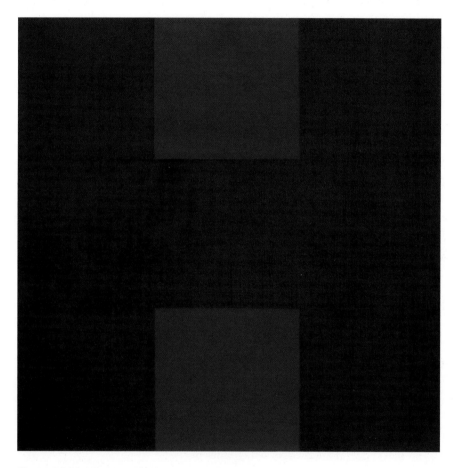

Figure 34 | Ad Reinhardt: *Abstract Painting No. 3*

timeless, spaceless, changeless, relationships, disinter-ested painting—an object that is self conscious (not unconscious), ideal, transcendent, aware of no thing but Art (absolutely no anti-art). (Rose 1991, 83)

In short, Reinhardt fabricated a Void consisting of nine rectangles of slightly varying black tonalities. He often publicly insisted that these black squares were the endpoint of a process of elimination, a reductive abstraction: "I'm merely making the last painting that anyone can make" (Rose 1991, 13). I believe that his extensive unpublished writings, collected by Barbara Rose in *Art as Art,* indicate that he was hoping his paintings would engender a transcendental experience of the Void.

Here are some excerpts from Reinhardt's relevant notebook jottings about the Void and painting:

Awareness of hidden things, look toward what is hidden
Avest for that which has no dimension, no time
Nothing to take hold of, neither place, time, measure, nor
    anything else
Beyond essence, inconceivability
Beyond light, limit, the unmixed, the unfettered, the
unchangeable, the untrammeled
Intangible, invisible, illimitable
Beyond "seeing," beyond foul and fair
Of what transcends all affirmation
What is beyond all negation          beyond becoming
Advance toward the formless, what is without contour,
Encounter nothingness…
At home with voids, reality and self sums, products of zero
"Not that", it is "no thing," "nil," "nothing"
"A non-rendering of non-experience" turning up as dark
    shadow . . .

No ordinary seeing but absolute seeing in which there was
  neither seer nor seen . . .
Painting that is almost possible, almost does not exist, that
  is not quite known, not quite seen . . .
"An ineffable energy, seen invisibly, known unknowably"
(Rose 1991, 106–9)

Art necessary, but necessary for nothing
The ultimate ground
(111)

Sign which refuses to signify
(106–9)

From the language employed, especially the quotations, it is
obvious that the artist was familiar with Taoist, Hindu, and
Buddhist texts. His notes also contain evidence that he attempted
some kind of spiritual practice:

Become pure by detaching itself from everything
Withdraw from sense objects, multiplicity . . .
Injunction—prohibit revelation to the uninitiated
Not distinguish knower and known . . .
Free of all
Grew out of practice of specific technique
Detachment from desires, quieting of faculties
Nonsensuous, formless, shapeless, colorless, soundless,
odorless
No sounds, sights, sensing, sensations          No intensity
No images, mental copies of sensations, imagings,
  imaginings
No concepts, thinkings, ideas, meaning, content

Repetition of formula over and over again loses all meaning
Nothing left except monotonous disappearing image
Focus of required one-pointed direction . . .
An invasion of the ultimate
(Rose 1991, 113–14)

Aside from these musings, the question remains: Do Reinhardt's black paintings succeed in creating experience of the ultimate Void? Most art critics did not get this from Reinhardt's "monotonous disappearing image[s]." Hilton Kramer's contention that "Reinhardt's paintings are the most genuinely nihilistic paintings I know" was among the more positive critical responses (1966, 534). Nevertheless, Priscilla Colt and Barbara Rose, two New York art critics, understood what Reinhardt attempted to achieve. Colt wrote:

> Although before these paintings the eye is refused its expected satisfactions, attention is fixed, held. Awareness, freed of the excitation of complex perceptual stimuli, becomes curiously suspended, abstracted. Self-consciousness ebbs; the observer is, in a literal sense, transfixed. This is not loss of awareness and it differs from "pure contemplation" because it is tied to a perceptible reality—the painting. The experience is prolonged, sustained, heightened by unexpected after-images, flickerings of light and spatial shiftings. The effect is mesmeric, hypnotic; one has the sense of being drawn into them, "lost" in them, a sense of disembodiment. (Colt 1964, 34)

This analysis offers good description of the early stages of meditation. Colt believes her interpretation goes beyond

Reinhardt's claims for his painting, but his unpublished notes were not available when she wrote her article. She goes on to say that it is "tempting" to make comparisons with Eastern art where a meditative effect is also intended, but stylistically and iconographically Reinhardt's paintings remain connected with Western tradition (1964, 34). Colt believes that the cruciform patterns, which are quite evident in Reinhardt's earlier work and are only relatively submerged in the black paintings, offer an inescapable association with the Greek cross (34).

Barbara Rose, citing Reinhardt's description of the black paintings as "high as a man, as wide as a man's outstretched arms," relates the cruciform patterns to the Renaissance module of proportions based on the Vitruvian man with his outstretched arms. Along with Colt, she believes that the black paintings can bring about a meditative experience. Rose wrote, "Because the cruciform image requires time to focus, and requires an act of focusing so demanding that it changes the state of the viewer's consciousness, the black paintings reflect some of the values the Eastern cultures Reinhardt become progressively involved with as his revulsion with the function of art in the West grew" (Rose 1991, 82).

Reinhardt's black paintings function very much like mandalas in Eastern art. Trisected mandalas of nine squares are frequently found in Japanese Shingon Tantric Buddhist paintings (fig. 35), which Reinhardt must have been aware of as an avid student and teacher of Asian art. He had a firsthand experience of temple mandalas on his trips to Asia and occasionally referred to them in his writing. Shingon mandalas are replete with depictions of deities, but their most significant aspect is their structure. The cruciform configuration takes the viewer from the outer boundaries of the mandala to the center, both mirroring and facilitating the spiritual transformation from phenomenal

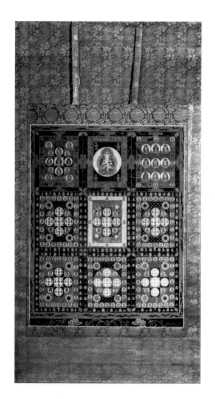

Figure 35 | Diamond World Mandala

to noumenal reality. Mandalas act as meditation aids; they are visualized internally in the meditator's mind to help focus awareness on the central deity of the configuration. The meditator then merges with the energy of the deity and dissolves this energy into the Void. In two-dimensional form or in three-dimensional temples, the mandala also has a balancing and harmonizing effect on the nervous system of the viewer.

In viewing Reinhardt's nine-square trisected black paintings, the observer at first sees a uniform continuum of flat black paint without markings. Then, in order to register the subtle black tonal shifts from square to square, the viewer must quiet his or her mind as the internal cruciform configuration brings the viewer into the center of the painting and into the Void. According to Reinhardt, the black paint itself facilitates this entry into the Void.

Reinhardt describes the Void as follows:

> *Void* [his italics], diluted by matter, disturbed by light,
>      split up
> Sucks time, space, identity into absolute of nothingness . . .
> The other side, transcendent
> Negative presence, "darkness," a getting rid of,
>      "blowing out"
> Diminishing, beyond shapes, colors, "melting away"
> *Dematerialization* [his italics], non-being
> "The dark of absolute freedom"
> Going from "darkness to darkness yet," *ultimate* [his italics]
> Black "medium of the mind," no distractions, no intrusions.
> "The *Tao* is dim and dark" Lao Tzu
> Ka'aba, black cube rock
> "The divine Dark" –Eckhart
> (Rose 1991, 97–98)

Reinhardt links black with the Void, the absolute, the ultimate, the transcendent, "blowing out," Nirvana, and so forth. If a viewer stays in front of a Reinhardt for an extended period of time, he or she tends to dissolve into a field of black energy, "a last vestige of brightness" bordering on the end of consciousness (Rose 1991, 75). Given my own meditation experience, Reinhardt's black paintings offer a good simulacrum of the end stages of *samadhi*.

## John Cage

Like the Ad Reinhardt's black paintings, the sound compositions of John Cage (1912–92) that have "silence" as their subject give the nonmeditator a taste of the meditative experience. Cage wanted to lead the listener to understand the emptiness of sounds, the experience of sounds without preconceptions. He was profoundly influenced by the phrase "form is emptiness" from the Heart Sutra.

Cage wrote extensively about silence.

> What happens for instance in silence? That is, how does the
>   mind's perception of it change? Formerly silence
>     was the time
>   lapse between sounds, useful to a variety of ends,
>     among them
> that of tasteful arrangement, where by separating
>     two sounds
> or two groups of sounds their difference or
>     relationships might
> receive emphasis or that of expressivity, where silences in a
> musical discourse might provide pause or punctuation;
>     or again
> that of architecture, where the introduction or interruption
> of silence might give definition either to a predetermined

structure or to an organically developing one.

Where none of
these or other goals are present, silence becomes something
else—not silence at all, but sounds. The nature of these is
unpredictable and unchanging. These sounds

(which are called
silence only because they do not form part of a musical
intention) may be depended upon to exist. The world

teems with
them, and is, in fact, at no point free of them. He who has
entered an anechoic chamber, a room made as silent as
technologically possible, has heard there two sounds,

one high,
one low—the high the listener's nervous system in

operation,
the low his blood in circulation. There are, demonstrably,

sounds
to be heard and forever, given ears to hear. Where these ears
are in connection with a mind that has nothing to do,[11]

that mind
is free to enter into the act of listening, hearing each sound
just as it is, not as a phenomenon more or less

approximating a
preconception.
(1961, 22)

---

[11] Cage expands upon this idea of the mind that has nothing to do as follows: "You have to be able to work in such a way that something happens free of the mind's operation. Anything that appears, appears by virtue of the emptiness of the space. I'm in an accepting frame of mind rather than a controlling frame of mind" (Kostelanetz 1982, 141).

The last sentence of the statement echoes the idea of "beginner's mind" in Zen Buddhism: striving to keep the mind open without emotional or mental projections. Cage attempted to hear each sound "just as it is" in the manner of the Zen experience of the "isness," or everyday suchness, of things.

Cage's interest in Zen Buddhism was well known.[12] He attended D. T. Suzuki's lectures on Zen Buddhism at Columbia University in the late 1940s and was an avid reader of books on Buddhism and Taoism. Some of his favorite texts were Blofeld's *The Zen Teaching of Huang Po on The Transmission of Mind*, L. C. Bennet's *Neti, Neti*, and Frederick Streng's *Emptiness: A Study in Religious Meaning*.

Cage's famous work *4'33"*, performed at Black Mountain College in 1952, was greatly influenced by Zen. Cage had a pianist, his friend David Tudor, uncover the keyboard at the beginning of the piece and close the keyboard at the end of four minutes and thirty-three seconds without touching the keys in the interval. "Silence" or the "noise" in the room became the concert. Cage saw the function of his work as bringing the viewer's attention to the music of ordinary sounds. The traditional role of the musician was therefore dispensable.

---

[12] A number of French and German artists also became interested in Zen soon after World War II. They are discussed in Helen Westgeest's *Zen in the Fifties* (1996). The little-known French artist Jean Degottex (1918–88) was greatly influenced by a 1958 French translation of D. T. Suzuki's book *Essays in Zen Buddhism* and even attempted to represent the eighteen emptinesses of the *Prajna Paramita* by means of a series of eighteen paintings from 1959 to 1961. These paintings get progressively more minimal until they become only a few loose brushtrokes on an empty canvas. For me, the oil brushstrokes are more akin to Surrealist automatic drawing than to Eastern painting. Yet Degottex's works show more of an interest in the Void than any of the other artists reproduced in Westgeest's book, aside from Yves Klein. See Westgeest, 117–20.

When we separate music from life what we get is art (a
compendium of masterpieces) with contemporary music,
   when it
is actually contemporary, we have no time to make that
separation (which protects us from living), and so
   contemporary
music is not so much art as it is life and any one making
   it no
sooner finishes one of it than he begins making another
   just as
people keep on washing dishes, brushing their teeth, getting
sleepy, and so on very frequently no one knows that
contemporary music is or could be art. He simply thinks
   it is
irritating, irritating one way or another, that is to say
   keep us
from ossifying.
(1961, 44)

For *4'33"* to work, the listener had to get beyond the initial irritation or boredom. "In Zen they say," Cage wrote, "if something is boring after two minutes, try it for four. If it is still boring, try it for eight, sixteen, thirty two and so on. Eventually one discovers that it is not boring at all but very interesting" (1961, 93).

Another intention of *4'33"* was to bring listeners to the awareness that one sound is as good as another, just as there is no difference in quality between washing the dishes and composing contemporary music. Cage's belief that "all sounds are excellent" (1961, 155) because each has infinite value was taken directly from *The Zen Teaching of Huang Po on The Transmission of Mind.* "The Dharma is absolutely without distinctions neither high nor low. . . . If he permits himself a single thought leading to

differential perception, he falls into heresy, contends Huang Po" (Blofeld 1958, 44).

Cage did not realize that the equivalence of all sounds and activities is nearer to an Absolute experience than to a relative practical reality. In meditation, all mental, physical, and external phenomena are sometimes experienced equally as ripples, points, or events in a field. At this stage there is no central self because the normal boundary lines of body and mind are absent. Yet even the most enlightened Zen Buddhist cannot transform every moment into an epiphany or get through the day without making distinctions of quality. The Zen master does both depending on what is appropriate in the situation.

*4'33"* was a useful way of exposing the nonmeditator to the Zen idea of nondistinction and "everyday suchness," providing he or she had the discipline and the motivation to transcend the initial boredom and irritation. Yet *4'33"* was only a beginning. I doubt that most listeners of *4'33"* heard the sounds in the room without thinking. Nor did most realize the other levels of voidness such as the voidness of self-identity, the voidness of substance, and the Dharmakhaya (the Great Void). To realize these levels of Void/void requires sustained meditation practice. Cage, himself, never practiced *zazen*—sitting meditation—in part, I think, because Suzuki almost completely neglected to mention sitting meditation in his lectures and writings.[13]

For Cage, steeling oneself to bothersome sounds, which is part of the process of nondistinction, was a "heroic" activity, not *zazen*. "What is heroic is to accept the situation in which you find yourself," he said in an interview (Cage 1981, 56). Also, in his book *Silence* he wrote, "But the important questions are answered

---

[13] Suzuki, an adherent of the Rinzai school of Zen, believed that there was too much emphasis on sitting in the rival Soto sect. For Suzuki "just sitting" led to spiritual stagnation. See Carl Bielefeldt, *Dogen's Manuals of Zen Meditation* (1988), 3.

by not liking only but disliking and accepting equally what one likes and dislikes. Otherwise there is no access to the dark night of the soul" (1961, 133). Acceptance, however, will not get one very far on the road to enlightenment other than slightly expanding a tolerance for what one ordinarily dislikes.

Cage disliked listening to Asian music despite believing that the "purpose of [Indian] music was to sober and quiet the mind, thus subjecting it to divine influences" (Clarke 1988, 122). This is not surprising given his antipathy to harmony, melody, and rhythm. Although *4'33"* greatly influenced the course of contemporary music and introduced people to Zen ideas, it is highly unlikely that in the initial and later performances it sobered and quieted the mind more than traditional harmonic trance music. In fact, engaging in repetitive Buddhist chanting, which is practiced by some Zen schools, is much more conducive to quieting the mind than Cage's *4'33"*. I think that most of the original audience found *4'33"* "irritating one way or another" (Cage, 1961, 44).

## John Cage and Nam June Paik

The Korean composer and video and installation artist Nam June Paik (born 1932) was inspired by the writing of D. T. Suzuki and also that of John Cage, mostly the latter's work of the early 1960s. *Zen For TV* (1963) in the collection of the Museum Moderner Kunst in Vienna displays a single wavy white line on a fuzzy ground on a black-and-white television set placed on its side. This is an act of rebellion against television whose usual function is to serve as a source of amusement, not a frame for visual static. *Zen for TV* is more a statement about Paik's attitude to television and mass culture than an embodiment of the Void. In *Zen for Film* (1964) Paik is more serious in his approach to the Void. Usually shown for an hour, it is a continuous loop of unexposed film. The

viewer sees the dust on the lens and the film as well as scratches on the film projected on the screen.

After being invited by Paik along with Merce Cunningham to see this film, Cage wrote the following commentary: "An hour long film without images. The mind is like a mirror; it collects dust; the problem is to remove the dust. Where is the mirror, where is the dust? In this case the dust is on the lens of the projector and on the blank developed film itself [the film was undeveloped]. There is never nothing to see. Here we are both together and separate. My *4'33"* the silent piece is Nam June's *Zen for Film*. The difference is that his film was not silence but something to see" (Stooss 1993, 22).

Here, Cage alludes to the famous poem of the Chinese Zen master Hui-Neng (638–718), which earned the latter the position of Sixth Patriarch. The runner-up for the position said that the essence of Zen was the removal of dust from the mind so it acts as a perfect mirror. Hui-Neng, however, went further in his understanding of Zen by saying that there was ultimately no mirror, no dust, and no mind. In another words, for Hui-Neng, Zen was not about polishing or emptying the mind, but about seeing the world without concepts. This is one of the authentic voids in Zen, albeit one in which the world does not disappear, as in *4'33"* where there is supposedly just silence and in *Zen for Film* where supposedly there are no images.

## Agnes Martin

Agnes Martin (1912–2004) lived in lower Manhattan near John Cage and Ad Reinhardt until she left for New Mexico in 1967, and, like Cage, she was influenced by the sutra of Hui-Neng.[14] In

---

[14] A version of the Hui-Neng sutra appeared in Dwight Goddard's *A Buddhist Bible*, published in 1932. A more authoritative version, translated by A.F. Price and Wong Mou-Lam, was published by Shambhala in 1969.

a letter to British art historian Daniel Clarke, Martin wrote, "My greatest spiritual inspiration came from the Chinese spiritual teachers, especially Lao Tzu . . . My next strongest influence is the Sixth Patriarch Hui Neng . . . I have also read and been inspired by the sutras of the other Buddhist masters and Chuang Tzu who was very wise and amusing" (Clarke 1988, 231).

Like Huang Po, the earlier Tang dynasty Zen master, Hui-Neng spoke of the nondiscriminating wisdom of pure perception, an idea that reverberates throughout Martin's writings. "When your eyes are open you see beauty in everything," said Martin. "Blake's right about there is no difference between the one thing and everything" (Haskell 1992, 17). To attain this level of pure perception, one must first examine one's own mind. According to Martin, "When [at first] you look into your mind you find it covered with a lot of rubbishy thoughts" (Martin 1992, 154) and then "by bringing my thoughts to the surface of the mind I can watch them dissolve" (41). This methodology is very similar to Zen and Vipassana meditation, both of which aim to go beyond thoughts to discover a purer level of mind.

For Martin, this was the artist's path as well. "You have to penetrate these [rubbishy ideas] and hear what your mind is telling you to do. Such work is original work" (Martin 1992, 154). "The way of the artist is an entirely different way, it is a way of surrender. He must surrender to his own [deeper mind]" (154). She also said, "[My] main intention is the destruction and conquest of the ego, of self, and can only go back in constant battle with itself repeating itself" (41).

Martin learned that an important prerequisite for this deep level of listening and surrendering was solitude. For many years, she lived alone on a mesa near Cuba, New Mexico, where she built her own adobe buildings and lived without electricity,

running water, or telephone. The nearest house was six miles away. "I became as wise as a Chinese hermit," she said (Simon 1996, 89).

She elaborated on the virtues of solitude:

> To discover the conscious mind in a world where intellect is held to be valuable requires solitude, quite a lot of solitude. We have been very strenuously conditioned against solitude. To be alone is considered to be a grievous and dangerous condition. So I beg you to recall in detail any times when you were alone and discover your exact reponse at these times. I suggest to artists that you take every opportunity to being alone, that you give up having pets and unnecessary companions. You will find the fear that we have been taught is not one fear, but many different fears. When you discover what they are they will be overcome. Most people have never been alone enough to feel these fears. But even without the experience of them they dread them. I suggest that people who like to be alone, who walk alone will perhaps be serious workers in the art field. (Martin 1992, 117)

It is in isolation that the meditator or artist eventually faces her mental chatter and deepest fears. Only then is there any hope of arriving at pure mind. Martin's goal was to find an abstract vehicle to convey the ecstasy of pure perception or pure mind. The subject of her paintings could not be the objective world: "Not nature but the dissolution of nature" (Martin 1992, 43). She said her artistic paradigm was "two late Tang dishes, one with a flower image, one empty—the empty form goes all the way to heaven" (35).

Beginning in Martin's painting of the early 1960s, the empty form that goes all the way to heaven was a grid of thin,

imperfectly straight horizontal and vertical lines on a flat, pale monochromatic surface (fig. 36). In the major part of Martin's oeuvre, the tiny rectangles created by the intersecting lines are "non-hieratic and non-relational . . . holding every part of the surface in perfect equilibrium" (Haskell 1992, 142). Also, as Martin has argued, "in art as in reality, the plurality of a varied and similar forms annihilates the existence of forms as entities. Similar forms do not show contrast but are in equivalent opposition. Therefore they annihilate themselves more completely in their plurality" (Michelson 1967, 46). Moreover, the little rectangles also counterbalance the square format of the paintings, in effect erasing the overall grid. "My formats," Martin pointed out, "are square, but the grids never are absolutely square, they are rectangles a little bit off the square, making a sort of contradiction, a dissonance, though I didn't set out to do it that way. When I cover the square surface with rectangles, it lightens the weight of the square, destroys its power" (Alloway 1973, 62).

The effect of Martin's paintings is very similar to that of Tantric yantras, as she acknowledged in an interview (Simon 1996, 87). As described earlier, the Shri Yantra diagram, used as an aid to meditation, has a balance of four triangles going up and four triangles going down. The upward-pointing triangles represent male energy, and the downward-pointing triangles represent female energy. This creates an equilibrium that calms and focuses the mind so that the meditator can enter the Void, symbolized by the *bindu* point at the center of the intersecting triangles. Eventually, after prolonged looking, the rectangles in Martin's work, which are fragile to begin with—thinly drawn and slightly quivering[15]—dissolve, as do the triangles in the Shri Yantra

---

[15] As many critics have noted, Martin's lines are nonmarks rather than marks. They have linked these nonmarks to her attempts at egolessness.

Figure 36 | Agnes Martin: *The Rose*

during the process of meditation. Like the meditative experience of the Shri Yantra, "the experience of her work," in the words of art critic Roberta Smith, "is prolonged, slow and perceptual, a revelatory experience in time" (1975, 73).

Unlike the Shri Yantra, however, the repetition of squares or rectangles in Martin's paintings creates the feeling of an endless field,[16] opening and expanding the mind of the viewer in preparation for the experience of the Void. While this kind of expansion does not happen in the Shri Yantra diagram, it occurs in Chinese landscape painting and Zen gardens where an attempt is made to create the illusion of an infinite space. Also, unlike the Shri Yantra diagram, the space anterior to the grids in Martin's works is not empty but is carefully painted, giving her work a presence not found in the Shri Yantra. Of course, the Shri Yantra is primarily a diagram to assist the meditative process and is only secondarily a work of art.

Art critic Thomas McEvilley likens Martin's space to the Taoist notion of the uncarved block, the matrix of creation, described in the *Tao Te Ch'ing* by Lao Tzu. The grids, he writes, "show the ground hyperactivated for the appearance of the figure, the image, yet still empty, suspended at the moment of hyperactivity just before the forms appear, and before infinity is compromised" (McEvilley 1987, 96). Art historian Anna Chave

---

[16] Martin's seemingly endless fields are based on her experience of the plains of Saskatchewan, where she grew up, as well as the deserts of New Mexico. "I was coming out of the mountains," Martin recalled, "and...I came out on the plain, and I thought Ah! What a relief...I thought This for me! The expansiveness of it. I sort of surrendered. This plain, it was just like a straight line. It was a horizontal line...Then, I found that the more I drew the line, the happier I got. First, though, it was just like the sea...then, I thought it was like singing! Well, I just went to town on this horizontal line, but I didn't like it without any verticals" (Gruen 1976, 94). The open plains of New Mexico also had influence on Georgia O'Keeffe and Agnes Pelton. Their paintings occasionally have large areas of empty, or relatively empty, space. With the exception of one or two paintings, however, I do not consider O'Keeffe and Pelton to be artists of the Void.

suggests that Martin's voids recall the void of the womb (Haskell 1992, 98). Chave quotes Martin, "Try to remember before you were born, as it was in the beginning there was no division and no separation" (99).

For me, Martin's pale spatial fields are an approximation of the etheric or chi body in Taoism, which connects to the uncarved block, the ultimate matrix Void in Taoism, but is not this matrix. In Taoism the chi body is a condensation of this ultimate matrix, more like a "breath" or a "vapour," than the clear formless Taoist Void of Ni Tsan. In fact, the art critic Hilton Kramer aptly characterizes Martin's fields as a "vapor," where "color is almost drained of color" (Kramer 1976, 23). I am not saying that Martin was consciously aware of the chi body, but that her paintings present a kind of intermediary void that connects with the Void, rather than primordial matrix itself. In Martin's own words, she was attempting to find "an empty form [that] goes all the way to heaven." By clearing away the rubbish in her mind, it is entirely possible that Agnes Martin made contact with both the chi body and the Void/Tao. I am reminded that her "greatest spiritual inspiration came from the Chinese spiritual teachers, especially Lao Tzu" (Clarke 1988, 231).

## Sam Francis

Sam Francis (1923–94) was also influenced by Taoism but he initially approached the Void with some trepidation. The empty white spaces of his early paintings are a place where "beauty and terror are coupled forever," Francis said (Hulten 1993, 54). Francis's *Moby Dick* (fig. 37) was in part inspired by Ishmael's lines in Herman Melville's *Moby Dick:* "It was the whiteness of the whale that above all things appalled me, so mystical and so well nigh ineffable was it, that I almost despaired in putting it in a comprehensible form" (Melville 1963, 234). Ishmael goes on

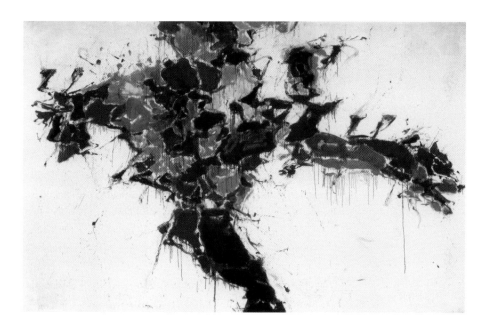

Figure 37 | Sam Francis: *Moby Dick*

to say that the fear of white may be the result of its "shadow[ing forth] the heartless voids and immensities of the universe" (234).

Melville's novel was only one influence on the work. Francis painted *Moby Dick* after an extended stay in Tokyo, and the work has a strong relationship to the flung-ink paintings of Japanese Zen painters. Francis's drippy asymmetrical splashes of paint charge the Void in a way that is similar to works of Zen painters. It is not surprising that Francis was admired in Japan well before he gained acceptance in the United States.

The Void becomes even more prominent in Francis's oeuvre following *Moby Dick*. In the Blue Balls series, begun in 1960 (fig. 38) while Francis was suffering from a serious kidney disease, blue biomorphs expand from a white center to the periphery of the paintings. The semitransparent blue shapes seem to dissolve and twist in on themselves. Art historian Peter Selz considers this series to be a kind of protoplasmic hallucination related to Francis's illness (Selz 1982, 74). For me, however, the works in the series are related to the practice of Taoist tai chi and qigong. In these practices, the adept dissolves into a void at the *dandien,* a point two inches below the navel, and then expands the energy encountered in this central point centripetally through the arms and legs in twisting and spiraling movements out into the cosmos.

In reference to some of his paintings of the early 1960s, Francis has remarked, "I used to think and talk about my center, my navel, and was very conscious of my center. I had never heard of *Tai chi*, which became very important to me later on, at that time, but these paintings actually deal with the energy source at the center" (Selz 1982, 34). Francis's paintings of the late 1960s embody this statement even more.

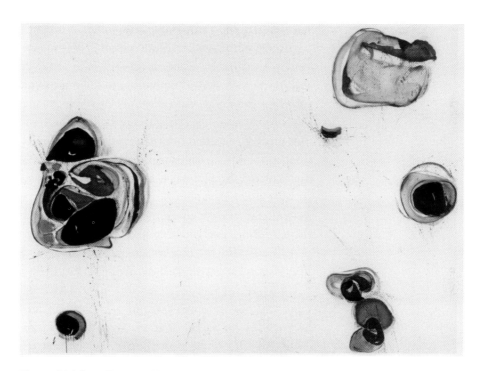

Figure 38 | Sam Francis: *Blue Balls I* from the Blue Balls series

In these later works, particularly the Sail series of 1965–68 (fig. 39), the central white space fills most of a canvas framed by thin margins of paint at the edges. The painting has become a window that leads the viewer into infinite space, notwithstanding the relatively small size of the canvases and that the white spaces can also be compared to white sails.

In the Mandala series of the early 1970s—squares with wide borders that enclose empty space—the size of the central open space is even smaller in comparison to the thick borders, but the paintings still bring the viewer, albeit more gradually than in the Sail paintings, into the infinite Void at the center (fig. 40). This gradual transition from the everyday world into the Void is what one would expect from a mandala. I think that the luscious multicolored drippings that make up the thick surface become an appropriate metaphor for the world of samsara, which is jettisoned as the viewer enters the Void. "The space at the center of these paintings [Sails and Mandalas] is reserved for you," Francis said (Selz 1982, 131). But, he admonished, "don't waste your time in this space, notice yourself dissolving" (Hulten 1993, 52).

The pure white interior areas of Francis's paintings are quite flat, just a thin covering of gesso on the canvas, because he intended "to get rid of as much matter as possible" (Hulten 1993, 55). This elimination of matter furthers the sense of melting into the Void and creates a transcendental experience, where, in Francis's words, the "mind is [left] on the outside" (Hulten 1993, 53).

## Mark Tobey

Mark Tobey (1890–1976) was another West Coast artist who attempted to represent the Void, although in a much different way than Francis. The light-filled quality of the Void is different in their respective paintings—Francis's bright light reflects a

Figure 39 | Sam Francis: *Untitled* from the Sail series

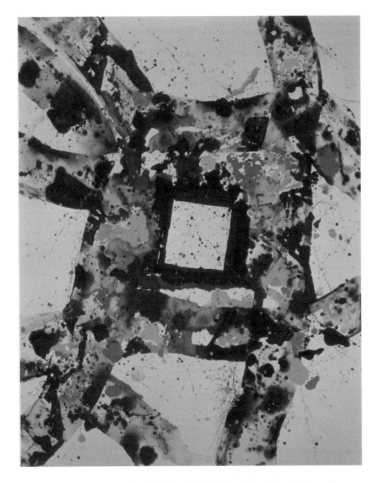

Figure 40 | San Francis: *Facing Within* from the Mandala series

Southern Californian locale, while Tobey's darker light refers to the atmosphere of Seattle. Also, Tobey's Void, in contrast to Francis's, is a continuum of minuscule curvy lines.

The Void was an ongoing theme in Tobey's painting for ten years, beginning with *Edge of August* in 1953 (fig. 41), continuing in two groups from 1954, the Voids and Meditative series, and culminating in *Sagittarius Red* of 1963. In each work there is a continuum of interpenetrating infrastructures composed of tiny marks that are cut off by the frame or fade off into empty space. The marks vibrate with energy both individually and collectively in the continuum. The viewer does not think of either Tobey's or Francis's works as having mass or even form. Also, in a Tobey painting, there is no illusionistic space or single point of view. He referred to these aspects of his work as "multiple space" and "moving focus" (Seitz 1962, 27). He said, "Multiple space bounded by involved white lines symbolizes higher states of consciousness" (22). I think Tobey is saying that when an overall configuration of vibrating lines replaces a single point of view and illusionistic space, the result is reflective of the nonfocused attention of meditative states instead of the rational mind.

The basis of Tobey's lines or marks, called white writing by commentators, is Chinese calligraphy, introduced to him by his student Teng Kwei in Seattle in 1923. Tobey practiced calligraphy with increasing proficiency for a number of years. He asserted that his methodology was "writing a picture instead of building it up in the Renaissance tradition" (Kuh 1962, 236).

Tobey also practiced Chinese painting, which is derived from calligraphy. "I have just had my first lesson in Chinese brush from my friend and artist Teng Kwei. The tree is no more a solid in the earth, breaking into lesser solids bathed in chiaroscuro. There is pressure and release. Each movement, like tracks in the snow, is recorded and often for itself. The Great Dragon is

Figure 41 | Mark Tobey: *Edge of August*

breathing sky, thunder and shadow; wisdom and spirit vitalized" (Tobey 1951, 230).

As I have previously noted, the Chinese brushstroke and calligraphic line, if produced correctly with the particular rhythmic breathing derived from Taoist meditation practices, contains chi (energy). Tobey's marks, which he preferred to call "living lines" or "moving lines," are not linguistic or pictorial signifiers like Chinese calligraphy but they have chi. "The Old Chinese used to say," Tobey once remarked, "it is better to feel a painting than to see it" (Roberts 1959, 41).

Tobey, like Taoist inspired calligraphers, was aware that his moving lines related to breathing. "We artists must learn to breath more," he wrote (Tobey 1951, 230). As he later argued to William Seitz, a motionless painting even if well executed has no "breath in it; it doesn't breathe" (Seitz 1962, 31). In both traditional Taoist paintings and Tobey's work, the artist's breath and the pulsation or breathing of the universe is connected through the brushstroke.

In Tobey's work, the relationship between macrocosmic and microcosmic levels can also be seen in the small scale and tiny lines that suggest the infinitesimal, and the repetition and proliferation of elements that suggest an infinite continuum of energy. Tobey tuned to the microcosmic level during his sojourn in Japan in 1933. In a letter to Katherine Kuh, he wrote, "While sitting on the floor of a room in Japan and looking out on a small garden with flowers blooming and dragon flies hovering in space, I sensed that this small world, almost underfoot, shall I say, had a validity all its own, but must be realized and appreciated from its own level in space. I suddenly felt I had too long been exclusively above my boots" (Kuh 1962, 243).

In his diary he wrote, "Japanese vision takes into account such small forms of life—gives them the dignity of a kakemona

[shrine] . . . it is this awareness to nature and everything she manifests which seems to characterize the Japanese spirit. An awareness of the smallest detail of her vastness as though the whole were contained therein, and that from a leaf, an insect, a universe appeared" (Rathbone 1984, 25). This is the Zen experience of "everyday suchness," which is usually realized through meditation, as I describe earlier. Tobey actually practiced formal meditation during a a stay in a Zen monastery in Kyoto in 1933. In addition to engaging in *zazen* practice, he was given a *sumi-e* painting of what he called a "free brush circle" (Tobey 1958, 24), namely an *enso*. Tobey reached the conclusion that the success of this *enso* in expressing the Void demanded "getting out of the way" (Tobey 1951, 24).

In the same article about these experiences in Japan, he goes on to say, "We hear some artists speak today of the act of painting . . . But a state of mind is the first preparation and from this the action proceeds. Peace of mind is another ideal, perhaps the ideal state to be sought for in the painting and certainly preparatory to the act" (1951, 24). I think this statement is an implicit critique of "action painting" as practiced by the New York School of Abstract Expressionism. Tobey clarified his critique of action painting to art critic Katherine Kuh, "I believe that painting should come through the avenues of meditation rather than the canals of action" (Kuh 1962, 236).

Accordng to Tobey, the inner meditative space of the artist is necessary if he is to convey vast outer space. "The dimension that counts for the creative person is the space he creates within himself," he said. "The inner space is much closer to the infinite than the other, and it is the privilege of a balanced mind—and the search for an equilibrium is essential—to be aware of inner space as he is outer space" (Schmied 1964, 11). Indeed, in the Hindu, Buddhist, and Taoist yoga traditions, the boundaries

between inner and outer space dissolve in meditation practice. In his paintings, Tobey gets very close to the meditative experience where inner and outer infinite space are conflated.

## Robert Irwin, James Turrell, and Douglas Wheeler

For a group of Southern California sculptors, including Robert Irwin, James Turrell, Douglas Wheeler, Maria Nordman, Hap Tivey, and Eric Orr, merely representing space was not enough. To express the full presence and power of space, they felt the need to go beyond illusionistic or abstract notation on the canvas. The artist, they felt, must present space directly.

I will concentrate here on a few installations by Robert Irwin, James Turrell, and Douglas Wheeler that exemplify their interest in the Void. The Void is only one of several subjects in their work, and better examples may be found in their careers as well as in the work of other light and space artists. I have chosen only those installations that I have seen personally because these works cannot be adequately comprehended from reproductions; they demand the actual presence of the viewer.

From 1962 to 1964 Robert Irwin (born 1928) isolated himself in his Los Angeles studio, painting, in his own words, "a total of twenty lines over two years of very, very intense activity. I mean I essentially spent twelve and fifteen hours a day in the studio, seven days a week" (Weschler 1982, 70). He further told his biographer, Lawrence Weschler, "I started spending the time just sitting there looking. I would look for half an hour, sleep for half an hour, look for half an hour. It was a pretty hilarious sort of activity" (73). Irwin later recognized this process of looking as being similar to Zen meditation in that he had to transcend his own boredom and restlessness as well as his mental and emotional projections to make progress. Eventually Irwin moved

from looking at a line to seeing the line on canvas. He also saw the energy lines of the room and then saw them dissolve into the Void.[17]

The disks of 1967–69 are an early series of installations by Irwin that involve seeing and the Void. *Untitled* (fig. 42), one of these disks, is a white-painted Plexiglas circle measuring fifty-three inches in diameter. The depth decreases from two and one-half inches at the center to one-sixteenth of an inch at the edges. The disk is suspended by a hidden armature extending twenty inches from the wall and is lit by four lamps of equal intensity that create a horizontal shadow about ten feet wide at the center of the disk. My experience of an Irwin disk echoes art critic Melinda Wortz's description of her experience: "After some time of looking at these objects in their controlled installations, they seemed to dissolve into the empty space surrounding them. Consequently it became virtually impossible to distinguish figure from ground. The discs enabled me to perceive the interchangeability of substance and void, which is the goal of meditative practice" (Wortz 1981, 63).

The energy-filled empty white space that emerges as the disk dissolves is a better simulacrum of *samadhi* than can be found in painting. The advantage of the disks over a Reinhardt or a Rothko painting, for example, is that Irwin has created a device that tends to eliminate itself as an art object while still giving the viewer an aesthetic experience of the Void. As Wechsler has pointed out, "Otherwise pedestrian critics were driven to flights of poetry [to describe Irwin's Disks]. Words like 'pearlescent,' 'crepuscular,' 'mandarin,' 'lunar,' 'Venusian' wafted from their pens, phrases like 'etherealness and interior equivocation'" (Weschler 1982,

---

[17] See my book, *Technicians of Ecstasy*, for an extended discussion of Irwin and the process of seeing.

Figure 42 | Robert Irwin: *Untitled*

106). These are words that such critics would not have ordinarily used in discussions of painting and they are symptomatic of the new order of experience that Irwin engendered in this installation even among observers with no meditative practice or knowledge. "After the Disks," Irwin recalls, "there was no reason for me to go on being a painter" (Weschler 1982, 107).

Nor did he need objects such as the disks to facilitate contact with the Void. Indeed, an ongoing theme in his later work is the creation of numinous empty spaces through the use of scrim, a thin, translucent, white nylon, cotton, or silk mesh usually found in drapery and upholstery linings and in theater screens. The last time I saw one of Irwin's scrim installations was at the *Singular Forms* exhibition at the Guggenheim Museum in New York in 2004, which focused on minimal and postmiminal art. The exhibition curators had adjusted *Varese Scrim* (1973), an installation in the Panza collection, for a wall measuring 150⅜ inches by 563 inches in an empty room at the Guggenheim. The nylon scrim of the same dimensions extended parallel to the wall at a distance of 76 inches.

*Varese Scrim* is viturally objectless. I did not notice anything upon entering the room, but gradually, as I approached the scrim, I saw that it transformed the space between the wall and the scrim into a light field of the utmost delicacy and subtlety. This field beame an aesthetic entity that I wanted to contemplate for hours. It had distinct associations with the Void that I experience in meditation. *Varese Scrim* had a noticeably calming effect on my nervous system, similar to meditation. From Irwin's point of view, the scrim pieces are a "zeroland" (Ferguson 1993, 169) intended to make the viewer hover as long as possible in the gap between perception and conception. This is the point where sensations or objects are not identified as such.

The title of Lawrence Weschler's monograph on Robert Irwin succinctly sums up the artist's intentions: *Seeing is Forgetting the Name of the Thing One Sees.* This is a state of heightened awareness that is practiced in Vipassana and Zen meditation. Irwin's intentions are mainly aesthetic, however. "Basically," Irwin says, "it's [the work is] just to make you a little more aware than you were the day before how beautiful the world is [before you begin naming sensations or things]" (Ferguson 1993, 173).

Like Irwin, James Turrell (born 1943) uses the principal media of space and light. "Light," he said, "is often seen as the bearer of revelation rather than the substance of the revelation. It is something that illuminates other things. For example we speak of hanging a show and then lighting it, revealing the persistence of the way we actually think about light. But light may just as well be the content of the substance" (Wortz 1980, 9).

Although Turrell was inspired by the painting of Turner and Rothko, to which he was exposed in an undergraduate art history class, he felt their attempts at communicating the sublime through light and space were limited by the material nature of paint and canvas. Turrell came to the realization that nonmaterial subjects, especially those with spiritual connotations, should be transmitted through nonmaterial means. Having gone to college in the 1960s (graduating from Pomona College, California, in 1965 with a B.A. in psychology)—an era when commodity fetishism came under attack—Turrell wanted to create works that could not be bought and sold in the marketplace. His distaste for consumerism resonated with his Quaker background, which predisposed him to separate the spiritual from the material.

In the late 1960s, Turrell began to experiment by projecting an intense light on a corner of a room so that from a certain distance it took the form of a three-dimensional rectangle. As

a viewer approached this seemingly solid form hovering in the corner, it started to disappear and ultimately became a two-dimensional form on the wall. When the viewer pulled back, the two-dimensional form became solid again. The goal of the works in the Projection Series is to make viewers aware of their illusion-making capacity, which transforms nothing into apparently solid objects. This occurs when the solid rectangle collapses into a two-dimensional shape and when it is perceived as just a rectangle of empty light. To my mind, Turrell's *Afrum* (1967), one example of the Projection Series, which I saw at the Whitney Museum of American Art in 1980, is a superb example of the Buddhist phrase from the Heart Sutra, "form is emptiness, emptiness is form." I think the following diagram rather than a reproduction of the piece itself conveys this simultaneity of form and emptiness as well as the way we make something out of nothing.

Turrell is aware that the task of making us aware of our illusions is related to the Bodhisattva ideal in Buddhism. "The idea of the Bodhisattva, one who comes back and entices others on the journey, is to some degree the task of the artist. It is a different role from that of one [the Buddha] who is there when you get there. The Bodhisattva entices you to enter that passage, to take the journey. This is where I began to appreciate an art that could be a non-vicarious act, a seeing whose subject was your seeing" (Turrell 1993, 18). Similarly, he says, "My work is about your seeing rather than you investigating in my seeing" (Svestka 1992, 61). He explains this further: "You are looking at your looking [in his pieces]. This is in response to your seeing and the self-reflexive act of seeing yourself see" (Turrell 1993, 26).

To make us aware of our illusion-making capacity by means of words is to make nothingness into a concept once again. This is another meaning of "emptiness is form." Turrell attempts to avoid this conceptualization in his Projection Series by going beyond words. Turrell argued, "What takes place in viewing a space is wordless thought. It's not as though it's unthinking and without intelligence; it's that it has a different return than words" (Brown 1985, 46).

The most impressive Turrell installations with the Void as the principal subject are the series based on Ganzfields. In these works the observer is surrounded by a homogeneous field of light. Ganzfields were originally created by a perceptual psychologist to simulate flying conditions in fog. Turrell became aware of Ganzfields during his participation in the Experiments in Art and Technology (EAT program) instigated by Maurice Tuchman of the Los Angeles County Museum of Art in 1968. The project involved collaboration with Robert Irwin and Dr. Ed Wortz, a psychologist and chief of the environmental control systems laboratory for the NASA manned space-flight program.

Wortz, Turrell, and Irwin thought it would be a great idea to combine an anechoic chamber that induces maximum deprivation with a Ganzfield for an ultimate experience of the Void. The piece was never realized as they could not reconcile the differing technical requirements. Wortz, who began the collaboration as an open-minded but hard-nosed scientist, gave up his position at NASA to be a counselor at the Buddhist meditation center in Los Angeles. I am not surprised, because being in a Ganzfield is a good approximation of the experience of the Void in *samadhi* states, and Wortz probably wanted to take the next step into the Void by becoming involved in meditation.

In *City of Arhirit* (1967), the Ganzfield at Turrell's Whitney Museum show, a field of blue-filtered ambient sunlight came right up to the viewer's eyes. It was a very disorienting experience because experiencing the Ganzfield was like being in a very dense fog. For me, *Arhirit* was blissful and beautiful, an altogether enrapturing experience of incandescent light energy. It recalled periods in meditation when I had come into contact with a field of undifferentiated blue light, which, like the light in *Arhirit,* appeared to vibrate with a kind of electrical energy.

As Swami Muktananda states in his book on kundalini meditation, he believes that this blue light field is where the individual'a own *shakti,* or energy, begins to meet the Brahman, the Void. He says that a blue pearl appears in the chakra at the top of the head of the meditator in deep *samadhi* and then expands into a blue Void (Muktananda 1980, 35).

Douglas Wheeler (born 1939) creates light squares, which he calls "encasements," that also illicit a sense of the blue Void. Made of white plastic sprayed with a special lacquer finish, these boxes enclose invisible argon-filled glass tubing. *Untitled* (Light Encasement) of 1968, which I saw in the *Beyond Geometry* exhibition at the Los Angeles Country Museum of Art in September

of 2004 measured sixty-eight by sixty-eight inches and projected about two and a half inches from the wall. Wheeler's encasements are designed to be seen in a small room with white walls, the environment at the Los Angeles County Museum. The encasement suffused the entire room a with pale whitish glow that gradually produced bluish overtones as the boundaries of the square encasement begin to disappear. An anonymous English critic from *Punch* said about a similar work of Wheeler's at the Tate Gallery that he had created a "neon temple" where the viewer has "an experience not only of a limitless void but the limbolike presence of it." (Butterfield 1993, 123). This statement reifies my own experience of Wheeler's installation at the Los Angeles County Museum.

In deep kundalini meditation, every cell of the body becomes fully alive with energy, then dissolves into the Void. This sensation, which is largely indescribable, goes beyond what is established by an encasement, scrim piece, or Ganzfield. However disembodied the works of Irwin, Turrell, and Wheeler are, they are still things to look at. The viewer is separate from the Void field, not one with it as in deep *samadhi,* where there is no boundary between subject and object.[18] To be aware of the Void as an aesthetic object while you are dissolved into it in meditation is to violate the principle of the voidness of the Void, one of the sixteen types of void elaborated in Tibetan Buddhism.

I think that art critic Robert Hughes inadvertently summed up the strengths and limitations of all three artists' works when he commented about Turrell: "Turrell has contrived an exquisite

---

[18] Hap Tivey, who has intensively practiced *zazen* for many years, and Eric Orr, who has been deeply involved in the study of Tantra, have also produced rooms that give the viewer an experience of the Void. Since I have seen these rooms only in reproduction and read descriptions of them, I cannot say that their installations go further than those of Irwin, Turrell, and Wheeler. From what I can surmise about Tivey's and Orr's work, the viewer seems to look at the Void rather than becomes the Void.

poetry out of sheer emptiness" (Hughes 1981, 81). Of course, this is what is expected from Turrell, Irwin, and Wheeler. Their works of art have enormous value in making the viewer aware of the poetry and power of the Void, but the advanced meditator eschews an awareness of this poetry in favor of pure awareness itself. Let me try and explain this: When I am deeply in the Void in meditation and I say, "wow, this is a great experience," or "how beautiful is this Void," I am making a mental concept out of the experience and no longer meditating on the level that I had attained prior to making a formulation.

## Anish Kapoor

In his sculptural objects, Anish Kapoor (born 1954) also creates a poetry out of sheer emptiness. His stone and fiberglass sculptures enclose empty spaces that resonate with the power of the Void. "My work," Kapoor said, "has to do with coming to immateriality. Apparently the concept of zero is an Indian invention, the word for it is Ka. Ka also implies void, vast emptiness. As is natural in such situations, it is paradoxical, in that it contains everything" (Lewallen 1991, 25).

The Hindu goddess Kali, whose name is derived from the root word *Ka,* is the Great Mother and the Great Devourer. She is the primal Void from which everything comes and returns, and she is present in everything. To her devotees, she appears in the anthropomorphic form of a goddess. I believe Kapoor's *Adam* (fig. 43), a monolithic sandstone block enclosing a rectangular opening filled with powdered black pigment, is his homage to Kali, although he has given this sculpture a Western title. Kapoor is well aware of Hindu mythology, yet in both the titles of his work and the statements about his art, he tends not to focus on his Indian ancestry or Indian metaphysics. Perhaps, he wants to ensure that his sculptures have a universal appeal.

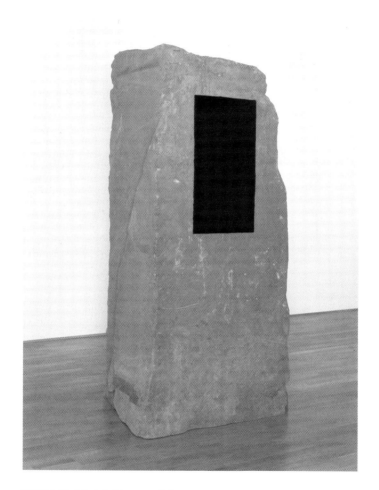

Figure 43 | Anish Kapoor: *Adam*

Kapoor's *Adam* relates to Kali in several ways. I have already discussed the connection of the Void with the late nineteenth-century bronze sculpture of Kali from Rajasthan—mainly a rectangular frame that encloses an empty space (fig. 3). Bronze arms extend from the sides of the frame as the Void goddess embraces her devotees into her emptiness. While Kapoor's abstract sculpture lacks these figurative elements, the basic idea is the same. The empty space of the sculpture is associated with Kali.

The powdered black pigment in the central opening of *Adam* also relates to Kali. Kapoor elaborates on the importance of the color black to his work: "I seem to be moving from light to darkness. I think I know why that is. One of the things that has also had a very strong pull for me has been what I call a matriarchal view of creativity of energy. It seems to me that this is toward darkness, to the womb on some level. But this is too descriptive. It is one of the features of the way. Darkness is formless" (Lewallen 1991, 16).

Black is the color of Kali. This incandescent blackness is associated with her spiritual power, as reflected in the words of Rampasad Sen, an eighteenth-century devotee of Kali.

> Why is Mother Kali so radiantly black?
> Because she is so powerful,
> even mentioning her name destroys delusion, . . .
> There are subtle hues of blackness,
> but her bright complexion
> is the mystery that is utterly black,
> overwhelmingly black, wonderfully black,
> when she awakens in the Lotus shrine
> within the heart's secret cave,

her blackness becomes the mystic illumination
that causes the twelve-petal blossom there
to glow more intensely than golden embers.

Her lovely form is the incomparable Kali-black,
blacker than the King of Death,
Whoever gazes upon this radiant blackness
falls eternally in love
and feels no attraction to any other,
discovering everywhere only her.

This poet sighs deeply:
where is this brilliant Lady,
this Black light beyond luminosity . . .

the mind becomes absorbed completely
in her astonishing reality
Om Kali! Om Kali! Om!
(Hixon 1994, 123)

In my experience and that of some of my students in the deepest stages of *samadhi,* where there is just a trace of consciousness remaining, one encounters an incredibly luminous black Void, an astonishing black reality. The black Void of Rampasad's poems reflects a deeper state of meditation than does the blue Void of Swami Muktananda. Ad Reinhardt calls this black Void "the last vestige of brightness" and attempts to incorporate it in his black paintings, while Kapoor approximates this radiant black by using powdered pigments in his sculptural work. He discovered these pigments in India where they are employed in Hindu rituals for their brilliant, otherworldly light. In *Adam* the black

pigment, filling up a portion of the central space of the sculpture, both energizes this space and creates an illusion of great depth, which is highly conducive to the expression of the black Void.

When the expanse of space is enlarged, as in *Mother as Void* (1989–90) and *Madonna* (1989–90)—large bowl-shaped sculptures combining Plexiglas and powdered pigment—the illusion of an infinite space is magnified and the object quality of the sculptures begins to disappear. As Kapoor said, "They are an attempt to make an object which is not an object, to make a hole in the space, make something which actually does not exist" (Lewallen 1991, 16).

Even in *Void Field* (fig. 44), an installation of heavy square monoliths, the mass of the sandstone blocks is negated by a small black hole of powdered pigment on each block. "*Void Field,*" Kapoor said, "is a work about mass, weight, about volume and at the same time seems to be weightless, volumeless, ephemeral; it is really turning stone into sky" (Lewallen 1991, 21).

For me, *Void Field* is also related to the idea that form is ultimately immaterial. This idea is expressed in Turrell's Projection Series, but in Kapoor's *Void Field* material substance is given a greater emphasis. His work takes viewers from solid to void, but it is much more difficult to go from Void to solid; the Void is not identical to form, as it is in Turrell's *Afrum*. As Kapoor said, "And it seemed that once I'd made *Void Field,* this earth into sky object, it occurred to me that it would be wonderful to attempt the opposite" (Lewallen 1991, 21). In other words, he would attempt to use the Void as a starting point for a sculptural object. But Kapoor has not done so yet.

Fear of the Void is another subject of Kapoor's work. For Documenta IX (1992) in Kassel, Germany, he built *Descent into Limbo,* a concrete box six meters (about nineteen and a half feet) by six meters (ten and a half feet) that contained at the center a

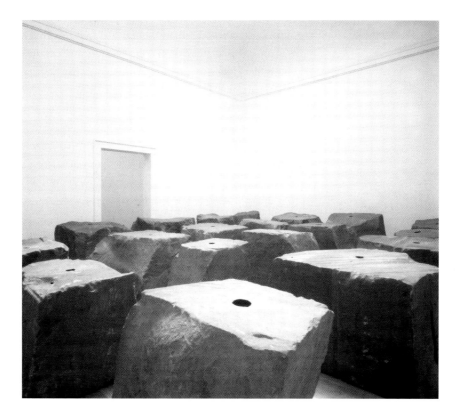

Figure 44 | Anish Kapoor: *Void Field*

three-meter (nearly ten-foot) circular opening of blue pigment. Focusing at this center from the outer interior perimeter of the box, viewers saw a flat blue surface on the floor, but as they approached the central circle, they felt as if they were standing at the edge of an abyss of endless depth. "The void has many presences," Kapoor said. "Its presence as fear is towards the loss of self from a non-object to a non-self. The idea of being somehow consumed by the object or the non-object, in the body, in the cave, in the womb. I have always been drawn to a notion of fear, towards a sensation of vertigo, of falling, of being pulled inwards. This is a notion of the sublime which reverses the picture of union with light. This is an inversion, a sort of turning inside out. This is a vision of darkness" (Celant 1996, 34). The Void can be a source of exhaltation, but it can also be a source of terror as the sense of the self slips away. This dual nature of the Void is often encountered even by the most seasoned meditator.

## Montien Boonma

The Void has many presences for Montien Boonma (1953–2000). His installations are informed by a search for the Void as a source of solace after encountering the horrible void of his wife's death from breast cancer and his own death from a brain tumor in 2000 at the age of forty-seven. I hesitate to call Boonma a Thai artist because his formal vocabulary reflects contemporary Western art, particularly the sculpture and installations that he saw on his many trips outside Thailand. Indeed, his work has little relation to traditional Thai art, although he was a devout Thai Buddhist. It is not surprising, then, that most of Boonma's work is in Western museums and collections. According to Apinan Poshyananda, author of the principal monograph on Boonma, "Corporate and private collectors [in Thailand] often complained that his Buddhist concepts were too somber or too

difficult to grasp, or that his art material were too ephemeral" (2003, 38).

An early work that embraced the Void was *Drawing of the Mind Training and the Bowls of the Mind,* an installation of actual alms bowls, bowls manufactured by Boonma, and drawings created during a residency in Worspede, Germany, in 1992 and now one of the few installations by the artist in a private collection in Thailand. The installation was partly the result of a self-conscious meditative exercise during which he drew images, from 3 a.m. to 6 a.m. every day, of the alms bowls used by Buddhist monks. For Boonma, the drawing of these bowls helped overcome the emotonal pain of being separated from his wife, Chanchan, who was suffering from breast cancer. Boonma has related:

> When I realized this work, every morning before I started to work, I read the teaching of Luang poh chag, Suphatto, the master monk of Wat Nong, paa Phong in Ubon Ratchathanee [a well-known Buddhist teacher in Thailand]. He writes about the practice of a calmed mind…I wanted to stay alone and I felt good when I thought about the shape of a monk's bowl. The idea of making a monk's bowl came to me when I asked myself what I wanted . . . I am completely fascinated by the shape of the monk's bowl. For me it is organic and geometric and ambiguous. The bottom of the bowl is curved, so that it can stand by itself without support from anything underneath. Monks always hold the bowl with their arms. When I think about the space in the bowl, I prefer to be inside the space which is separated from the outside world. I would like to place my mind inside the bowl. (Poshyananda 2003, 78–79)

In *Drawing of the Mind Training and Bowls of the Mind* (fig. 45), a row of variously colored and shaped alms bowls with sealed tops are delicately positioned in various angles on a wooden platform below a display of forty-two drawings of alms bowls that are loosely affixed to the wall. The drawings also depict alms bowls in different colors and from different angles. In the drawings, some of the bowls also appear to be sealed. Both the precariously placed sculptures of alms bowls and the fluttering drawings are intended to remind the viewer of the Buddhist idea of impermanence. The sealed bowls represent the sanctuary of a closed empty space, a Void, for mental and emotional rest.

Boonma's search for a mental and emotional sanctuary is also evident in *Lotus Sound* (fig. 46). Here the artist built a concave wall of small, blue terra-cotta, bell-shaped sculptures. Each sculpture is delicately placed to allow spaces between the bells, thus establishing a pattern of closed and empty spaces. The bells were inspired by the temple bells of Doi Suttep in Chaing Mai, Thailand, whose soothing sounds gave Boonma solace during his wife's illness.

The lattice of closed and open spaces in *Lotus Sound* was probably influenced by the perforated bell-shaped stupas that partly conceal the seventy-two sculptures of the Adi Buddhas at the Stupa of Borobadur, a Buddhist monument in Java, Indonesia. The Adi Buddhas symbolize the Dharmakaya, or Void body, of the Buddha, which is normally hidden from perception but can be apprehended in meditation. The observer of *Lotus Sound* glimpses the empty space and blank gallery wall beyond the concave wall of the bells. The lattice of open and closed spaces is made of very carefully stacked bells, while the lattice work of the Borobadur Stupa is constructed from stone. The fragile balance of Boonma's assemblage of bells (a later work collapsed at the pop of opening a soft-drink can) is a direct reference to the difficulty

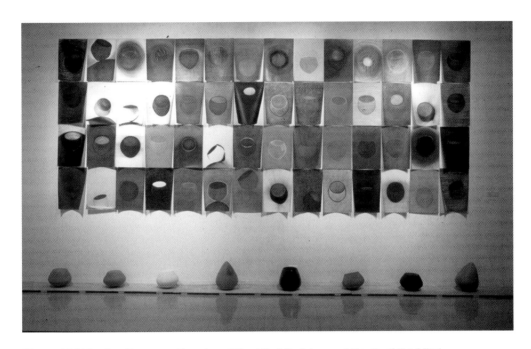

Figure 45 | Montien Boonma: *Drawing of the Mind Training and Bowls of the Mind*

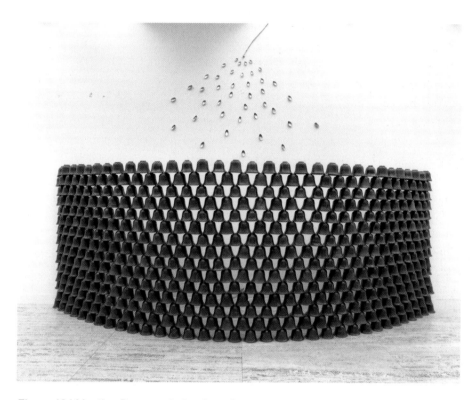

Figure 46 | Montien Boonma: *Lotus Sound*

of maintaining pointed concentration during meditation. The great Japanese Zen Master Ikkyu likened this unwavering attention to "stand[ing] tiptoe on the tip of a needle" (Ikkyu 1989, 74). I think Boonma's *Lotus Sound* is also an excellent metaphor for the mental equilibrium required in meditation.

An additional element in the *Lotus Sound* installation is a relief of gold-colored terracotta drops mounted over the wall. These drops allude to the lotus, the signifier of spiritual unfolding in Buddhism. This lotus may also symbolize the ultimate spiritual realization of the Dharmakaya body.

In *Melting Voids: Molds for the Mind* (1999), one of Boonma's last sculptures, the observer is also meant to experience a simulacrum of the Void body of the Buddha, as well as the physical body. Boonma, fascinated by the lost wax method of bronze casting, created plaster molds of Buddha images affixed with bronze casting tools, such as pliers, tongs, bent casting pipes, and chisels. The rough exterior of these molds is intended to reflect the difficulties of samsara. The viewer is invited to stick his or her head into the open mold, literally taking refuge in the empty space enclosed by the plaster—a metaphor for the Void body of the Buddha.

It is not surprising that one of the Western influences on Boonma was Arte Povera (literally "poor art"), a movement of mostly Italian artists in the 1960s and 1970s who employed natural and/or rough-hewn materials as a protest against the slick commodity fetishism of contemporary society. Although Boonma did not usually borrow specific motifs from the contemporary artists whom he admired, the philosophy of Arte Povera echoed contemporary Thai Buddhist commentaries on the corrupting influence of consumerism on Thai society. These commentaries came from monks who were disgruntled with the support of the traditional Buddhist hierarchy for the starus quo in

Thai society. Boonma actively sympathized with this "Buddhism with a small b" as this anti-official, anti-establishment Buddhism is called in Thailand. It is no accident that a long speech by one of these monks, Sulak Sivaraksa, is quoted in the monograph on Boonma's work. A passage from his speech reads: "If Buddhists understand structural violence and its roots in hatred *(dosa),* and learn to eliminate it mindfully and non-violently, Buddhism will be a source for social liberation in the modern world. Similarly, consumerism is linked directly or indirectly to greed *(lobha)* and lust *(raga)* of which are clearly revealed in advertisements and the mass media. . . ." (Poshyananda 2003, 131).

I think Montien Booma's works are also a source for "liberation," not only from consumerism—they are mostly installations that cannot be easily bought and sold—but also from conventional ways of thinking about sacred art.

# AFTERWORD | The Importance of the Void in Art

The presentation of the Void in Eastern and Western art is a reaffirmation of the significance of ultimate reality for those who are intellectually aware of the philosophical meanings of the Void as well as for both beginning and advanced meditators. The Void in art can remind us that our investment in the permanence and solidity of the objects and thoughts in the world has only as much weight as we choose to give these things of the world as they are not the ultimate reality. Indeed, it is this "overloading of objects," as the Buddhists call it, that is the primary cause of our suffering. Shifting to the reality of the Void is a way in which the illusory weight of the world can be reduced. For all but the most enlightened practitioners who are constantly in a meditative state—and I have not yet met one—advanced meditators, including myself, have periods when we are lost in our minds, and works of art that embrace the Void are valuable ways to wake us up to this other reality. Moreover, in a home, temple, or monastery, they create, along with traditional paintings of deities, an energy field that deepens spiritual work.

For those encountering the Void for the first time by means of either Western or Eastern art, the experience of the Void can be an exhilarating event that may encourage a mental and emotional shift to realities other than those supported by traditional Western culture. In my life, reading books and looking at the Void in Western and Eastern works of art provided an important

momentum to take up traditional Eastern methods of spiritual practice that I found to be more advanced and more accessible than Western techniques. I would have had to learn Hebrew, for example, to gain access to Kabbalah, the core spiritual practices of my ancestors.

Even if the encounter with the Void in works of art remains an aesthetic experience that is not carried beyond the walls of the gallery, museum, or temple, I would argue that a different order of aesthetic experience is created when one is in contact with these works compared with others. For example, in a work where there is "nothing," or not much to see, like a Mu Ch'i, Ni Tsan, Ad Reinhardt, or Agnes Martin painting, or a scrim piece by Robert Irwin, the viewer has to slow down the mind and emotions to apprehend the work. The process is a gradual revelation similar to meditation. The work of art is a mental suspension, not a mental diversion. Many of the artworks in this book take us above the level of the mind rather than just allowing us to substitute one set of thoughts for another.

# BIBLIOGRAPHY

Adorno, Theodore. 1984. *Aesthetic Theory*. Trans. C. Lenhardt. London: Routledge and Kegan Paul.

Akenside, Mark. 1835. *Poetical Works*. London: William Pickering.

Alloway, Lawrence. 1965. Barnett Newman. *Artforum* 3 (June): 20–25.

———. 1969. Notes on Barnett Newman. *Art International* 13 (Summer): 35–39.

———. 1973. Agnes Martin. *Artforum* 11 (April): 32–36.

Ashton, Dore. 1983. *About Rothko*. New York: Oxford Univ. Press.

Bachelard, Gaston. 1988. *Air and Dreams*. Trans. Edith and Frederick Farrell. Dallas: Dallas Institute Pub.

Barnes, Susan. 1989. *The Rothko Chapel: An Act of Faith*. Austin: Univ. of Texas Press.

Barrow, John D. 2000. *The Book of Nothing*. New York: Pantheon Books.

Baudelaire, Charles. 1983. *Les Fleurs du Mal*. Trans. Richard Howard. Boston: David Godine.

Beckett, Samuel. 1931. Serendo et quiesciendo. *Transition* 21 (March): 13–20.

———. 1957. *Murphy*. New York: Grove Press.

———. 1958. *How it is*. New York: Grove Press.

———. 1965a. *Molloy, Malone Dies and the Unnamable*. New York: Grove Press.

———. 1965b. *Proust and Three Dialogues with Georges Duthuit*. London: John Calder.

———. 1970. *More Pricks than Kicks*. New York: Grove Press.

———. 1976. *I Can't Go On, I'll Go On: A Samuel Beckett Reader*. Ed. Richard Seaver. New York: Grove/Weidenfeld.

Belz, Carl. 1973. Fitting Sam Francis into History. *Art in America* 61 (January/February): 40–45.

Benjamin, Walter. 1979. The Work of Art in the Age of Mechanical Reproduction. In *Marxism and Art*. Ed. Maynard Solomon. Detroit: Wayne State Univ. Press.

Bennett, L. C. *Neti, Neti*. 1959. London: John M. Watkins.

Besant, Annie, and C. W. Leadbeater. 1967. *Thought Forms*. Madras: Theosophical Publishing House.

Bhaba, Homi, and Pier Luigi Tazzi. 1998. *Anish Kapoor*. Berkeley: Univ. of California Press.

Bielefeldt, Carl. 1988. *Dogen's Manuals of Zen Meditation.* Berkeley: Univ. of California Press.

Blair, Hugh. 1965. *Lectures on Rhetoric and Belles Lettres.* Vol 1. Carbondale: Southern Illinois University Press.

Blofeld, John. 1958. *The Zen Teaching of Huang Po on the Transmission of Mind.* New York: Grove Press.

Boime, Albert. 1986. Caspar David Friedrich: Monk by the Sea. *Arts Magazine* 61 (November): 54–63.

Bois, Yve Alain. 1991. *Ad Reinhardt.* New York: Rizzoli.

Borsch-Supan, Helmut. 1972. Caspar David Friedrich's Landscapes with Self -Portraits. *Burlington Magazine* 14 (September): 620–30.

———. 1974. *Caspar David Friedrich.* New York: George Braziller.

Breslin, James. 1993. *Mark Rothko.* Chicago: Univ. of Chicago Press.

Brown, Jonathan. 1974. *Francisco de Zurbarán.* New York: Harry N. Abrams.

Brown, Julia, ed. 1985. *Occluded Front: James Turrell.* Los Angeles: Lapis Press.

Buck, Robert T. 1972. *Sam Francis: Paintings 1947–1972.* Buffalo: Buffalo Fine Arts Academy.

Burke, Edmund. 1968. *A Philosophical Enquiry into the Origin of Our Ideas of the Sublime and the Beautiful.* Ed. James T. Boulton. Notre Dame: Univ. of Notre Dame Press.

Butterfield, Jan. 1980. *Sam Francis.* Los Angeles: Los Angeles County Museum of Art.

———. 1993. *The Art of Light and Space.* New York: Abbeville Press.

Byron, George. 1975. *Childe Harold's Pilgrimage and Other Romantic Poems.* Ed. John D. Jump. London: Dent and Sons.

Cage, John. 1961. *Silence.* Middleton, CT: Wesleyan Univ. Press.

———. 1967. *A Year From Monday.* Middleton, CT: Wesleyan Univ. Press.

———. 1973. *M.* Middleton, CT: Wesleyan Univ. Press.

———. 1979. *Empty Words.* Middleton, CT: Wesleyan Univ. Press.

———. 1981. *For the Birds: In Conversation with Daniel Charles.* Boston: Marion Boyars.

———. 1983. *X.* Middleton, CT: Wesleyan Univ. Press.

———. 1990. *I to VI.* Cambridge: Harvard Univ. Press.

———. 1996. *Musicage.* Ed. Joan Retallack. Hanover, NH: Univ. Press of New England.

Calas, Nicolas. 1967. Subject Matter in the Work of Barnett Newman. *Arts Magazine* 42 (November): 38–40.

Casper, Marvin. 1972. Maitri: Space Awareness. *Loka 2: A Journal of the Naropa Institute*, 69–70. Garden City, NJ: Doubleday.

Caws, Mary Ann, ed. 1982. *Stéphane Mallarmé: Selected Poetry and Prose*. New York: New Directions.

Celant, Germano. 1996. *Anish Kapoor*. Milan: Edizioni: Charta.

Cheng, François. 1994. *Empty and Full*. Trans. Michael Kohn. Boston: Shambhala.

Clark, Kenneth. 1971. *Leonardo da Vinci*. Baltimore: Penguin Books.

Clarke, David J. 1988. *The Influence of Oriental Thought on Postwar American Painting and Sculpture*. New York: Garland Publishing.

Coe, Richard N. 1968. *Samuel Beckett*. New York: Grove Press.

Colt, Priscella. 1962. The Paintings of Sam Francis. *Art Journal* 22 (Fall): 102–7.

———. 1964. Notes on Ad Reinhardt. *Art International* 8 (October): 32–34.

Compton, Susan. 1976. Suprematism: The Higher Intuition. *Burlington Magazine* 18 (August): 577–85.

Conze, Edward. 1954. *Buddhist Texts through the Ages*. Oxford: Bruno Cassirrer.

———. 1958. *Buddhist Wisdom Books: The Diamond Sutra, The Heart Sutra*. London: George Allen and Unwin.

Coplans, John. 1967. James Turrell: Projected Light Images. *Artforum* 6 (October): 43.

Dagyab, Loden. 1995. *Buddhist Symbols in Tibetan Culture*. Trans. Maurice Walshe. Boston: Wisdom Publications.

Dahl, Arthur. 1984. *Mark Tobey: Art and Belief*. Oxford: George Ronald.

Danielou, Alain. 1992. *Gods of Love and Ecstasy*. Rochester, VT: Inner Traditions.

De Beauvoir, Simone. 1960. *La force de l'age*. Paris: Gallimard.

Demosfenova, Galina, ed. 1991. *Malevich*. Trans. Sharon Mckee. Paris: Flammarion.

Dijksterhuis, E. J. 1961. *The Mechanization of the World Picture*. Trans. C. Dikshoorn. Oxford: Clarendon Press.

Douglas, Charlotte. 1975. Suprematism: the Sensible Dimension. *The Russian Review* 34 (July): 266–81.

———. 1989. Beyond Reason: Malevich, Matiushin, and Their Circle. In *The Spiritual in Art, Abstract Painting, 1890–1995*. New York: Abbeville.

———. 1994. *Malevich*. New York: Harry N. Abrams.

Dumoulin, Heinrich. 1963. *A History of Zen Buddhism*. Boston: Beacon Press.

Eitner, Lorenz. 1970. *Neoclassicism and Romanticism, 1750–1850, Sources and Documents*. Vol. 2. Englewood Cliffs, NJ: Prentice Hall.

Failing, Patricia. 1985. James Turrell's New Light on the Universe. *Art News* 85 (April): 70–78.

Ferguson, Russell, ed. 1993. *Robert Irwin.* Los Angeles: Los Angeles Museum of Contemporary Art.

Feuerstein, Georg. 1989. *The Yoga Sutra of Pantanjali.* Rochester, VT: Inner Traditions International.

———. 1998. *Tantra.* Boston: Shambhala.

Finberg, A. J. 1961. *The Life of J. M. W. Turner, R.A.* Oxford: Clarendon Press.

Fishcher, John. 1970. Portrait of the Artist as an Angry Man. *Harpers Magazine* 241 (July): 16–23.

Foster, Paul. 1989. *Beckett and Zen.* Boston: Wisdom Publications.

Freeman, Kathleen. 1971. *Ancilla to the Pre-Socratics.* Oxford: Basil Blackwell.

Freke, Timothy. 1998. *Sufi Sages.* North Clarendon, VT: Charles Tuttle.

Fung, Yu-Lam. 1948. *A Short History of Chinese Philosophy.* New York: MacMillan.

Gablik, Suzi. 1987. Dream Space. *Art in America* 75 (March): 132–33.

Gage, John. 1980. *Collected Correspondence of J. M. W. Turner.* Oxford: Clarendon Press.

———. 1987. *J. M. W. Turner: 'A Wonderful Range of Mind.'* New Haven, CT: Yale Univ. Press.

Gehlek, Nawang. 2001. *Good Life, Good Death.* New York: Riverhead Books.

Giacometti, Alberto. 1974. The Dream, The Sphinx, and the Death of T. Trans. Joachim Neugroschel. *Tracks* 1 (November): 52–58.

———. 1990. *Écrits.* Paris: Herman.

Goldwater, Robert. 1971. Rothko's Black Paintings. *Art in America* 59 (March/April): 58–62.

Goosen, E. C. 1958. The Philosophic Line of Barnett Newman. *Art News* 57 (Summer): 30–31.

Gowing, Lawrence. 1966. *Turner: Imagination and Reality.* New York: Museum of Modern Art.

Gruen, John. 1976. Agnes Martin: Everything, everything is about feeling . . . feeling and recognition. *Art News* 75 (September): 91–94.

Guinard, Paul. 1960. *Zurbarán et les peintres espagnols de la vie monastique.* Paris: Les Editions du Temps.

Hanh, Thich Nhat. 1992. *The Diamond That Cuts through Illusion.* Berkeley: Parallax Press.

Haskell, Barbara. 1992. *Agnes Martin.* New York: Whitney Museum of American Art.

Heidegger, Martin. 1968. *Existence and Being.* Chicago: Henry Regnery.

Heindel, Max. 1936. *The Rosicrucian Cosmic-Conception.* Oceanside, CA: Rosicrucian Fellowshop.

Henderson, Linda, and Dalyrmple Henderson. 1983. *The Fourth Dimension and Non-Euclidean Geometry in Modern Art.* Princeton, NJ: Princeton Univ. Press.

Herbert, Robert. 1964. *Modern Artists on Art.* Englewood Cliffs, NJ: Prentice Hall.

Hess, Thomas B. 1971. *Barnett Newman.* New York: Museum of Modern Art.

———. 1974. The Art Comics of Ad Reinhardt. *Artforum* 12 (April): 46–51.

Hibbard, Howard. 1983. *Caravaggio.* New York: Harper and Row.

Hixon, Lex. 1994. *Mother of the Universe.* Wheaton, IL: Quest Books.

Hohl, Reinhold. 1971. *Alberto Giacometti.* New York: Harry N. Abrams.

Holtzman, Harry, and Martin S. James, ed. and trans. 1986. *The New Art—The New Life: The Collected Writings of Piet Mondrian.* Boston: G. K. Hall.

Hughes, Robert. 1981. Poetry Out of Emptiness. *Time* 117 (January 5): 81.

Hulten, Pontus. 1993. *Sam Francis.* Bonn: Editions Cantz.

Hume, David. 1959. *A Treatise on Human Nature.* Vol. 1. New York: Dutton.

Hunt, John Dixon. 1976. Wondrous Deep and Dark: Turner and the Sublime. *Georgia Review* 30 (Spring): 139–68.

Ikkyu. 1989. *Crow With No Mouth.* Trans. Stephen Berg. Port Townsend, WA: Copper Canyon Press.

Inge, William. 1948. *The Philosophy of Plotinus.* London: Longmans, Green.

Institute for the Arts. 1982. *Yves Klein: A Retrospective, 1928–1963.* Houston: Rice Univ.

Janik, Allan, and Stephen Tolmin. 1973. *Wittgenstein's Vienna.* New York: Touchstone.

Judd, Donald. 1970. Barnett Newman. *Studio International* 179 (February): 66–69.

Kandinsky, Wassily. 1955. *Concerning the Spritual in Art.* New York: Wittenborn.

Kenner, Hugh. 1968. *Samuel Beckett.* Berkeley: Univ. of California Press.

Kierkegaard, Soren. 1954. *Fear and Trembling, and the Sickness unto Death.* Trans. Walter Lowrie. Princeton, NJ: Princeton Univ. Press.

Klein, Yves. 1974. *Selected Writings 1928–1962.* London: Tate Gallery.

Koerner, Joseph. 1990. *Caspar David Friedrich and the Subject of Landscape.* New Haven: Yale Univ. Press.

Kostelanetz, Richard. 1982. *A John Cage Reader.* New York: C. F. Peters.

———. 1988. *Conversing with Cage.* New York: Limelight Editions.

———. 1993. *John Cage Writer: Previously Uncollected Pieces.* New York: Limelight Editions.

———. 1996. *John Cage (ex)plain(ed).* New York: Schirmer Books.

Kozloff, Max. 1971. Andy Warhol and Ad Reinhardt: The Great Acceptor and the Great Demurrer. *Studio International* 181 (March): 113–17.

Kramer, Hilton. 1966. Art. *The Nation* 196 (June 22): 533–34.

———. 1976. An Art That's Almost Prayer. *The New York Times*, May 16, section 2, 23.

Kramrisch, Stella. 1981. *Presence of Shiva*. Princeton, NJ: Princeton Univ. Press.

Kripal, Jeffrey. 1998. *Kali's Child*. Chicago: University of Chicago Press.

Krippendorf, Jost. 1990. *James Turrell*. Zurich: Turske and Turske.

Kuh, Katherine. 1962. *The Artist's Voice: Talks with Seventeen Artists*. New York: Harper and Row.

Lao Tzu. 1962. *The Way of Life*. Trans. Witter Bynner. New York: Capricorn Books.

———. 1992. *Tao Te Ch'ing*. Trans. Stephen Mitchell. New York: Harper Perennial.

Larson, Kay. 1981. Dividing the Light from the Darkness. *Artforum* 19 (January): 30–33.

Levy, Mark. 1993. *Technicians of Ecstasy: Shamanism and the Modern Artist*. Norfolk, CT: Bramble Books.

Lewallen, Constance. 1991. Interview with Anish Kapoor. *View* 7 (Fall): 1–35.

Lindsay, Jack. 1966. *The Sunset Ship: Poems of J. M. W. Turner*. London: Scorpion Press.

———. 1985. *Turner*. New York: Franklin Watts.

Lippard, Lucy. 1967. *Ad Reinhardt: Paintings*. New York: Jewish Museum.

Lipsey, Roger. 1989. *An Art of Our Own: The Spritual in Twentieth Century Art*. Boston: Shambhala.

Lyotard, Jean François. 1971. *Discours, figure*. Paris: Klincksieck.

———. 1993. *Sam Francis*. Los Angeles: Lapis Press.

MacCurdy, Edward. 1955. *The Notebooks of Leonardo da Vinci*. New York: George Braziller.

Malevich, K. S. 1969. *Essays on Art, 1915–1933*. Ed. Troels Anderson. Trans. Xenia Gloweacki and Arnold McMillan. London: Rapp and Whiting.

———. 1978. *The Artist, Infinity, Suprematism, Unpublished Writing, 1913–1933*. Ed. Troels Anderson. Trans. Xenia Gloweacki and Arnold McMillan. Copenhagen: Borden.

Marmer, Nancy. 1981. James Turrell: The Art of Deception. *Art in America* 69 (May): 90–98.

Martin, Agnes. 1992. *Writings/Schriften*. Winterthur, Switzerland: Kunstmuseum Winterthur/Edition Cantz.

Matt, Daniel C. 1994. *The Essential Kabbalah*. San Francisco: Harper Collins.

McEvilley, Thomas. 1987. Gray Geese Descending: The Art of Agnes Martin. *Artforum* 25 (Summer): 94–99.

Megged, Matti. 1985. *Dialogue in the Void: Beckett and Giacometti*. New York: Lumen Books.

Melville, Herman. 1963. *Moby Dick*. New York: Russell and Russell.

Michelson, Annette. 1967. Agnes Martin: Recent Paintings. *Artforum* 5 (January) 46–47.

Miller, Philip B. 1974. Anxiety and Abstraction, Kleist and Brentano on C. D. Friedrich. *Art Journal* 33 (Spring): 205–10.

Milton, John. 1962. *Paradise Lost*. Ed. Merrit Y. Hughes. New York: Odyssey Press.

Monk, H. Samuel. 1960. *The Sublime*. Ann Arbor: Univ. of Michigan Press.

Motherwell, Robert. 1992. *Collected Writings*. Ed. Stephanie Terenzio. New York: Oxford Univ. Press.

Muktananda, Swami. 1980. *Meditate*. Albany: State Univ. of New York Press.

Murti, T. 1970. *The Central Philosophy of Buddhism*. London: Allen and Unwin.

Newman, Barnett. 1990. *Selected Writings and Interviews*. Ed. John P. O'Neill. New York: Alfred Knopf.

Nietzsche, Friedrich. 1967. *The Birth of Tragedy*. Trans. Walter Kaufman. New York: Vintage.

Nishitani, Keiji. 1982. *Religion and Nothingness*. Trans. Jan Van Bragt. Berkeley: Univ. of California Press.

Nodelman, Sheldon. 1997. *The Rothko Chapel*. Austin: University of Texas Press.

O'Flaherty, Wendy Doniger. 1981. *The Rig-Veda: An Anthology*. London: Penguin.

Otto, Rudolf. 1958. *The Idea of the Holy*. Trans. John Harvey. New York: Oxford University Press.

Ouspensky, P. D. 1970. *Tertium Organum*. Trans. Nicholas Bessaraboff and Claude Bragdon. New York: Vintage.

Pantanjali. 1998. *Yoga: Discipline and Freedom*. Trans. Barbara Stoller Miller. New York: Bantam.

Pascal, Baise. 1958. *Pensées*. Trans. W. F Trotter. New York: Dutton.

Pessoa, Fernando. 1991. *The Book of Disquiet*. Trans. Alfred MacAdam. New York: Pantheon.

Plagens, Peter. 1968. A Sam Francis Retrospective in Houston. *Artforum* 6 (January): 38–43.

Poshyananda, Apinan. 2003. *Montien Boonma: Temple of the Mind*. New York: Asia Society.

Rabten, Geshe. 1986. *Echoes of Voidness*. Ed. and trans. Stephen Batchelor. London: Wisdom Publications.

Radhakrishnan, Sarvepalli. 1924. *Philosophy of the Upanishads*. London: Allen and Unwin.

Radhakrishnan, Sarvepalli, and Charles Moore. 1957. *A Sourcebook in Indian Philosophy*. Princeton, NJ: Princeton Univ. Press.

Ratcliff, Carter. 1972. Sam Francis: Universal Painter. *Art News* 71 (December): 57–59.

Rathbone, Eliza E. 1984. *Mark Tobey: City Paintings*. Washington, DC: National Gallery of Art.

Restany, Pierre. 1992. *Yves Klein*. Trans. Andrea Loselle. New York: Journal of Contemporary Art Editions.

Roberts, Colette. 1959. *Mark Tobey*. New York: Grove Press.

Rodman, Seldon. 1957. *Conversations with Artists*. New York: Devin Adair.

Rose, Barbara. 1991. *Art as Art: The Selected Writings of Ad Reinhardt*. Berkeley: Univ. of California Press.

Rosen, Steven J. 1976. *Samuel Beckett and the Pessimistic Tradition*. New Brunswick, NJ: Rutgers Univ. Press.

Rosenberg, Harold. 1978. *Barnett Newman*. New York: Harry N. Abrams.

Rosenblum, Robert. 1975. *Modern Painting and the Northern Tradition*. New York: Harper and Row.

Rothko, Mark. 1947–48. The Romantics Were Prompted. *Possibilities* 1 (Winter): 84.

Rowell, Margit. 1980. *Ad Reinhardt and Color*. New York: Simon Guggenheim Museum.

Rowley, George. 1970. *Principles of Chinese Painting*. Princeton, NJ: Princeton Univ. Press.

Sandler, Irving. 1966. Reinhardt: The Purist Backlash. *Artforum* 5 (December): 40–47.

Sartre, Jean-Paul. 1955. Giacometti in Search of Space. Trans. Lionel Abel. *Art News* 54 (September): 26–29, 63–65.

Schenk, H. G. 1969. *The Mind of the European Romantics*. New York: Anchor Books.

Schmied, Wieland. 1964. *Tobey*. New York: Harry N. Abrams.

Scholem, Gershom. 1960. *On the Kabbalah and Its Symbolism*. Trans. Ralph Manheim. New York: Schocken.

———. 1995. *Major Trends in Jewish Mysticism*. Trans. Ralph Manheim. New York: Schocken.

Seitz, William. 1962. *Mark Tobey*. New York: Museum of Modern Art.

Selz, Peter. 1965. *Alberto Giacometti*. New York: Museum of Modern Art.

———. 1982. *Sam Francis*. New York: Harry N. Abrams.

Seo, Audrey, and Stephen Addiss. 1998. *The Art of Twentieth Century Zen*. Boston: Shambhala.

Siegel, Linda. 1974. Synaesthesia and the Paintings of Caspar David Friedrich. *Art Journal* 33 (Spring): 196–204.

———. 1978. *Caspar David Friedrich and the Age of German Romanticism*. Boston: Branden.

Simmons, W. Sherwin. 1978. Kazimir Malevich's Black Square: The Transformed Self, Part One: Cubism and the Illusionistic Portrait. *Arts Magazine* 53 (October): 116–25.

———. 1978. Kazimir Malevich's Black Square: The Transformed Self, Part Two: The New Laws of Transrationalism. *Arts Magazine* 53 (November): 130–41.

Simon, J. 1996. Perfection is in the Mind: An Interview with Agnes Martin. *Art in America* 84 (May): 82–89, 124.

Singh, Jaideva. 1990. *The Doctrine of Recognition*. Albany: State Univ. of New York.

Smith, Roberta. 1975. *Reviews: Agnes Martin, Pace Gallery. Artforum* 13 (Summer): 72–73.

Soria, Martin. 1955. *The Paintings of Zurbarán*. London: Phaidon Press.

St. Augustine. 1998. *Confessions*. Trans. Henry Chadwick. New York: Oxford Univ. Press.

St. John of the Cross. 1976. *The Dark Night of the Soul*. Trans. E. Allison Peers. London: Burns and Peters.

Stainer, Margaret. 1989. *Agnes Pelton*. Fremont, CA: Ohlone College Art Gallery, 1989.

Stich, Sidra. 1994. *Yves Klein*. Stuttgart: Cantz Verlag.

Stooss, Toni, and Thomas Kellein, eds. 1993. *Nam June Paik: Video Time-Video Space*. New York: Harry. N. Abrams.

Streng, Frederick J. 1967. *Emptiness: A Study in Religious Meaning*. Nashville, TN: Abingdon Press.

Suzuki, Daisetz Teitano. 1930. *Studies in the Lankavatara Sutra*. London: Routledge and Kegan Paul.

———. 1949. *Essays in Zen Buddhism*. London and New York: Rider.

Svestka, Jiri. 1992. *James Turrell: Perceptual Cells*. Düsseldorf: Edition Cantz.

Tanahashi, Kazuaki. 1985. *Moon in a Dewdrop: Writings of Dogen*. San Francisco: North Point Press.

———. 1987. *Brush Mind*. Berkeley: Parallax Press.

Tate Gallery. 1965. *Alberto Giacometti: Sculpture, Paintings, Drawings*. London: Arts Council of Great Britain.

Tobey, Mark. 1951. Reminiscence and Reverie. *Magazine of Art* 44 (October): 228–32.

———. 1958. Japanese Traditions and American Art. *College Art Journal* 18 (Fall): 20–24.

Trieb, Marc, and Ron Hageman. 1980. *A Guide to the Gardens of Kyoto*. Tokyo: Shufnotomo.

Trungpa, Chogyam. 1972. A Workshop on Psychotherapy. *Loka 2: A Journal of the Naropa Institute,* 71–73. Garden City, NJ: Doubleday.

Turrell, James. 1993. *Airmass*. London: South Bank Center.

Vaughn, William. 1972. *Caspar David Friedrich 1774–1840: Romantic Landscape Painting in Dresden*. London: Tate Gallery.

Vidler, Alec. 1961. *The Church in an Age of Revolution*. Baltimore: Pelican Books, 1961.

Wackenroder, Wilhelm. 1975. *Confessions of an Art Loving Friar*. Trans. Edward Mornin. New York: Ungar.

Weber, Max. 1916. *Essays on Art.* New York: William Rudge.

Weschler, Lawrence. 1982. *Seeing is Forgetting the Name of the Thing One Sees.* Berkeley: Univ. of California Press.

Westgeest, Helen. 1996. *Zen in the Fifties.* Amsterdam: Waanders Publishers.

Wilton, Andrew. 1981. *Turner and the Sublime.* Ontario: Art Gallery of Ontario.

———. 1987. *Turner and His Time.* New York: Harry N. Abrams.

Wittgenstein, Ludwig. 1961. *Tractatus Logico-Philosophicus.* Trans. D. F. Pears and B. F. McGuinness. London: Routledge and Kegan Paul.

Woodson, Yoko. 2001. *Zen Painting and Calligraphy, 17th to 20th Centuries.* San Francisco: Asian Art Museum.

Wortz, Melinda. 1980. *James Turrell: Light and Space.* New York: Whitney Museum of Amrican Art.

———. 1981. Surrendering to Presence: Robert Irwin's Esthetic Imagination. *Artforum* 20 (November): 63–69.

Zakian, Michael. 1995. *Agnes Pelton: Poet of Nature.* Palm Springs, CA: Palm Springs Desert Museum.

Zelazny Roger. 1995. *Warriors of Blood and Dream.* New York: Avon Books.

Ziff, Jerrold. 1964. J. M. W. Turner on Poetry and Painting. *Studies in Romanticism* 3 (Summer): 193–215.

Zimmer, Heinrich. 1946. *Myths and Symbols in Indian Art.* New York: Bollingen.

# INDEX

Page numbers followed by "d" denote diagrams;
page numbers followed by "f" denote figures